KAREN MAHONY

THE BAROQUE
BOHEMIAN CATS' TAROT

The cat is the animal to whom the Creator gave the biggest eye,
the softest fur, the most supremely delicate nostrils, a mobile ear,
an unrivaled paw and a curved claw borrowed from the rose-tree.

Sidonie Gabrielle Colette

MAGIC

REALIST

PRESS

A Magic Realist Press Publication

(the Magic Realist Press is an imprint of Xymbio Ltd.)
6-9 Bridgewater Square
BARBICAN
LONDON EC2Y 8AH

Cards and book design by Karen Mahony and Alex Ukolov,
baba studio, Prague.

baba studio
Břetislavova 12
Mala Strana
Prague 11800
Czech Republic

www.magic-realism.com
www.bohemian-cats.com
www.baba-prague.com
www.tarotofprague.com

Prined and bound in Prague, Czech Republic by TRICO

British Library Cataloguing in Publication Data
A catalogue record for this publication is available from
the British Library.

ISBN 0-9545007-2-5

A note on why NOT to try this at home! All the images were done using models that were
then digitially combined with photographs of cats. No cats were harmed in any way. In fact
no cat was even inconvenienced! Please don't try really dressing any cat.

CONTENTS

About the Authors

Karen Mahony and Alex Ukolov run their design atelier "baba studio" in the centre of Prague. Both are designers with many years of experience in both commercial and not-for-profit design. Alex is Russian, a graduate of the Kharkov Fine Art University in the Ukraine. Karen is Irish and did her post-graduate masters degree at the Royal College of Art in London.

Their joint aim at baba studio is to produce design that is thought provoking and socially useful but at the same time sensuous, extravagant and fun. The studio has a particular focus on collaborative and inclusive projects and aims to explore and extend the whole notion of "Magic Realism" across a variety of media. Wherever possible, baba studio aims to produce and publish its own work.

The studio name, baba, comes from a truly global word that can mean "strong woman" or "old woman" in Slavic languages, but also "baby" in English, "father" in Turkish and Bengali, and of course a very good cake in many languages...

All costumes were made by Anna Hakkarainen. Anna is Finnish, and studied textile design at the Academy of Design in Kuopio and Institute of Design in Lahtiworks in Finland. She has also done post–graduate work at the Academy of Fine Arts in Prague.

Acknowledgements

We would like to thank the following people and organisations:

Bronislava Nováková,
Country Cats, Prague
Siberian Cats
www.countrycat.cz

Lada Škaloudová,
Siberian cats, Prague
http://ceskasibir.pc.cz

Světluše Veselá, D'Este, Prague
Exotic and Persian cats

Michal Jakeš,
Nozomi Teco, Nozomi de Casto,
British Shorthair cats, Prague

Jarmila Marková, Blue Orchide-CZ,
Russian Blue cats, Prague

Julia Craig–McFeely
Oxford, UK
Siamese, Burmese and Tonkinese cats

The Prague cats rescue home
http://www.kocky–online.cz

John J. Hodgson, miniature Baroque gilt furniture

Neil Carter, miniature bronze statue of Mercury

Celia St John, antique fabrics and trimmings

Aeclectic tarot forum

Czech Cat Society
http://www.kocka-info.cz

THE TRADITION OF CATS IN CLOTHES

The Baroque Bohemian Cats' Tarot follows in a long tradition of images of dressed cats. There is actually a surprising amount of popular art that shows cats (and other animals) in human situations, and wearing clothes. The better of the older pieces have never lost their appeal and have become collectible, with originals sometimes fetching high prices.

A Victorian "scrap"

An illustration by Louis Wain

While many anonymous artists in the 19th century produced the ever-popular "scraps" that sometimes showed well-drawn dressed cats, by far the best known work is by Louis Wain, the English Victorian cat artist. His work continues in print today, and is still wildly popular, particularly in Britain. In a BBC radio interview in 1925, no less a fan than the author H.G Wells said about Wain, "He has made the cat his own. He invented a cat style, a cat society, a whole cat world. English cats that do not look like Louis Wain Cats are ashamed of themselves." Wain was extremely prolific and had a long and successful career, producing work that was strikingly humorous, and often incorporated a strong story-line in the scenes shown. Notoriously and tragically, however, he finished his life suffering from serious psychological illness and drawing ever wilder and stranger cats – hopefully not a warning to other artists who show dressed cats...

In the USA, Renate and Alfred Mainzer became well known in the late 1930s and '40s as the producers of humorous postcards showing drawings of animals, of which the most popular were cats in various human situations. Although this work was generally known as the "Mainzer Dressed

A.Mainzer Cats postcard

Cats Series", in fact the artist was not one of the Mainzers themselves but a certain Herr Hartung. The work continues to be quite popular even today. H. Dixon (his first name seems unknown) was a much later illustrator in similar mode. His cats tend, however, not to be dressed, but are otherwise

anthropomorphic, and often have great facial expressions. Still in the USA, it was Harry Whittier Frees who really took up the baton from Wain and produced several (it's unclear quite how many) dressed cats books between the 1920s and 1940s. Clearly, there was a demand. In the preface to one of his books, Whittier Frees reassuringly tells us: "Every subject in them was a living, healthy, active animal brought into position by patient kindness.

Dashing cat by V.Konashevich

No drugged animals much less any that was artificial or stuffed, could give the results shown in this book." We can only hope that this is entirely true.

One of Satoru Tsuda's books

Even the Soviet Union was not immune to a love affair with dressed cats. From the 1970s onwards, many a Soviet child enjoyed fairy stories illustrated by V.Konashevich, many of which featured cats in splendid clothes.

There was a positive cult around dressed cats in the 1980s. Something to do with the economic boom perhaps (cats with money to burn on lavish wardrobes?) Terry de Roy Gruber produced "Cat High" a spoof US college yearbook, in 1984. At around the same time, in Japan, there was the phenomenon of the so-called Pelorian Cats (in fact, they are always small kittens). These are rather kitschy and hyper-realist in style and became a craze that swept the country and resulted in the production of over 500 items, including books, posters, badges, watches – and even lingerie. Satoru Tsuda "Mr. T" was the artist, although he seems to have worked with a whole group of photographers. The work carries on, with new kitten characters appearing regularly.

Recently in the UK Susan Herbert has become known for her charming and witty illustrations of cats in various historical settings. Unlike the "Pelorian" work, these are drawn in traditional style; in fact in many ways they take us right back full circle to the days of Louis Wain – though with a refreshingly modern sense of humour.

Another cat by V.Konashevich

A SHORT HISTORY OF TAROT

The early history of tarot is shrouded in mystery and obscurity, and some commentators love to emphasise this as a way of enhancing the romance of the cards. However, the rather mundane truth is that the history of tarot is no more mysterious than the history of many early games, and it's now generally accepted that tarot probably began not as an occult or esoteric tool, but simply as a card game. The exact date and place of its birth is hotly disputed and, because so few early cards survive, the origins of the imagery may never be absolutely determined. Because of this, there are still many people who argue that we can't entirely dismiss the idea of a mysterious background, linked to the Egyptian rites, to the Kabbala, or perhaps to the medieval Templars. But while it's impossible to disprove these theories conclusively, it is important to realise that there is virtually no evidence as yet to support them, and much that points to tarot being devised simply for playing a game (still popular in much of Europe) that's a little like our modern game of Bridge. The word "tarot" itself seems to be derived from the Italian verb "taroccare" which means "to reply with a stronger card", as the game was essentially designed around the twenty-two trump cards.

The wonderfully evocative pictures and symbols used on the early decks perhaps made it inevitable, however, that they would begin to be used for more esoteric purposes sooner or later. While there are some early references to the use of cards for a simple form of fortune-telling, true cartomancy (divination with cards) does not seem to have been at all widespread until a French psychic and fortune-teller called Etteilla (real name Alliette) popularised it in the late 18th century. Etteilla designed his own pack of divination cards, which is actually quite different from what we now think of as the classic tarot. There has been much disagreement about just how significant Etteila was. Arthur Waite in *The Pictorial Key to the Tarot* dismissively described him as an "illiterate but zealous adventurer". But he does seem to have been immensely popular in his time, and his deck of cards was a great success – versions of it are still available today.

Another very significant figure of early cartomancy was Antoine Court de Gébelin, who is largely responsible for the idea that tarot was Egyptian in origin and incorporated Egyptian occult symbols and ideas. Although he could offer little proof for this theory, it became popular and was a significant reason for the growing interest in tarot as an exotic esoteric tool.

In the 19th century using cards for divination gradually became quite popular, and in the early 20th century this finally resulted in the publication of an enormously influential set of cards now known as the Rider Waite Smith (RWS). This was developed by Pamela Colman Smith (who did the paintings) and Arthur Waite, and published by Rider in 1909. Waite and Smith were members of the influential Golden Dawn esoteric society (the poet W. B. Yeats was another well-known member who probably advised on the design of this deck). Like most traditional tarots the RWS deck consists of twenty-two trump cards (the twenty-two cards used in the game of tarot to trump other cards) and fifty-six others divided into four suits: Wands, Swords, Cups and Pentacles (or Coins), each with four Court Cards (Page, Knight, Queen and King). But the RWS cards differ fundamentally from nearly all of the earlier tarot decks because each card, including the "pips" (the suit cards from ace to ten), is fully illustrated with a picture that tells an evocative story. This was the first 78-card occult tarot deck to depict the lesser cards in this way and it made it relatively easy for a beginner to understand and memorise their meanings. Waite and Smith also changed the names of some of the "trumps" and reordered them slightly. Because this was a deck designed for cartomancy and not for game playing, the ordinary suit cards were termed the "Minor Arcana", and the "trumps" were called the "Major Arcana", Arcanum means "secret" in Latin.

The RWS has become by far the most popular model for modern tarots – probably mostly because of its use of illustrations for every card. The Baroque Bohemian Cats' Tarot follows this system and so it can easily be used with most recent books about tarot interpretation. As there are a number of really excellent tarot writers around these days, it really is worth reading some specialist books to extend the range and depth of your understanding. There are even whole books devoted to Reversals (cards that appear upside down in a reading) and to the Courts (never the easiest of cards to interpret). While this companion book is more than sufficient to get you started and to help you develop your skills, you may well find it rewarding to take your studies further than the range of any one book.

CATS AND TAROT

There seems to be some definite, if indefinable, link between cats and tarot. The traditional Rider Waite Smith deck shows a black cat on the Queen of Wands card, and many newer decks have followed this tradition. But this doesn't, in itself, seem nearly enough to explain the continuing association between cats and the cards. Another part of the reason may of course be the very ancient association of cats with magic and witchcraft. But perhaps a lot of the underlying explanation is simply that many tarot enthusiasts seem also to be cat lovers. Could it be that people who are attracted to animals as enigmatic, untamable and yet at the same time as warmly emotional as cats also find some of these same qualities in the tarot?

Nowadays there are really quite a few tarot and oracle decks that show cats on all or most cards, so much so that the "cat tarot" has almost become a sub-genre of its own - and a very popular one. Some of these decks are definitely intended for cartomancy but currently most are "art decks", interesting and sometimes beautiful but not primarily meant for serious use. Our aim in the Baroque Bohemian Cats' Tarot is to produce a tool as well as a piece of art - we hope it will prove to be not only one of the most attractive but also one of the most readable cat tarots to date.

How to use the descriptions of the cards.

Most of this book is made up of information on the imagery of each card, and its potential interpretations. To make it easy to begin, short keywords and phrases are included at the beginning of each card. These deal with both the normal and the reversed meanings (a card is "reversed" when it appears upside-down in a spread). The fuller description discusses interpretation in more detail, and is a good starting point for any more serious study of the cards. Please remember that although the book largely follows the conventional interpretations for each card, you don't have to take these as the cut and dried "correct" meanings. In any real-life tarot reading, it's important to look carefully at the pictures and trust your intuition about how a particular spread may relate to your querent's concern (the "querent" is the person asking the question). The possible interpretation of each card is quite broad; it's up to you as a reader to find the meaning that fits with each individual situation.

One last point to mention is that you may wonder why is there also a small section for each card called Cats' Interpretation. This began as something

intended simply to add some humour and whimsy to the descriptions. However, as I wrote more of these pieces I realised that they are often surprisingly useful at giving a fresh and sometimes thought-provoking point of view on the more conventional meanings. Several times I found that they opened up my own attitude and approach to interpreting a card. So please don't always just gloss over these, I offer them as worthy of a little reflection, as well as being fun. Sometimes the world seen according to a cat's viewpoint and behaviour can be an oddly revealing place.

A note on the numbering of the cards

Among tarot enthusiasts there is considerable argument about what the "correct" system of numbering for the Major Arcana cards is. When Arthur Waite and Pamela Colman Smith produced their highly influential Rider Waite Smith deck in 1909 they changed the ordering commonly found in older tarots. The reason for this was not stated clearly, but seems to have been related to the need for the deck to correspond more closely to the esoteric thinking of The Golden Dawn society. Ever since, there has been disagreement about whether to follow the older system of numbering, or that of the RWS deck. Readers will often have strong feelings about this, particularly if they use some form of numerology in their readings.

Because of this continuing controversy about the best numerical order, we have not put numbers on the Major Arcana cards of The Baroque Bohemian Cats' Tarot. However, in this book we have used the ordering suggested by Arthur Waite (you can see it listed on the next page) so that the cards can be easily referenced if you are using a RWS-based book. When you read with the cards, you can decide for yourself which system of numbering, if any, works best for you.

An old American deck of Oracle cards, showing cats in various situations

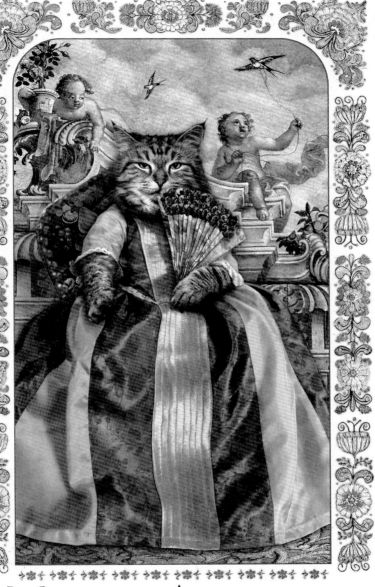

MAJOR ARCANA

MAJOR ARCANA

The twenty-two cards that make up the Major Arcana have remained broadly the same since the early 15th century decks, although there have been various regional differences. There have been also been some changes over time to suit evolving attitudes and interests; perhaps the most notable and controverial of these has been the RWS renaming of the original "La Popessa" as The High Priestess. There have also been variations in the images used, with different conventions sometimes arising in different regions or time periods. However, it can be argued that the archetypes that these cards stand for have nevertheless not altered significantly and continue to have a timeless quality about them. In most of the Majors, there is a symbolism that we recognise almost instinctively, and this is what gives them their associative and evocative power to spark ideas, thoughts and feelings in us.

The Majors (cards of the Major Arcana) tend in many ways to be taken more seriously and to be given more importance in an interpretation of a reading than the other cards simply because they are so archetypal. They are usually given a certain amount of spiritual as well as mere "fortune-telling" significance. Waite talks in the *Pictorial Key* about the "higher intention" of the Major Arcana and it's often said that only these cards go beyond the rather day-to-day issues of past, present and future actions to address more fundamental spiritual issues in life. It is common nowadays for people to think of these twenty-two cards as a sequence showing a philosophical and spiritual progress through life, that is known as "The Fool's Journey".

0 The Fool	XI Justice
I the Magician	XII The Hanged Man
II The High Priestess	XIII Death
III The Empress	XIV Temperance
IV The Emperor	XV The Devil
V The Heirophant	XVI The Tower
VI The Lovers	XVII The Star
VII The Chariot	XVIII The Moon
VIII Strength	XIX The Sun
IX The Hermit	XX Judgement
X The Wheel of Fortune	XXI The World

0 THE FOOL

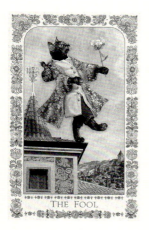

THE FOOL

A young cat blithely takes a step off a roof, seemingly unaware that he could be about to fall. Behind him, a weather vane of an angel carrying a large quill pen seems to watch in amusement. Below, a little creature, half animal and half sun, peeps out from the sgraffito decoration on the wall below.

It's sunny and bright and surely no harm will come to this fool? After all, cats do tend to fall on their feet.

A Cat's Interpretation

For a cat, a leap from a high place is a good deal less foolish than it would be for a less agile animal. Cats have a remarkable physical ability to twist in the air, so as to almost always land firmly on their paws. They also have an inbuilt mental facility for judging depth and distance and so take "risks" that for them are in fact quite safe. So this step into the unknown may not look at all foolish to a cat.

Keywords and phrases

Foolish wisdom • Chaos and freedom • Blind faith • Stepping into the unknown • Trusting in fate and fortune • Throwing yourself into the arms of luck.

Keywords and phrases for reversed cards

Being afraid to take a risk • Applying sensible caution • An inability to trust • Being over-cautious about people or situations.

The Fool is the outsider of the tarot deck. Usually numbered zero or nothing, this card is not part of the system, but instead seems to represent a time before time or a place outside all known structures or locations. This gives the card the meaning both of chaos (the chaos before the world was created, or that exists beyond it) and also of freedom. The Fool is literally "without" rigid rules or limits and this is the key to understanding the card, and arguably a key to grasping the meaning of the tarot itself.

In readings, the more common and down to earth meaning of The Fool is often about a reckless step that isn't sensible by any logical assessment; but that impulsively you feel you still have to take. Perhaps the word "simple" is

worth thinking about in relation to the Fool. He is simple both in the old country sense of the person who is a bit "simple in the head", but also simple and direct in terms of behaviour and feelings. The wise fool who trusts such direct impulses knows that there are moments when you have to just believe in fate and take a step into the unknown. While this may look crazy, oddly enough sometimes blind faith is rewarded by good luck, and things work out just fine and dandy. We all know that fortune favours the brave – but sometimes she also favours the fool and the simpleton.

In fairy stories the familiar "king's youngest son" is a typical Fool figure. He's the innocent who is sent out into the world to do an impossible task and because he does not realise the impossibility, and also because he blindly trusts the various odd figures who offer to advise and help him, he actually manages to achieve it. One of the most gentle and appealing of these fairy tales is Andrew Lang's "The White Cat" in which a beautiful white cat (who is an enchanted princess) meets the young fool, supplies the increasingly impossible demands of the boy's father and turns failure into triumph – and the fool into a king. Maybe it's purely a coincidence that it's still an American superstition that to see a white cat on your path is good luck.

Of course in "Puss in Boots" a much less refined cat befriends a rather different kind of fool, a lovelorn but hopelessly inept young man. By upsetting all the norms and flouting every rule in the book, Puss in Boots brings about a happy ending; at least for himself and the hero, if not for all the more establishment figures that they encounter. There is often, in the Fool card, a touch of the bravado and cheekiness of Puss in Boots.

In the Baroque Bohemian Cats' card the Fool himself is a brindled cat in a chaotic random mixture of ginger and black. He (or is it "she" for after all most ginger and black tortoiseshell cats are female?) is a rough–looking character in some ways, but also a cocksure dandy. Richly dressed and carrying a flower high in front of him, he seems perfectly happy and confident, with no anxiety about any imminent danger. A fool perhaps, but also someone at one with himself and with the world.

The reversed interpretations of The Fool all come from the central meaning of the card, which is about following your instincts rather than your rationale. This means that the possible reversed meanings can seem initially contradictory. Either they can signal an inability to take a risk, a caution that may or may not be justified (which is it? Ask your instincts.) Or they can point to a wild leap into something reckless, in a situation in which if you really

went by your gut feelings you would know that the step won't work out. As ever in tarot, the way to find the right interpretation in a reading is to consider context and trust your intuition – and of course this advice is particularly appropriate when interpreting The Fool card.

Notes on the sources

The cat is a young European cat photographed at the Prague Cat Rescue Home. She (in fact it turned out to be a "she", though in spite of her colouring we didn't realise this at the time) was striking for the way in which she simply got into everything – with no sense of caution. She just had to be constantly everywhere and investigating everything, a real Fool attitude. I laughed out loud when I noticed that on the cats' home website she was described as "unusually energetic".

The angel is from a gilded Baroque fountain near Old Town Square in Prague. We've always liked the jolly angels on this fountain and it seemed appropriate to include the one who is obviously taking notes for the record. However, one thing we found attractive is that for a serious recording angel, she has a refreshingly carefree and unjudgmental manner.

The original angel from a fountain in central Prague

I THE MAGICIAN

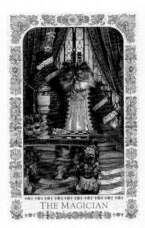

THE MAGICIAN

A sumptuously dressed Persian cat stands in front of a pair of velvet curtains, between which is a gilded iron gate barring the way to stairs. On the games table in front of him are a sword, a bone cup with a complex spiraling stem, a golden disc and a mask. In his hand you can just see that he holds aloft a flowering gilded wand.

A Cat's Interpretation

Cats often seem to be natural channellers of energy, fired with a spark of pure life-force. A cat's nature is essentially mercurial, much more flighty and less predictable than that of a dog. This is why we often feel we can trust the cat less; cats can be tricksters who can put on a convincing act whenever they need to. Yet we almost admire them for this – dazzled by their sheer *joie de vivre* we enjoy being conned by our cats.

Keywords and phrases

Focused creativity • The power to transform • Applied energy • Thrilling concepts brought to life • A flash of inspiration • Irony and mischief – of a rather brilliant kind • Dazzling with ease.

Keywords and phrases for reversed cards

A laboured process of creativity, not easy or quick • A smaller act of creation – not quite inspirational but still creative • Something seemingly wondrous that turns out to be a trick or a scam • Difficulty in making contact with your creative impulse, you know it's there, but...

The Magician in tarot is a complex figure. He is at once an actual magician – a blindingly powerful figure who can make something from nothing, conjure gold from base metals and control the elements – and, at the same time, he's a charlatan and trickster. Perhaps in real life the two have always been intertwined in the common imagination? Often we are torn between a suspicion that the wonders we are shown are only tricks, and at the same time a strong desire to believe, or at least to suspend disbelief.

The Magician in this card has not only the usual implements of sword, cup and pentacle on his table but also a mask to symbolise both the mystery of

the creative spark – an enigma at the heart of art and creation – and the disguise behind which the "real" trickster hides. There is also perhaps a subtle further element of "masking" in this card. The mixed colour of this cat suggests that "he" might in fact be female. The Magician can be deceptive in entirely unexpected ways! Don't take anything at face value.

It's worth looking closely at the cup on this image. It has a most unusual spiral design that immediately reminds us of the many meanings of this shape; it is at once the winding road to the stars, W.B. Yeats' "widening gyre" (a symbol Yeats, a member of the Golden Dawn, used repeatedly in his poems) and the stairway to heaven. It could also be a slippery slope downwards of course. The Magician, as the first card in the Major Arcana (remember that the Fool is placed outside) is the one that points the way to follow. But only if we can distinguish truth from trickery, and true path from false promise.

Our Magician cat stands in front of a curtain. Again, the meaning points in two directions at once. Either this is the curtain of a theatrical stage, and the whole thing is merely a performance, or the curtain is, perhaps, the veil that in many religions hides the Creator, that moment and spark that begins all things. Is it possible that it can be both at one and the same time, depending on the perception of the viewer? As we are often told, the Creator him or herself can be revealed in the most unexpected places.

So, this is a complex card indeed. But if we bring all these meanings together, at its most profound The Magician can simply tell us that even the most astounding and unknowable things in life – the origin of the universe, the meaning of existence itself, the energy of the cosmos – are in one sense merely a game that we need to understand is at once resonant with significance and simultaneously meaningless. As Zen Buddhism would say "Everything is nothing but the mind", and our very mind is in some ways a trickster that does not merely see the world, but actually invents it. This can be regarded as the reason for the traditional appearance of the symbol for infinity on this card – infinity is the ultimate paradox, because it represents both all time, and so absolutely no time at all. These very concepts, when grasped fully, can both amaze and awe you and at the same time make you laugh at their absurdity, just like the Magician himself.

The reversed meanings concentrate on the trickster side of the card. This doesn't mean that they are necessarily negative. While this card reversed may well warn of a scam or a swindle, it may also stand for the brilliant showman

who amazes and delights you even while you know that it's all done with "smoke and mirrors". While such a person may not be a genuine magician or a true creative genius, there may still be a place in your life for the delightful, illusionary artiste. To some readers, this card reversed can show panic and anxiety attacks, a bolt from the blue that strikes into you the hyperventilated terror of panic rather than bringing positive energy. This reading is comparatively unusual and should only be made if the other cards strongly support it, for instance if some of the other "mental disquiet" cards such as the Nine or Ten of Swords also appear in close and meaningful proximity.

Notes on the source material

The cat is a Persian. The extraordinary "angry fish" table legs are actually adapted from table legs showing "blackamoor boys" that were popular in the Baroque period (and indeed later too). We didn't like the patronising aspect of these depictions, so instead changed the figures to show a grinning, sharp-toothed fish with two tails.

> *Ars* means something like agility or the ability to turn something to one's advantage, and *artifex* – i.e. "artist" means a "trickster above all". That the original artist was a conjuror can be seen from words such as 'artifice', 'artificial", and even 'artillery".
>
> *Villem Flusser, The Shape of Things, a Philosophy of Design.*

The original blackamoors, from a piece in the Wallenstein Palace, Prague

II THE HIGH PRIESTESS

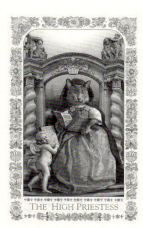

THE HIGH PRIESTESS

A hooded High Priestess sits flanked by two pillars on which little angels peek out from under veils. In front is another angel who offers an important-looking golden book. Behind, a cloudy city glows in the early evening light. The Priestess simply smiles enigmatically...

A Cat's Interpretation

The Egyptian cat goddess, Bast, is in many ways the ultimate High Priestess. While revered and strictly respected, she was also simply loved. Her trace can be found in many domestic cats, who can suddenly change from fluffy kitties into creatures who seem directly connected to an ethereal world that we humans can rarely see. Mysterious cat, but at the same time utterly familiar.

Keywords and phrases

A deep spirituality • Looking into yourself for the answers • Reflection and soul searching • Wisdom from self-knowledge • A focus on higher matters – with some detachment from the mundane world • Being in touch with the inner mysteries of life.

Keywords and phrases for reversed cards

Waiting to be lead spiritually, rather than finding your own path • Restlessness, an inability to be still and to look within • Some loss of spirituality.

The High Priestess indicates both knowledge and mystery, both of a very personal kind. Unlike the Hierophant she is neither teacher nor authority, but instead someone who looks inward to her own heart to find the truth. She isn't a cold figure, and if consulted, she may willingly impart advice or guidance. However, this may come in a form that will demand both mental strength and patience to unravel the puzzles of the underlying meaning.

The High Priestess represents an inner intuition that sits right outside the hierarchies of organised religion and recognised conventions of belief. While the Hierophant works through institutions, rules and structure, the High Priestess is essentially an independent figure who looks to her own insight to find inspiration. Her power comes from her personal ability to seek answers

both from within herself and directly from her contact with the Divine, rather than from any official position. She may of course inspire followers, but she does not seek to build an establishment around herself.

This can be quite a demanding card to interpret, but the important thing to understand in a reading is that The High Priestess does not represent a particular person or faith, but rather the fundamental desire to find an individual path to the deeper meanings and truths in life. The card can often indicate a spiritual journey or, more radically, the need to stop relying on a leader, guru or priest and instead begin to take the search inside your own mind and soul. Depending on the context of the overall reading, this soul-searching can be profound and long lasting, or a much briefer period of learning to rely on your own intuition or "sixth sense". However long the process, it needs to be done in a spirit of quiet seriousness. Indeed, Aarland Ussher in *The Twenty Two Keys of the Tarot*, described the High Priestess as "the spirit of seriousness" and, as he says, she is always weighty, never slight or whimsical.

In this card, a little smiling angel hands the Priestess the books that she is reading. This indicates that her knowledge comes straight from the Divine, rather than through a priesthood. The other angels at the top of the pillars are half-veiled, a subtle reference to the veils that are shown obscuring the sacred site behind the Priestess on the traditional RWS depiction.

One last note, we may remember as we look at the image of this card, that according to some Buddhist belief, the body of the cat is the temporary resting place of the soul of very spiritual people.

Notes on the source material

The High Priestess is a particularly thoughtful looking and beautiful blue-point Siamese. The angel holding out the book is from St. Nicholas Church, which is a particularly famous example of Central European High Baroque and has a great number of elaborate and appealing cherubs.

The city seen through the mist is of course Prague. It's worth mentioning that the church spire that can just be seen is the Church of Our Lady Victorious in which the "Infant of Prague" is kept.

> **I believe cats to be spirits come to earth. A cat, I am sure, could walk on a cloud without coming through.**
>
> *Jules Verne*

20

III THE EMPRESS

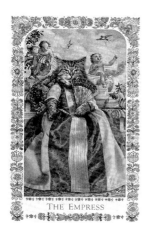

THE EMPRESS

Lavishly dressed, calm and composed, the Empress sits surrounded by exquisitely pretty images of nature and childlike cherubs. But look again, isn't there a rather wild smile on the face behind that heavily feathered fan?

A Cat's Interpretation

Even the most domestic cat is a little wild underneath; the connection with nature is never entirely lost. But nature is not always of the smiling and tamed garden sort. Like it or not, she is also cruel sometimes, as even the most domestic kitty shows when she goes hunting...

Keywords and phrases

Mother nature • Abundance and growth • Motherhood and fertility • Letting your emotions rule • The female principle, the "Yin" of life.

Keywords and phrases for reversed cards

Some loss of contact with nature, or with your own feelings • Anxieties or issues about fertility • Pollution, destruction of habitats • Conflict with the natural world • Allowing some rationalism into your emotional world.

Nature in all its glory is beautiful, but remember that it's also "red in tooth and claw". This Empress is mother of the Earth and as such, she should be shown respect, as well as enjoyed for her natural splendour. She is the source of fruitfulness and plenty, of rich emotion and lavish generosity. But don't treat her too lightly, as like all parts of the natural world she should be venerated as well as enjoyed. The Empress represents the natural senses, emotions, nature and, in one possible interpretation, even the Earth herself. She has been called the "Corn-woman" and the "Mother-Imago" (Ussher).

As an archetype of nature, there is nothing about The Empress that has been learnt or acquired through civilisation. She is the classic Earth Goddess who simply is the way she is - deeply passionate, unrestrained by any ideas of convention, and gorgeously forthright and unaffected. In a reading she often indicates fertility, deep emotion and an utterly natural way of going about things. On a more negative note she may also imply a lack of rationality and a tendency to act too much on sheer passion rather than any logic. The female cat is a particularly apt representation of the Empress - always in

touch with her surroundings, she can be warm and purring one minute, but quite capable of instinctively lashing out with her claws the next.

The Empress on this card is mature, and has something of the look of a European wild cat. She is lavishly dressed but the fan that she holds in her paws is trimmed with iridescent feathers. These should act as a reminder that nature is not all sweetness – it can also involve a natural order in which some animals, including cats, are natural predators. In the background cherubs cavort. One holds a pink rose, beautiful and full-blown, a symbol of the emotions and senses. The other plays with a swallow tied to a string. An attempt to tame the untamable? Think about the fact that witchcraft was in part derived from the very ancient practice of worshipping a female goddess and also that cats and witchcraft are intimately associated, and you can clearly see the Empress as the personification of something wild, natural, female, and divine. A counterpoint to the more establishment and orderly male aspects of divinity.

As in many of the Major Arcana, there is a broad range of possible interpretations of The Empress reversed. Mostly, the card signifies a rather negative loss of contact with the earth, nature and the emotions. However, if it seems to refer to a period following an over-emotional episode, then it can be entirely positive, meaning that some necessary logical and hard-headed thinking is finally being allowed into the situation.

Notes on the source material

The Empress herself is a young female Siberian – who when we first met her was surrounded by kittens. She is holding a wonderful miniature 1920s celluloid fan made to look like mother of pearl. It is topped with real peacock feathers. Although this fan is not in period, it in fact looks elaborate enough to be Baroque – and with its feathers, we felt it was ideal for the extra meaning we wanted to add to this card.

The background is from the interior of a Baroque wooden bandstand in the gardens of the castle at Český Krumlov (a town famed for its exquisite Renaissance architecture). It depicts "spring", one of the four seasons painted on each of four segments of the ceiling. A local Czech, František Jakub Prodys, painted these delicate little pictures in 1752. The bandstand is open to the elements all year round, and is surrounded by woodland. Remarkably, it is unprotected but also undamaged and so can still be freely enjoyed in its natural setting.

IV THE EMPEROR

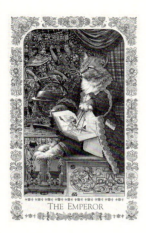

THE EMPEROR

A superb ginger tom cat is in the act of precisely measuring the objects shown on an etching that illustrates the mathematical art of perspective drawing. The etching is informative rather than evocative, but it's Baroque and done with a style and artistry that's beautiful in its own right. However, the Emperor is not admiring it, instead he is simply gauging it, applying a rational rather than an aesthetic viewpoint. Yet on his bench is a little figure of an owl, an age-old symbol of wisdom.

A Cat's Interpretation

No cat is a complete rationalist – though many can think very rationally when it's necessary. Most are very fond of order, but not logic. They like to eat at set times (and in between of course), sleep in familiar places, trace well-laid tracks when they go out and stick to their own territory. Cats are not, in day-to-day life, at all keen on improvisation or change.

Keywords and phrases

Strict Rationalism • Structure and order • Reason and Logic • Hierarchy.

Keywords and phrases for reversed cards

Loosening up a little – letting your emotions show • You may think you are being logical, but are you really? • Some lack of authority, perhaps because of immaturity.

If the Empress was the archetypal Great Mother, then the Emperor can be thought of as an archetype of the father. He brings to mind many mythological authoritative father figures such as Zeus, father of the heavens in classical belief, the biblical Jehovah and the Norse Thor. Stern and dominant, he represents conscious, rational thought directed with firmness and determination. He is impressive, but often daunting and unapproachable. The Emperor's power comes from his ability to be perfectly logical, controlled and structured in all his thoughts and actions. While his complete lack of emotion can seem almost computer-like rather than human and humane, he represents the reality of the need sometimes to put aside feelings and depend instead on good, rigorous logic. He also reminds us that this approach is capable of commanding a lot of respect from those around.

However, while hard rationalism is sometimes essential, it can be a demanding ruler in your life. By all means allow the cold logic of the Emperor to guide decisions that need to be taken without sentiment, but remember that however powerful a purely logical approach is, it can quickly turn into a strange kind of tyranny if it isn't tempered by compassion. The Emperor is at his best when he allows himself to be influenced at least a little by the warm emotionality of the Empress.

The image on this card shows an Emperor who is very much absorbed in the etching that he holds. However, his interest seems to be in measuring it accurately, rather than in contemplating it for its artistry. This isn't wrong in any way, but it is distinctive. Most of us would rather gaze and enjoy, than measure and gauge. Having said that, however, the Emperor himself does not seem cold – he is cool, calm and rational, but we can assume from looking at him that he might, on occasions, be capable of humour. The tapestry behind also suggests this. To a modern eye the tableau shows an Emperor who is being gestured at rather rudely – the whole thing is a little absurd and funny. What might be suggested here is that the totally rational and logical approach of the Emperor is not necessarily humourless. Many of the most authoritative and respected rulers and leaders have had a tremendous sense of wit and irony, but this will always be based on a logical assessment of any absurdities of a situation.

Notes on the source material

The Emperor himself is a long-haired European cat with a splendid coat and, when we met him, an attitude to match. The bench he is sitting on is a small ivory carved box found in the Museum of Decorative Arts in Prague.

The tapestry shows an Imperial "Triumph", scenes like this were popular in tapestries of the Renaissance and later. The etching our Emperor is studying is a remarkable Renaissance technical drawing that shows how to represent perspective. It is also on display in the Museum of Decorative Arts in Prague.

V THE HIEROPHANT

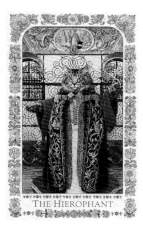

THE HIEROPHANT

Standing full-square and in some grandeur in front of gilded iron railings, the Hierophant holds up a bunch of golden keys. Will these unlock the establishments of learning and knowledge that he guards?

A Cat's Interpretation

Do cats form institutions? Probably not. Do they learn from their elders? To some extent, but probably mostly only when they are kittens. Perhaps this means that a cat can never comfortably represent the Hierophant but is more naturally the Hierophant reversed – someone who kicks against the establishment? It's true that what we admire in our feline companions is usually not authority, but rather the refusal to be told what to do, or indeed to bow down to authority in any way.

Keywords and phrases

Conforming to the establishment • Not bucking the system • Respecting rules and regulations • Civilisation and civic order • Tutoring or guardianship • Institutions and traditions, particularly educational or religious ones.

Keywords and phrases for reversed cards

Beginning to look for answers within, rather than from an authority • Trusting your own intuition, not following the rules • Upsetting the structure – or finding that the establishment around you is crumbling.

The Hierophant provides a counterpoint to The High Priestess in the Major Arcana. He is a figure of the establishment, drawing his power from order and structure, and from being part of a hierarchy, whereas the High Priestess is essentially a lone mystic, consulted by her people, but, unlike the Hierophant neither obeyed or obeying any authority.

Because of this status as the representative of law, order and regulations, The Hierophant is a card that can evoke strong feelings, particularly nowadays, when we often see authority figures as being reactionary and oppressive. Many people react to it with some hostility, especially when they interpret it as referring to restrictive, stuffy rules and strictures. However, there is a completely different way of seeing the Hierophant. When you look at the

image on this card, you'll see that the cat holds two golden keys in his paws. These are the traditional keys held by the Christian St. Peter, but at the same time they can be regarded as keys to any higher knowledge. Seen in this way, the Hierophant is revealed as a gatekeeper and guide. He holds the keys to a type of learning and understanding that only comes through discipline and a willingness to become the humble student of those with more experience and wisdom. Whether this is in formal education, a religious or spiritual institution or any setting that imposes structure and hierarchy, an ability to suppress your own individualism and conform to the imposed order may be part of the process of opening the door to the knowledge you desire.

In writing about this card, Aarland Ussher goes further and implies that tangible sacrifice is necessary in order to fully understand the learning and insight offered by The Hierophant. Maybe it's true that there are times when we must give up our ego and submit to rules and regulations that we find irksome? The message of The Hierophant is that like it or not, we must recognise that deeper knowledge cannot always be acquired with ease, or purely by personal meditation.

Notes on the source material
The cat is a splendid Maine Coon. The gilded railings are from the Strahov Monastery in Prague. The wall-painting of the bishop is from the highly decorated old Jesuit Monastery in Český Krumlov, Southern Bohemia (see illustration). The building is now a hotel, and has been carefully restored.

> **I care not much for a man's religion whose dog and cat are not the better for it.**
> *Abraham Lincoln*

Wall painting from the old Jesuit Monastery, Český Krumlov

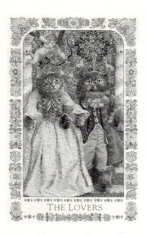

THE LOVERS

VI THE LOVERS

Placed in front of a rich tapestry of flowers and trees, this couple look cool, buttoned up and rather proud, a classic formal wedding pose, rather than a picture of ardor. Yet the blazing red of the rich surroundings and the presence of the little cherub that aims his arrow above hint that something entirely more passionate is about to begin. In fact, not all is as cool and conventional as it appears...

A Cat's Interpretation

Few cats form a close relationship with their mates, although it does happen from time to time. But mostly any "romantic" encounter is a brief one, and the real passion and commitment is reserved for those they live with – whether cats or people. Even then, it's debatable how much faithfulness most cats show. Of course they can be genuinely affectionate, but it's just that to many a cat, there seems no point in making choices when it comes to love and fondness – they find no problem in bestowing it equally on several households.

Keywords and phrases

Sheer Passion • Sexuality as part of an emotional bonding • Love and desire or a powerfully touching relationship • Values of faithfulness and commitment • A choice between passion and reason.

Keywords and phrases for reversed cards

Thwarted, or temporarily blocked, love • Passion, but a lack of anything deeper • Some unfaithfulness in a close relationship • Refusing to make a choice or commitment in love.

The Lovers represents not only passion, but also strong emotional relationships and values, or beliefs that are based on raw feelings rather than rationality. Desire can take many forms. It may of course have a powerfully romantic focus, but it can also refer to loves that are less physical, but no less passionate. Unlike The Devil card, The Lovers signifies that giving yourself up to passion, when it is truly based on love, can be an act of generosity that can lead to both happiness and spiritual calm.

The Lovers card is one of those that have several layers of meaning. At first sight it simply looks like a picture of a happy couple, but historically it used

to show a young man making a choice between two women, who represented either romantic attraction as opposed to a more mature relationship, or, more simply, passion versus reason. Nowadays the card still carries some connotation of choice and this can make it less straightforward to interpret than you might initially think.

We've tried, in our image of The Lovers, to suggest some of the inherent ambiguity. Our pair actually look a little formal and cold – far from passionate. Perhaps they have made a choice about duty, and have entered into an alliance that has been decided by head rather than heart? Yet, crucially, there is tremendous hope in the image. The rich red and flowered background seems to breathe passion, and the cherub that emerges from all this lushness is just about to fire his arrow. It may be that duty is about to turn into a real, intense love? This is worth thinking about. A deep love, and the kind of passion that is mental and spiritual as well as physical, often takes time to emerge. On the traditional card that originally showed a young man making his choice, one has to wonder if the older, plainer woman who seems to represent "reason" may not actually lead to a more fulfilling relationship than the young blond beauty who is the passionate alternative? Similarly, our image may suggest that passion and devotion really can strike even in a situation in which all that is expected is duty and obedience. Never underestimate Cupid.

Notes on the source material

The "bride" in this card is a Siberian, and her groom is a Persian. In fact, the groom is tortoiseshell and so may – in true pantomime style – be a girl dressed as a boy (male tortoiseshells are rare).

VII The Chariot

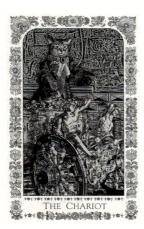

THE CHARIOT

Firmly at the reins, a determined young cat in military dress drives a gilded coach across a painted and decorated courtyard. The scene behind him shows a classic "triumphal procession" complete with a charioteer in the victory parade.

A Cat's Interpretation

Even the sweetest and fluffiest seeming cat will usually have a willpower that defies belief. When it comes to training, it's usually the cat that trains its people, rather than the other way around. A cat has no hesitation in trying to control your behaviour, because they know who really has the whip-hand in the household – and it isn't you.

Keywords and phrases

Mental control • Willpower and absolute focus • An iron will • Triumph in conflict • Power and control, perhaps to a ruthless degree • Total determination to direct things your way • Singlemindedness.

Keywords and phrases for reversed cards

Letting your grip relax a little • Being unable to take control • Steering your course – but perhaps not quite in the right direction?

The Chariot is about knowing where you are going, and exactly how to get there. Nothing is going to stand in the way. That's fine, but remember that this card does not signify the right to ride rough-shod over others, just because it suits you.

Finding the correct way to interpret The Chariot during a reading is often challenging, simply because the card can indicate a range of aspects of willpower and control from the positive to the very negative. At its most unpleasant, it can stand for achieving success in war and conflict through a focused and determined ruthlessness. In this aspect, it is clearly related to the classical scenes of "Triumph" that have been so popular in artwork since the Renaissance. However, in other circumstances The Chariot indicates a useful and necessary application of will and concentration and the ability to retain discipline and self-control in difficult circumstances.

The Chariot is similar to The Emperor in being about the power of the will, and belief in the absolute rightness of your own decisions. However, while The Emperor is essentially about intellectual and rational willpower, The Chariot shows willpower applied to action. Even when The Chariot seems to apply purely to a mental activity, it will still be one that is likely to cause waves and attract attention. The Emperor might, for example, represent the development of a ground-breaking theory, but The Chariot would be that theory put forcibly into promotion, a movement or a fiery intellectual campaign.

In the context of this particular card it is worth noting that the chariot of Freya, Norse goddess of love and fertility, was pulled by two black cats. After serving Freya for seven years, the cats were rewarded by being turned into witches, disguised as black cats.

Notes on the source material

The cat is an Abysinnian in what's known as the "normal" colour, a kind of fox red/brown. He is sitting in a Baroque golden chariot that is currently on display in the castle at Český Krumlov. This chariot is interesting, because although it looks like pure gold it is in fact merely gold foil laid on to wood and there are only two or three kilos of gold in the whole piece. Far too elaborate for use, it ended up being used as a bed in the castle. The sgraffito picture behind shows a complex depiction of a chariot surrounded by fantastic figures and some wild decoration.

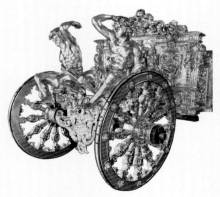

Baroque "golden" Chariot from Český Krumlov

VIII STRENGTH

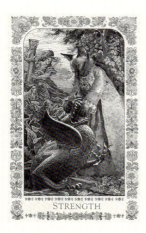

STRENGTH

A serene cat calmly controls a monstrous dragon rising out of the water at her feet. In the background a traditional figure of Strength looks on. She seems to be dropping her pillar casually on to an understandably grumpy lion.

A Cat's Interpretation

The inner strength of cats can often be seen most clearly in feral street cats. They seem to be able to maintain a strength of character and a determination against all the odds. Sometimes they look frail, but at heart they can be very strong indeed, with tremendous fortitude in the face of difficulty and deprivation. In spite of this, do remember that a little help never goes amiss. Even the strongest feral may sometimes need some loving care and assistance from willing humans.

Keywords and phrases

Calm strength under pressure • Determination and patience • Courage and fortitude • Inner conviction of purpose • A quiet mind is stronger than a violent action.

Keywords and phrases for reversed cards

Losing some strength and inner calmness • Being unsure that you can overcome obstacles • Trying to exert some physical force because you doubt that your mental resolve is enough • Feeling some weakness - usually in your level of confidence.

Self-confidence and serenity are at the core of real strength. Strength isn't about force, but comes instead from the knowledge that you really can achieve what needs to be done; calmly, quietly, but in a way that overcomes all resistance. The word "strength" has many potential meanings. We can talk about a strong physical material, a strong emotional bond, strength of purpose, or sheer brute muscle. The strength that this card represents is usually a mental or moral power - one that can overcome force without resorting to physical might or violence. Aarland Ussher describes this particularly memorably as "wisdom declaring itself as power" (Ussher). The main message of this card is that a calm and focused mind can overcome wild or brutal actions. There is a zen-ness about this, the idea of a flexible

tree being stronger than the most powerful wind, or of a steady drip of water being stronger than the stone on which it falls. This card used to be called "Fortitude" and it's worth briefly considering the particular nuance of this title. Fortitude implies patience, perseverance and endurance, all qualities of an inner strength. Fortitude is also about having courage in a difficult situation, and about showing a calm mental conviction and staying power. This shows how strongly this card contrasts with The Chariot, which is essentially about the use of sheer force or focused, fierce willpower.

In our image, an almost meditative cat is calmly subduing a fearsome dragon that rises from a river. Does the monster represent inner demons rising out of her own subconscious rather than any threat from outside? Whatever it is, she wrestles it almost without raising a hair - she is utterly confident. In the background is another picture of Strength, which manages to combine the two traditional depictions, of a woman carrying a heavy pillar, and of a woman controlling a lion, into one image. Strength indeed.

Notes on the source material

The dragon is from a Renaissance statue in Prague's Wallenstein Garden. The cat is a seal-point Siamese, with typical piercing blue eyes. She is standing against a tapestry on which there is an unusual depiction of Strength, who is usually shown either carrying a pillar or subduing a lion. Interestingly, in the picture here, from a courtyard at Český Krumlov Castle, "Fortitude" is shown with both pillar and lion, so while unusual, our tapestry isn't unique.

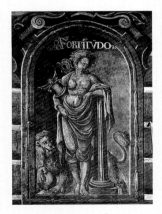

Wall painting of "Fortitude" from Český Krumlov Castle

IX The Hermit

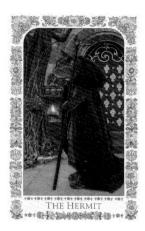

THE HERMIT

An elderly grey cat makes his way alone across an empty street in the evening twilight. He is heavily hooded and holds up a lantern and a staff with the head of a wolf; or could it be Anubis, the jackel-headed Egyptian god who could foretell the time of death? To one side is an incredibly gnarled tree, showing the beauty that often comes with age.

A Cat's interpretation

It isn't uncommon for a cat to decide to withdraw from society and live on its own. This may be for many reasons - perhaps this animal has had a bad experience with humans it has lived with, or it is simply old and tired of the noise and bustle of others. However, in true cat fashion even the most solitary and anti-social cat will not deliberately lead a life of physical self-denial. Alone perhaps, but uncomfortable? Never!

Keywords and phrases

Introspection • A mental or spiritual quest • Meditation • A deliberate withdrawal from the world • Thinking deeply and carefully • The passing of time - and the wisdom that comes with it.

Keywords and phrases for reversed cards

Coming back to the world after time away • Being unwilling to look deeply into matters • Resisting the natural ageing process • A depressed or neurotic withdrawal, rather than a calm and considered one.

Like many of the Major Arcana cards, The Hermit has a more normal interpretation, and a less common one. Usually, it represents a withdrawal from the everyday concerns of life in order to gain insights into deeper matters. This withdrawal may be actual - a literal need to be solitary - or it may be more symbolic, perhaps a psychological withdrawal or disengagement from the everyday. It may also take the form of a journey or quest undertaken alone, and for spiritual, rather than practical reasons. This brings to mind all the lone sages of mythology and also, it should be said, the isolated witches and wizards of ancient fairy tales.

The less common interpretation of this card is about the passing of time.

The card actually used to sometimes be titled "Father Time" and this gives quite a different nuance to the elderly figure. In many world myths about Hermits they are believed to live to an incredible age, while existing in a style in which time simply passes them by. In one sense the years never touch them. Just as a candle burning down is an old symbol of the shortness of our lives, so the lantern traditionally held by the Hermit may originally have symbolised this, rather than, or in addition to, enlightenment.

These two meanings – deep meditation and the passing of time – can be reconciled very easily if you consider that it's the knowledge that life is short that often motivates us to look inside ourselves and begin to think about the meaning of our existence.

The presence of Anubis, the Egyptian god who could foretell the time of death, and who also guided souls into the afterlife, is one visual reminder of the way in which this card may remind us that life is short and that we sometimes need to think deeply about its purpose and focus. As we grow older, the desire to make some spiritual sense of life often becomes stronger. But surrounded by everyday duties and tasks we can endlessly put off any search for deeper truths or enlightenment. The Hermit counsels us to step aside, even for a short while, and cut ourselves off from the bustle in order to be able to think, contemplate and meditate in peace.

Notes on the source material

The cat is a very elderly Russian Blue female who was probably nearing the end of her life. When we met her she was surrounded by young cats and kittens, but in fact had separated herself both physically and, it seemed, mentally from all of them. The head of the staff is made from a remarkable door handle that we found at Prague Castle.

Of all animals, he alone attains to the Contemplative Life.
Andrew Lang

When the moon gets up and night comes, he is the Cat that walks by himself, and all places are alike to him.
The Cat That Walked By Himself
Rudyard Kipling

X Wheel of Fortune

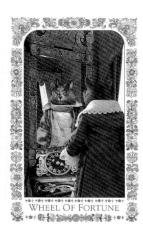

A well-dressed cat stands in a richly furnished room. He looks into an ornate Venetian mirror, but what he sees is not himself as he is now, but a mirror image that is poorly clothed and beaten looking. Is it past or future? On the table is a clock framed by golden angels.

A Cat's Interpretation

The most pampered, comfortable domestic cat can suddenly find its fortunes changing if it gets lost, or if its human carer can simply no longer look after it. When you go into any cats' rescue home you will see cats that this has happened to. The happy side to this is that it's these domesticated cats that often find new homes quickly, so their fortunes can turn again...

Keywords and phrases

Luck, fate and fortune • The inevitable cycle of chance • Outside influences on your destiny • A change, for better or worse.

Keywords and phrases for reversed cards

Resisting fate and fortune • Struggling against the ups and downs of life • Being stuck with a run of bad (or good?) luck • Trying to stay the same forever – blocking change because it seems risky.

"What goes up must come down" as the old saying goes. The Wheel of Fortune reminds us that however well we plan our lives, fate will always take a hand. Essentially, the card is about both hope and humility. When things go badly, we can comfort ourselves with knowing that luck may change again. When they go well, we should realise that this may not be forever, and so we shouldn't let it make us vain or self-satisfied. All life is full of ups and downs, and none of us is immune to these.

In a reading this card can indicate a distinct change of fortune – for better or worse. However, it can also just act as a reminder that life is never totally predictable, and that nothing stays the same. This is a very heartening thought when times are hard, but can equally stand as a warning that we shouldn't slip into smugness or complacency when all is going well. The cat on this card is obviously in a very comfortable situation. His room is richly decorated in red, a colour of money and power, and the furnishings are

sumptuous. But the figure who stares back at him from the mirror looks ill and tattered. Is this a memory or a vision of the future? It really doesn't matter, the important thing is to realise that both figures are real – only time and fortune separate them.

Notes on the source material
The cat is a mature Russian Blue. The room that this is set in is actually a large and lavish bedroom at Český Krumlov Castle. The "clock" is constructed from a 19th century clock-face (which is very Baroque in style) and two angels taken from the entrance to a door in Prague's Old Town.

> **He [the cat] regards**
> **the wheel of existence from without, like the Buddha.**
> *Andrew Lang*

Relief scuplture from Prague's Old Town district

XI Justice

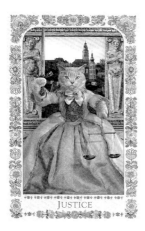

JUSTICE

A cool cream cat sits in front of two pillars that flank a window. Beyond can be seen two towers, silhouetted against the sky. Though the scene looks solemn, one of the faces on the pillars is smiling with what looks suspiciously like a sense of humour...

A Cat's Interpretation

In many cats you really can see a natural sense of justice – a cat will return kindness with affection, but can often bear a long grudge towards anyone who has been cruel to it. Perhaps the most famous, and grisly, story about the justice meted out by a cat (both during and after its life) is "The Black Cat" by Edgar Allen Poe, in which a cat finally delivers its mad and cruel owner into the hands of the law. Harsh, but fair.

Keywords and phrases

Taking responsibility for the consequences • Reaping what you sow • "Truth will out" • Justice will be done • Fair-mindedness and fair play.

Keywords and phrases for reversed cards

An injustice • A doubt about whether justice will be done • Some double-dealing • "Getting away with it".

Justice is in some ways one of the sternest cards of the tarot, and also one of the easiest to understand. It's about fairness, ethics and honesty as well as cause and effect. The meaning could be summed up as both a warning and a promise that "you will reap what you sow". Just how welcome this message is probably depends on whether or not you have a clear conscience.

In readings it can be important to think about which aspect of justice is indicated. Is it the querent who – for good or bad – will get what they deserve, perhaps in a formal setting such as a court action? Or is the card indicating that justice will fall on someone else? In either case, remember that justice is not by any means always negative, you can be fairly rewarded as well as punished. The whole point, in a sense, is that justice is inherently neutral. Remember too that a rather milder interpretation of this card is that it can point to a generalised recognition of responsibility and of cause and effect.

The cat who represents Justice is serious, and stares out with piercing eyes, but she is also beautiful and in some ways soft. Justice is sometimes severe, but she isn't cruel.

The reason that the figures on the pillars in this image look rather cheerful is because we wanted also to show a less serious aspect of the idea of Justice. We've all had moments when something happens and we have to shrug and laugh and admit, "Well, I really asked for that!" Ideally being fair should sometimes be about good humour and acceptance, rather than solely about the more coldly judgemental aspects.

Looking at the image, you'll see that there is some resemblance between this card and the Queen of Swords. This is entirely deliberate; in many ways the Queen of Swords is a more day-to -day representation of many of the ideas and attributes of Justice. Both images show women who hold swords aloft, to represent their ability to cut through to the core of matters. Both are also associated with a keen sight that goes beyond the physical world - each can see through deception to the truth. The difference between the two cards lies, as is usually the case when you compare Major and Minor Arcana, lies with the fact that Justice is much more about an archetypal principle, whereas the Queen of Swords is likely to represent the actual experiences and characteristics of a person. Justice can come into your life in many forms - even in a form as abstract as the idea of Justice, or the desire for or impulse towards fair play.

Notes on the source material
The cat is a British Shorthair. The pillars are from a house in Český Krumlov, and the scene in the background is also of Český Krumlov, showing the castle rising up against the buildings of the old town.

Old tortoisehell miniature scales from Bohemia

XII THE HANGED MAN

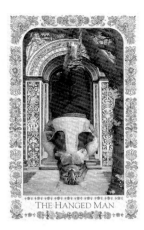

THE HANGED MAN

Hanging in such perfect stillness that even the birds are not frightened, this cat looks out with piercing cyan eyes. Behind is an archway that is covered in pictures and symbols. In the corner of this riot of imagery, just in sight, is an allegory of "Faith". Does this tell us something about the state of mind of this serene figure?

A Cat's Interpretation

Cats are very good at stillness, much more so than most humans. A cat who is gazing at nothing can appear sunk in deeply profound thought –although of course it's a matter of opinion whether this is really the case. But it's interesting to note that in some Buddhist faiths the cat is a repository for the soul of someone who has been particularly spiritual in a past life.

Keywords and phrases

Transcendence and illumination • Spiritual surrender • Sacrifice - usually of the ego • Letting go of material concerns • Enlightenment – perhaps by seeing things a whole new way • Detachment from selfish considerations • A state of mental suspension from everyday things • Letting go.

Keywords and phrases for reversed cards

Not following your inner beliefs • Being made to dance to the tune of others • Feeling mentally hectic, and unable to suspend thought even for a short time • Struggling with spiritual beliefs - without finding peace.

The Hanged Man is one of the most powerful and well-known images of the tarot. The mystery and fascination of this card come from the fact that the hanging figure seems to be in some sort of transcendent state, not in pain, but rather in ecstasy. There has been much discussion of the derivation of this figure, because it is not, like some of the other Majors, a standard image of Renaissance iconography. It has been said that as traitors were sometimes punished by being hanged by one foot, the card may originally have stood for "Traitor", or it may have been a "Shame" painting (escaped criminals were sometimes depicted in public places in Shame paintings of this sort). What is remarkable, if this really was the origin of the image, is the way in which it has changed its meaning entirely. Nowadays there is absolutely no association

with shame or punishment and instead, a strong aura of spirituality and the self-sacrifice made by the seeker of truth.

Today, this card tells us that giving up the ego is necessary in order to gain insight and enlightenment. This may mean sacrificing something quite small, perhaps just some degree of material or physical comfort, or it might be an inner demand that you let go of your deeper security, dignity or status. Giving up part of yourself, or what you hold dear, will certainly be uncomfortable, but it may be the only way to gain the ability to see the world through new eyes. Sometimes we have to submit to some stress in order to allow ourselves to undergo a mental transformation.

This all sounds very serious in tone, yet there is some absurdity in the image on this card; the little bird that gazes at the Hanged Man makes us smile, as does the posture of the cat himself who looks a little silly. It's important to realise that there is indeed something of the "wise fool" here. To gain enlightenment may mean allowing yourself to look foolish, and also being willing to see the world, in a sense "topsy turvy". Many religions teach us that holiness and absurdity are often surprisingly closely associated and that the spiritual seeker can look like a simpleton to others. The point is that he or she does not care, being entirely suspended away from everyday concerns and embarrassments. To be the Hanged Man is to let it all go. The reward is attainment of deep, unimaginable faith and an understanding of real truths.

Notes on the source material
The cat is a Maine Coon. The background is the richly sgraffitoed front of the Ball Games House (the Míčovna) a Renaissance building in the Royal Palace Garden in Prague.

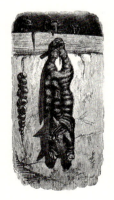

Each cat had an important mission to fulfil, for when a human being who had attained a certain degree of holiness died, the cat acted as the host of his soul for the rest of its natural life. Only by this means could the departed soul gain Paradise.
The Cat in Religion and Magic,
(with reference to Buddhist belief)

From "Aesop's Fables" illustrated by Ernest Briset

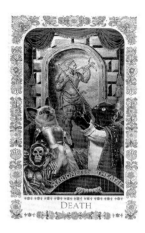

DEATH

XIII Death

A performance in a marionette theatre. The two cats seem almost to be "hamming it up" – the actress about to faint away as the actor declaims his speech. But while it's funny, there is also something faintly sinister about the scene, especially with the smiling skeleton looking on...

A Cat's Interpretation

If a cat has nine lives this may mean that they understand the true meaning of this card more easily than a human. Perhaps each of a cat's deaths is a transformation, which even if difficult, leads to refreshed life and a new start.

Keywords and phrases

The death of a strong part of one's identity • A physical or spiritual death • The absolute closure of a cycle or phase in your life • A difficult event, but one that prepares you for a transformation.

Keywords and phrases for reversed cards

Denying the need to let part of your identity go in order to move on • A realisation that you are mortal • A brief brush with death, or simply with a life-changing experience.

Is the Death card really about death? This is one of those questions that can provoke a fierce discussion among any group of tarot enthusiasts. In its least alarming, and most usual interpretation, the Death card is not about actual death but rather about the "death" of one distinct part in your life. This may involve giving up some element of your self-identity, or leaving behind an aspect of your life that you are strongly attached to. Whatever the exact form of this transition, this card warns us that it may feel difficult and a serious wrench, even if it then leads to better things.

As Aarland Ussher has written, "Death is not only the frontier between Time and Eternity, but that between the Future and the Past" (Ussher). So what about physical death itself? Well, yes, this card does sometimes seem to refer to a physical death. After all, this is a part of life and the tarot really does seem to span the whole of life's experiences. Although this is not a common occurrence in a reading there are occasions where the card seems very clearly

to point to a death, though often this is one that has already occurred, not one which is about to happen - remember that the popular idea that this card prophesies doom is usually pretty far-fetched. But in general, one thing that we have tended to lose in the West is an acknowledgement of the fact that dying is a reality. It's part of life, and shouldn't be denied or feared. This card can usefully remind us of that.

The picture shows two cats kneeling on a stage; apparently transfixed by something they can see above them, they almost look as if they are praying. An alternative, and rather cheekier reading of the image is that the male cat is declaiming and the female almost fainting way as she listens - a real melodrama, and perhaps a slightly tongue-in-cheek reference to our sometimes overly melodramatic attitude to the Death card. In a nod to the traditional RWS image, one cat is dressed in vestments, as a priest, while the other is a woman in rich clothing. The lesson of such figures is that death takes everyone, regardless of worldly riches or religious or spiritual status.

Where the image differs widely from the traditional is the setting of a "Marionette Theatre" presided over by a figure of death ringing a little golden bell. The theatre calls to mind the famous quote from Shakespeare:

Life's but a walking shadow, a poor player
That struts and frets his hour upon the stage
And then is heard no more
 Macbeth [V, 5]

While the cats look alarmed, they are, of course, only acting. But then perhaps all of life is merely a shadow? Even if you take this slightly grim interpretation, there is, overall, something comic about this card. This is entirely appropriate. In earlier times there was both a dread of death, and at the same a good deal of black humour about it. The common images of "Memento Mori" ("remember death") pictures were meant as an exhortation to live well - in many senses.

Notes on the source material

One cat is a European jet-black cat from Prague; the other is a young blue-point Siamese. The "marionette theatre" sign is from a theatre in the centre of Prague's Old Town.

Every life should have nine cats.

Anonymous

The Cat, because of her unique position in symbolism as the representative of Hecate, goddess of Death, is a widely respected omen of approaching mortality.

The Cat in Religion and Magic

Si tu ne meures pas avant de mourir,
tu mourras en mourant.
If you do not die before dying,
you will die when you die

The motto of the Order of Teutonic Knights (1198-1410)

Since each of us is blessed with only one life,
why not live it with a cat?

Robert Stearns

Sign from a modern marionette theatre in Prague

XIV TEMPERANCE

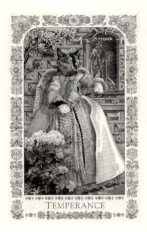

TEMPERANCE

There is a calm cool elegance about this winged calico cat who stands quietly pouring water between two exquisitely worked goblets. The contrast between the stark wall behind and the lush vegetation growing on the water's edge where she stands is harmonious, not jarring, and overall the scene looks silent and peaceful.

A Cat's Interpretation

This card is sometimes titled "Balance" and when we think of cats and balance what usually comes to mind is a physical ability rather than a mental one. Cats certainly have a superb sense of physical poise, but do they have the same mental equilibrium? Most cats, given the chance, will lead lives in which all things are quite well mixed and in moderation. It's recently been discovered that cats have a built-in tendency not to overdose on any one food and so tend naturally to maintain a varied and balanced diet. So a cat's temperate lifestyle is partly instinctive and may need no self-denial on the cat's part at all. Which is good, as self-denial is something that cats don't excel at.

Keywords and phrases

Striking a healthy balance • Moderation in all things • Synthesising things that are contrary or opposite • A willingness to compromise • Order and harmony • Strength through flexibility – in the Zen manner.

Keywords and phrases for reversed cards

Being in a state of imbalance – constantly having to juggle things • Feeling restless and out of harmony with the world • Failing to combine different parts of your life – but at least trying • Refusing to compromise – though you actually know it's necessary.

After the very mixed feelings that the Death card arouses, it's in some ways a relief to come to the next card in the Majors sequence, the orderly, harmonious and peaceful Temperance. It also, of course, marks a quiet interlude before the upheavals and obsessions of The Devil. In contrast to the cards that frame it, Temperance is about achieving control and ease in your way of living. Its indicates the management of a beautiful balance, moderation, and a generally healthy way of being. Temperance is about

having power and command, not over others, but, (and more importantly) over yourself. In many ways The Devil and Temperance, who is usually shown winged like an angel, make up the pair – angel and devil – who some people believe sit on our shoulders throughout life, leading us into temptation on the one hand, and urging restraint and a moral self-control on the other. It's up to us to decide which we listen to.

Temperance is sometimes seen also as symbolising Time. Not in the way that the Hermit represents it, as the time and aging process that we all go through, but more in the sense of time as a moderating process. People tell us "give it time", or "time is a great healer" and it's true that very often the best way to begin to get back into balance is just to allow yourself some time to assess the situation and take a measured, calm view of your lifestyle.

One last curiosity to note is that while the Major Arcana includes the three classical virtues of Strength (Fortitude), Justice and Temperance, it excludes Prudence. This is one of the many oddities of the tarot that has motivated a lot of debate and speculation. Perhaps three virtues are enough?

Notes on the source material

The wall painting in the background is from the first castle courtyard in Český Krumlov Castle. The gold-rimmed goblets are based on an original 18th century glass, on display at the Museum of Decorative Arts in Prague.

Wall painting of "Temperance" from Český Krumlov Castle

XV The Devil

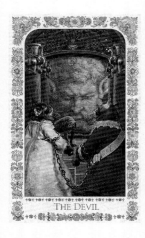

THE DEVIL

Two cats, a male and a female, stand in a temple, staring at the huge, red-lit tapestry of the devil on the far wall. Both are chained. Is this why they don't run from the vicious dog in front of them? Or is it that they are too entranced with the devil's beautiful face?

A Cat's Interpretation

Many black cats are still, today, called "Satan" in a (perhaps ironic) nod to the old beliefs about witches owning cat familiars with this name so that they could then talk to "Satan" freely. Unfortunately, the association of black cats with the devil has meant that many of them have been shunned or persecuted. Nowadays the belief has largely died out, although cat shelters still say that sadly the black cats are the hardest ones to home.

Keywords and phrases

Temptation and addiction • Giving in to unhealthy desires • Loss of self-esteem and self-control • The allure of sin • Hating your behaviour, but finding it hard to stop • Giving in to obsessions or compulsions.

Keywords and phrases for reversed cards

Resisting temptation • Being enticed by small and silly sins • Giving in to minor temptation, but not to any major addictions • Rejecting temptation.

The Devil card is almost always a negative one, although, like so many of the cards in tarot, it can occasionally be read "against type" in a more positive light. To deal with the usual interpretations first, The Devil symbolises the destructive impulse that works primarily not from without, but from within. We are told in folk belief that we all carry around our own angel - on our right shoulder - and devil - on our left. Whether you believe this literally or not, it is a fantastically strong image or metaphor about our need to take responsibility for our own actions, and to make choices. The suggestion is that we will all be constantly tempted to evil, or to behaviour we know is negative, but that there is always council at hand (perhaps simply in the form of our own conscience) to give better advice. It's our own responsibility to decide what to listen to and act on. In this way the Devil card tells us that

misfortune is often brought on by our own lack of self-discipline or a tendency to give in to harmful desires and dreams. It's a harsh message, but one that is worth acknowledging.

The picture on this card shows two elegant cats who seem to be almost fixated on the overwhelming, beautiful but ultimately dangerous image of the devil hanging on the end wall of the temple they have entered. The pillars that line the way to this devil are topped with eerie little grinning demons, which are androgynous; they represent, in a warped, exaggerated way, the desires of the flesh. They also stand for all the unpleasant aspects of addiction and loss of self-control. They are very physical figures but all the aspects of the body that they display are distorted and made ugly.

The dog growling in front of the picture is in many ways a cat's worst nightmare, but also he may actually, in this situation, represent a warning – we know that the devil is not really the glamorous creature that tempts us, underneath he's a snarling monster who will happily eat us up.

Notes on the source material

One cat is a Siberian; the other is a European tabby. The tapestry that dominates the scene is taken from a border in the series (now in Bratislava) showing the myth of "Hero and Leander". They are displayed in the Primaciálny Palace, Bratislava, Slovakia and date from 1630. The Devil is a significant emblem as the whole story is a tragic one of lost love and misfortune. The little demons are originally found on the base of the famous bronze "singing fountain" in the gardens of Queen Anne's Palace in Prague.

Detail of the "singing fountain" at Queen Anne's Palace, Prague

47

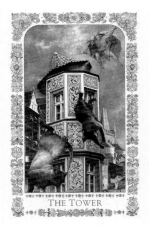

THE TOWER

XVI THE TOWER

Two cats fall from a tower as a storm brews and a figure in the sky hurls lightning bolts. All seems nightmarish and slightly unreal and there is a disturbing contrast between the pretty domesticity of the architecture and the drama of the god who throws his thunderbolts. Perhaps he is a "deus ex machina" intruding on otherwise ordinary lives?

A Cat's Interpretation

A physical fall does not represent the same disaster to a cat that it can to a human. Cats are famous for always falling on their feet and can sometimes survive even long falls without serious injury. In this way they are a good lesson for our understanding of The Tower. Though something happens that seems catastrophic at the time, the comforting reality is that we can survive and go on – perhaps even finding that we've fallen on our feet – or paws – once the crisis is over.

Keywords and phrases

Cataclysmic change that shakes you quite badly • Explosive events coming suddenly • Feeling as if everything has fallen to pieces • Dramatic disruptions and upheavals • A necessary shake-up in order for things to change • A sudden release of emotions that you've been bottling up.

Keywords and phrases for reversed cards

A change that feels huge, but in fact isn't • Avoiding a painful upheaval • Refusing to go through the mayhem that may in fact be necessary • Keeping the lid on explosive emotions – though you know they have to come out sometime.

The Tower is another of those cards that is often regarded, somewhat melodramatically, as being laden with doom and dire warnings. In fact, it does symbolise a disruption, but it also stands for a necessary, if hard, transformation. While this can be an unpleasant or even distressing experience at the time, it may be a very good thing in the long run and can actually result in some startling insights.

This card hasn't always been called the Tower; in older decks it was sometimes

entitled Fire, Hell or The House of God. In some ways it brings to mind the Tower of Babel, and has much the same sense of confusion, chaos and loss. Uncontrolled change is usually hard, and the fact that the Tower signals change that is also sudden makes it even more challenging. This is about change that is so unexpected and extreme that it can feel like complete mayhem. When this happens the cataclysm can be painful to cope with, but in fact in the long term it is often not negative. Sometimes The Tower can mean a release of anger or emotions that have been bottled up or denied and needed to get out sooner or later. The sudden and dramatic disruption that this brings can clear the way for new possibilities.

The Baroque Bohemian Cats' image is an unusual depiction, because instead of the more usual fortified tower, it shows a decorative, rather domestic one. The lightning striking it is wielded by a Zeus-like god, who seems to be looming over the building, high-lighted against a stormy sky. There is a sense that this is a nightmare, rather than reality, and the sky is lit in that "just before the thunderstorm" bright grey that can make everything seem out of focus. The thing to think about in this picture is that though the cats are in the act of falling, they are also already twisting around on to their front, as cats do. By the time they land on the ground, chances are they will be able to get up and walk away without serious damage. In the Tower-like moments of your life, remember that you too can land lightly, like a cat.

Notes on the source material

The tower itself is part of a well restored Baroque building in the old Malá Strana district of Prague. The background is based on an 1852 painting of "The Devil's Mill-race" by Bedřich Havránek. This is in the Kampa area of Prague.

The figure of Zeus (which we have considerably altered) is based on one painted on the wall of the outside courtyard at the entrance to Troja Castle in Prague.

The Egyptian placed great faith in the power of a living cat to protect him from all kinds of evil, natural or supernatural.
The Cat in Religion and Magic

XVII The Star

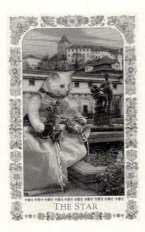

THE STAR

It's dusk, and all is quiet and still. In an empty courtyard, a white cat pours water from two magnificent vessels. One is streaming into a pool, the other onto the ground.

In the background, a fountain shows a naked Venus and cherub happily showering each other with water.

A Cat's Interpretation

The things a cat hopes for might at first thought seem slight – somewhere warm to sleep, companions to curl up with and some good food. But people who live with cats usually feel that it goes beyond that. Cats genuinely seem to look for, and hope for, a far deeper emotion that seems very close to love. Can an animal truly love? Why not? For those who have lived with a loving cat there is no doubt about the matter.

Keywords and phrases

Hope and an inner trust in fate • Finding recovery and healing • Generosity of spirit • Peace, calm and acceptance.

Keywords and phrases for reversed cards

Some lack of hope, a weakness and insecurity • Some health problems, though these are likely to be more feared than actual.

The Star, The Moon and the Sun form a trilogy in the Major Arcana. These three cards sit between the chaos and fear of The Tower and the rebirth of Judgement. They form a quieter space that is more about personal emotions and mental processes than external influences and events. Considered together, they make an interesting and significant sequence. The Star is primarily about hope – the hope that has to be the first reaction to any catastrophic upheaval (The Tower) if you are to recover and carry on. The Moon represents the imagination and a journey inwards to confront both dreams and nightmares – a potentially disturbing but necessary step to finding a way to a new life after the old one has been interrupted. The final card in the trilogy is The Sun – like The Star this is a very positive card but instead of being about inner hope The Sun is about looking around at the

world with clarity and going out to take your part in the events around you. It's also worth pointing out that while nowadays the sun, the moon and the stars are the chief emblems of the Virgin Mary, in ancient religions derived from the Egyptian mysteries, it was the cat that was associated with these three symbols.

Our Star is a white cat who sits at a clear pool in a garden at twilight. The scene looks very still – the Star is a quiet and contemplative card. She pours water from two very different jugs – one is patterned china, the other is silver lustre. One stream of water falls on the earth, the other into the water. These streams represent the fact that hope never dries up – it can be endlessly poured into any situation and can nurture those around us as well as ourselves. The fact that the water falls on both the water and the earth has been endlessly discussed. It may, in the old decks, have originally had both biblical and alchemical references. However, it can also be seen quite simply as an illustration of the fact that hope can bring optimism where there was none before (watering the dry land) or it can also be used simply, but just as productively, to add to a general pool of love and charity. Whatever the situation, hope is never wasted – faith, hope and charity know no bounds and we don't have to hold back in providing them.

Notes on the source material
Yet another white cat. White cats, and indeed black ones, do have a very special place in myth and belief, and perhaps that's why we found ourselves using so many white cats in this deck. This one is a British Shorthair.

She is in a courtyard based on the Wallenstein Palace Garden (to make the visual appearance of the card more harmonious, we have made several changes). The fountain statue (probably depicting the goddess Hera) is also from the Wallenstein Palace Garden.

Fountain group from the Wallenstein Palace garden

XVIII The Moon

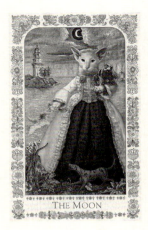

THE MOON

An ethereal, unearthly but beautiful white cat stands in the moonlight against a blue tapestry background. This shows a man swimming naked through water framed by two towers. A screech owl perches on the cat's paw and two rather unreal- looking dogs stand panting at her feet.

A Cat's Interpretation

Moon madness is something familiar to most cats, particularly those who go courting. It isn't only dogs that howl at the moon. On some nights a cat also throws off her domestic aspect, runs wild under the sky and reflects the light of the moon in her glowing eyes.

Keywords and phrases

Being "moon mad", seeing dreams and visions • Spells and enchantments – both good and bad • Allowing your subconscious to exert itself • Imaginings, both beautiful and bizarre • Feeling enchanted, but also bewildered • Some fear of the unknown, perhaps within yourself • Encounters with magic or delusions • Finding your psychic abilities.

Keywords and phrases for reversed cards

False magic - or fraudulent psychics • Refusing to connect with your own imaginings • Feeling sane and lucid again, after a period of illusion.

When you look at this card the intense blue eyes of the rather unearthly white cat seem to stare straight out at you. It's entrancing, but also unsettling, just as the moon herself is. The whole image is dreamlike and a little disturbing. The tapestry background is worn and so it's slightly unclear and shimmers as though not quite real. Dimly you can see the figure of a naked man swimming towards the nearest tower, which rises out of the water on its own island. Where is he going, and why?

If you simply switch off your rational mind and allow yourself to sink into this image, you'll begin to feel, as well as know, what this card is about. The Moon indicates great insights, but they nearly always come at the price of undermining your sense of reality. The imaginings and visions that are signified are fantastical and eerily beautiful, but they are also bizarre and in many cases unexplained. We may never know why the naked man is

swimming through this sea, yet the image can leave an indelible trace of memory, or conjure up half-remembered dreams.

The Moon is one of the most evocative and emotive cards in the tarot deck. Loved by some and dreaded by others, it's always a provocative card to see in a reading. It stands for both the "lunatic" side of the moon, but also for its romantic and inspired aspects. It's important to recognise that even when the manifestation of these visions and enchantments are at their most disturbing they may also bring understanding. The owl that sits on the Moon's paw is a symbol of this; a screech owl that screams in the night, not a calm and orderly bird at all, yet for all its oddity, it too signifies wisdom.

Finally, it's worth remembering that the cat is of course intimately connected with the moon in many mythologies. Diana, the moon goddess was very closely linked with the cat (and also the number 9 that itself is considered the number of the cat). According to *Zadkiel's Dream Book*, dreaming of cats is nearly always a bad omen of some sort: "If a young woman dreams of cats it is a sign that her lover is sly and very deceitful; if a young man dreams of cats, she whom he loves will be a vixen and will be sure to wear the breeches. If a tradesman dreams of cats, it denotes bad and dishonest servants. To dream of a cat and kittens is a sign of a numerous family, but not too good; trifling and vain. To dream that you kill a cat is an omen that you will discover your enemies, and defeat their purposes."

However, in traditional American superstition, it is good luck to dream of a white cat, but bad luck actually to see one at night.

Notes on the source material

The white cat is an Oriental. The tapestry in the background is based on two of the pictures (we have combined images and redrawn) of a series of six showing the myth of "Hero and Leander" – the swimming man is in fact Leander. They are displayed in the Primaciálny Palace, Bratislava, Slovakia and date from 1630. They actually have a very interesting history as they were designed by the painter Francis Cleyn, for the English King Charles I. After Charles' execution the tapestries were taken to Bratislava where for a time during the invasion of Napoleon they were hidden and not rediscovered until 1903. The idea of "hidden images" fits remarkably well with the meaning of The Moon card.

The Cat and the Moon

The cat went here and there
And the moon spun round like a top,
And the nearest kin of the moon,
The creeping cat, looked up.
Black Minnaloushe stared at the moon,
For, wander and wail as he would,
The pure cold light in the sky
Troubled his animal blood.

William Butler Yeats

The White Cat Moon, the Cleanser of the Night
The Cat in Religion and Magic

I wish I could write as mysterious as a cat.
Edgar Allan Poe

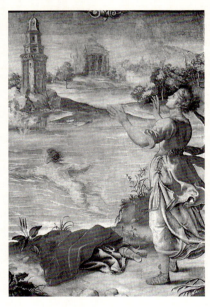

Detail of tapestry showing the story of Hero and Leander

THE SUN

XIX THE SUN

A young kitten, wearing only a little flowered corset, stands on a wooden fairground horse. She looks innocent and eager. Behind her is a glowing sundial, and also, just visible, a garden. All is sunny and bright.

A Cat's interpretation

Cats love sunshine. Nothing makes them happier. The cat that steps out to explore on a warm, sunny day is usually full of confidence and energy. When it's sunny, a cat's life is good!

Keywords and phrases

Clarity and mental openness • Insight and enlightenment • Magnificence and richness • Stepping out with confidence • Sheer vitality • Sunshine and roses.

Keywords and phrases for reversed cards

Some lack of clarity – nothing disastrous but perhaps misunderstandings in the way you are interpreting things • Happiness and confidence, but in a rather less complete way than the card would indicate unreversed •Clarity, but only of a partial kind • Taking a small step forwards – but with some unnecessary caution.

After the veiled and misty ambiguities of The Moon come the clarities of The Sun. The Sun card is the very embodiment of the popular song "I can see clearly now, the rain has gone", it's about reaching a glorious clarity of vision, perhaps after a time of confusion and muddled thinking. Suddenly, your mind opens up and things seem beautifully clear and obvious. How could you not have had this sharpness of vision before? The Sun is about suddenly reaching a time of energy and possibility, when you can step out confidently into new projects, new ambitions and new relationships, knowing that you are able to find success in all your projects.

In the Rider Waite Smith version of this card, a naked young child rides out on a horse. This signifies both the sense of rebirth and also the almost childish feeling of wonder and clarity that this card stands for. In our version, a kitten sits astride a fairground horse, an image of childhood but

also of fun and enjoyment. The idea of the fairground also contrasts with the rather formal garden behind. One way to see this kitten is as a representation of carnival - a period in which you leave the constraints of convention behind and revel in some pleasure and excitement, enjoying your "time in the sun".

While this card is not usually principally about throwing off convention (unlike the Four of Wands) it does sometimes have this connotation. Perhaps when you step forward into bold new projects there needs to be an element of leaving constraints and doubts behind? Sometimes we stay in a safe place, mentally and physically, simply because we lack confidence. With the Sun comes the promise of a burst of brilliance and a new-found ability to turn everything into a success. It's no wonder that we may find ourselves leaving behind a security that is no longer needed.

Notes on the source material
The fairground horse is a very old traditional one, probably Hungarian or Russian. It is our own. The sundial was photographed at Český Krumlov Castle, it is painted on a wall just beside the gardens.

By the way, if you are wondering how we got the kitten to stand on the horse, it was all done with a teaspoonful of cream - which we duly removed from the final image.

Whenever an Egyptian temple was dedicated to the sun, an image or symbol of a cat was prominently placed within
The Cat in Magic and Religion

If there is one spot of sun spilling onto the floor, a cat will find it and soak it up.
Jean Asper McIntosh

XX Judgement

JUDGEMENT

A kitten and a slightly indignant older cat are being gently carried up to heaven by smiling angels. In the background, more angels and cherubs celebrate. All is lit up in pink and golden light.

A Cat's Interpretation

We're told that a cat has nine lives, and as Judgement is about the experience of rising up from your past life and beginning a new one, presumably a cat enjoys this nine times? However, in general cats are very conservative and don't enjoy large changes in their home or environment. So for most cats, a whole new life may be more of a threat, or at least an inconvenience, than a promise.

Keywords and phrases

Awakening to a new life • Rebirth and renewal • Finding an alternative way of living • Feeling refreshed and rehabilitated • Putting the past behind you and going on to a whole new existence • Shaking off guilt or regret and realising that "today is the first day of the rest of your life".

Keywords and phrases for reversed cards

Finding it hard to put past regrets behind you – and getting held back as a result • Beginning a new life, but taking too much of the old ways with you • Feeling that you are being judged unfairly.

Judgement is one of those rather alarming cards that in traditional tarot decks tends to look forbidding to modern eyes. Although it usually shows a happy picture of souls being resurected from their graves by angels, nevertheless we almost instinctively find this makes us anxious – in most modern cultures anything associated with death tends to be shunned or denied. However, the very thing that makes Judgement a "difficult" card also makes it a powerful and often positive one. It tells us that we should accept that there are times in life when we have to be, in some sense, reborn. But to do this, we may first have to give up a former life. It isn't by chance that the Judgement card comes near the end of the Majors sequence. Only by passing through many good and bad experiences can we get to the point of being able to understand and achieve the kind of life that will finally be fulfilling.

There is an old European folk belief that if two cats fight near a dying person, or on the grave shortly after burial, then it means that they are really a devil and an angel fighting for possession of the soul. This brings up one interesting aspect of the Judgement card. Although traditionally it always shows souls being called to Paradise, it does, by the very idea of "judgement", also demand that we see that some souls may be deemed unfit. This is not to suggest that we have to believe in heaven and hell - many of us don't. But it does remind us that the whole concept of hard and absolute judgements is very much a part of this card. Again, it's a rather unacceptable idea to many of us nowadays, but in fact in life we do sometimes have to make very hard judgements, ones that may cause some pain as well as joy. Should we leave a failed marriage, or stay for the sake of the children? Should we admit an elderly parent to a nursing home, or care for them ourselves? Should we go to war or try to negotiate for peace? Judgements like these, whether on a global scale or a small, personal one, are an inescapable part of life.

Notes on the source material

The flying golden angels are taken from the tomb of St. John Nepomuk at Prague Castle. The smaller trumpet-playing angel is from St. Nicholas Church in Prague. The background picture is adapted from the ceiling paintings at the Clam-Gallas Palace, also in Prague.

In some countries the intrinsic merits of Puss were held to be sufficient to secure her admission to Paradise.
The Cat in Religion and Magic

XXI The World

THE WORLD

A resplendent tortoiseshell cat stands in a richly decorated gilt room. She carries two golden wands lavishly feathered at the ends, and, with her skirt raised a little at one side, looks as though she may just be about to dance... Behind her on the far wall a winged world emblem can just be seen amongst all the wall pictures of children, cherubs and flowers.

A Cat's Interpretation

If you see a cat on the first warm day of summer, basking in the sun, lying on its back, grinning and stretching its paws in ecstasy – that's what the sheer joy and sense of fulfillment in The World card means.

Keywords and phrases

Reaching a state of complete happiness • A joy so total that it feels like pure rapture • Sheer happiness - dancing through life • Finding the ultimate fulfillment, reaching your life's goal.

Keywords and phrases for reversed cards

Joy and happiness, but maybe not as deep as you'd really like • A glimpse of nirvana, but it's short-lived • Not quite the perfect life, but at least finding some sense of fulfillment.

The World is a card of completion, fulfillment and achievement. If you like to think of the Major Arcana as the story of "The Fool's Journey" through life, then this card represents the final arrival at a state of happiness so intense that it is rapturous. It has very much the same sense of lightness and unbounded joy or delight that you can see in The Fool, but added to this is a sense of achievement and profound insight and contentment.

The picture shows a cat dressed in particularly wonderful and delicate clothes and partly wrapped in yards of lace. Her skirt is slightly lifted as though she is perhaps about to dance. The room that she stands in is a joyous place of pink, pistachio green and lemon - and rich with gilt. Perhaps even more importantly, it's sunny and bright. The cat herself, although she looks quite serious and serene, also has a sense of fun and frivolity about her. She carries two golden wands tipped generously with bright feathers –surely a cat's idea of the ideal wand?

The World is the card with which the Major Arcana concludes. It stands for accomplishment and the achievement of a perfect wholeness. It's a card that bursts with a vibrant yet calm happiness. In readings it points towards attaining your "heart's desire" although only if this is something that has been worked for (remember that this card comes at the end of the long journey represented by the Major sequence). It will also be granted only if it's good for those around you as well as yourself, as The World is a card of harmony rather than self-seeking. The joy and satisfaction indicated does not have to be anything big. We might feel it about a major life event such as marriage, the birth of a child or a major work achievement, but equally there might be times when a burst of this radiant happiness comes over us in the simplest of ways; maybe during a sublime moment of realising the sheer beauty of life, in what might otherwise be an ordinary day.

Notes on the source material

The cat is a European tortoiseshell. She is standing in the "Hall of Mirrors" at Český Krumlov Castle. This hall is supposed to be magical, the mirrors are believed to have the power to make any woman who looks into them young forever, as long as she does not look into another mirror for ten years! The small "winged world" on the far wall is actually taken from a relief carving currently situated outside Český Krumlov museum.

Wall painting similar to the tradtional World card, from Český Krumlov Castle

Minor Arcana

The Minor Arcana cards are divided into four suits, Wands, Cups, Swords and Pentacles, all of which have their own distinct characteristics.

Part of the art of reading lies in recognising the patterns of the cards in the whole deck structure, rather than simply memorising the 78 "correct" meanings. Each card in the Minor Arcana falls in a matrix in which its interpretation is decided not only by the qualities of its suit, but also by its number. So, for example, all Wands have something in common, but then again, so do all the "Twos". If you can begin to see where each card fits in terms of both suit and number, then it becomes much easier to understand its entire range of possible interpretations. It also becomes clearer how to choose which interpretations to apply in any particular reading.

The Story of the Suit

To help to make the sequence of the numbered cards in each suit a little more graphic and memorable, I've written a short piece for each, very much in the style of the "Fool's Journey" that's often used to elucidate the Major Arcana. Hopefully this may help to show how the ups and downs, the progressions and set-backs of day-to-day life can be symbolised in the "lower" cards of each suit.

More about the Court Cards

Many readers almost dread a spread in which there are a lot of Court cards. They are seen as hard to interpret because they can seem very similar to one another, particularly in the traditional older tarot, or indeed in the Rider Waite Smith images. This can cause a good deal of confusion. However, the key to interpreting the Courts is quite simple - see them always in the context of their suit and also of their rank. For example all Cups suits have distinct Cups qualities, and also all Pages have some aspects in common. Combine these and you will quickly have a good idea of the essential qualities of each Court - and how distinctive each one is. Courts are very often seen as specifically indicating a person rather than an event or influence. If you take this interpretation, remember that the gender of the Court is not fixed. A Page, Knight or King could well be a woman. A queen could indicate a man. This can take some explaining to a querent however!

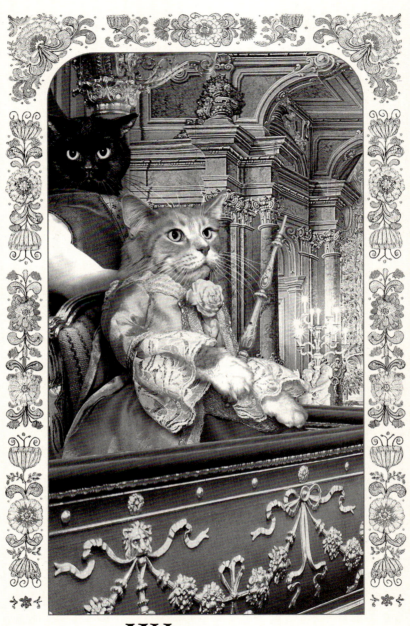

WANDS

WANDS

The Wands suit is traditionally associated with the element of fire, and Wands have qualities that refer to action, energy, speed and charisma. Like fire, Wands is attractive but also, if treated without due care and attention, dangerous. But Wands are not threatening in the aggressive or thought-out way of Swords, rather they stand for the kind of natural force that provides tremendous energy but that can also sometimes get out of hand and burn up everything in its path. A typical Wands person might burst into your life full of action, courage and ideas, but they would not necessarily notice if you or others were unwisely swept up in the enthusiasm and ended up getting fingers burnt or hearts broken. Easily bored, the Wands person might well be on to the next thing very fast, without realising that they're leaving some dreams in ashes behind them.

Having said all that, at their best the Wands cards indicate the refreshing presence of an abundance of life and passion in life. With the benefit of Wands influence and energy new projects can be quickly got off the ground and actively developed into something great. Sheer verve and enthusiasm will often make things happen, and this, together with the ability to be flexible and to adapt and invent if things later need to be changed makes Wands powerful movers and doers. Wands are adaptable, bursting with original ideas and always full of life and energetic abilities.

This means that a reading full of Wands signals a time of immense enthusiasm and activity. On the other hand, if Wands are absent it could point to a lack of the energy and fiery passion needed to get things moving.

The Story of Wands

An enterprise begins with energy and enthusiasm (Ace). Soon it begins to grow up and although initially you half want to keep it at the exciting "start-up" stage (Two) you quickly realise that you have to let it develop beyond just being your "baby". You launch it on the world (Three). So what next? Well, in typical Wands style you walk away from the enterprise, leaving someone else to manage it, and begin something new, risky, but also exhilarating. It feels great to do this (Four). Free at last! However, now you have both the old and the new on the go, and this begins to cause conflict. You seem to be getting into a lot of fights about where your energy should be going (Five). Still, through sheer energy you overcome this, win your squabbles and emerge triumphant. Everyone seems to be heaping praise on you all of a sudden (Six). But it doesn't last. There is both envy from those

around you and also a lot of infighting. Many others would like to pull you down and take your place. You're back to fighting – though more seriously this time as there is more to fight for (Seven).

At this point, you are really enjoying having so much going on at once. The struggles, the triumphs, the endless need to innovate and run fast to stay in one place – all this suits you. There is a glorious, if brief, period of feeling that it's all happening for you (Eight).

But the fights haven't really stopped. Constantly you feel you have to watch your back, as well as begin new things, as well as keep the old ones going, as well as looking out for new opportunities – and old enemies. Suddenly, it isn't all so much fun any more (Nine).

And one day you realise that the thrill of doing so much, of fighting so many fights, of being constantly in the centre of things, has worn off. You feel tired, burdened, and as though the old spark has gone out. How did this happen? You thought your energy and capacity was boundless, but now you realise it isn't. It's time for a bit of humility and some reassessment (Ten).

The Wands Court Cards

In Wands, the Court Card qualities are applied to action. All the Pages can be about news, but for the Page of Wands any such news is likely to be about things that need to be done with enthusiasm, energy and verve. Forceful and faithful, the Page will perform such tasks eagerly, and with confidence and honesty. He may also surprise you with some rather unconventional approaches.

The Knight of Wands has the enthusiasm of the Page, but to the point sometimes of being reckless and uncaring about other's needs. Like all the Court Cards of the suit, the Knight of Wands is innovative, energetic, charismatic and attractive, so he can certainly get things done. However, he tends to take risks and gets bored too easily, so although you can rely on him for adventure and action, you can't look to this Wand for commitment. The Queen of Wands is altogether more reliable in the way she applies her energy. Her well-balanced nature and good-humoured sociability mean that she can temper the Wands urge for immediate activity with the proper consideration for other people's feelings. This is a very attractive and rather flamboyant queen, and she may inadvertently leave some broken hearts in her wake. However, she is so cheerful and honest that any unrequited admirers will soon recover and simply enjoy being in her company. She

radiates vitality and can soon lift anyone's spirits.

The King has the same ability to inspire and cheer, but he is an altogether more forceful presence. He can, in fact, be rather dominating, but he also creates a lot of excitement around himself, and his bold flair and personal charisma usually means that he gets away with assuming leadership on almost every occasion. He is a natural showman, and simply loves to attract attention. Just try not to get offended if he overshadows you, he can't help his character, and usually means well.

The Baroque theatre at Český Krumlov Castle

ACE OF WANDS

An alert kitten holds a golden wand and clings to the back of a stone lion. The lion seems to lean affectionately to smile at his companion. Behind you can just see the shape of a clock and above, two grimacing lion's heads carved in richly reddish wood.

A Cat's Interpretation

Cats love to explore and investigate anything novel. While they may initially be a little wary, their natural curiosity nearly always wins out and they will enthusiastically investigate new sights, sounds and objects.

Keywords and phrases

Beginning a new activity • Enthusiasm for a fresh project • Grasping the opportunity • Being active and optimistic • Inventions and innovations • Courage and a refusal to be afraid • A fiery talent and passion.

Keywords and phrases for reversed cards

Things fall apart • Hopes come to nothing, the opportunity is not seized • A romantic energy is misused • Optimism is not fully realised – though good things may still result.

The Wands suit is about action, and in the Ace, tremendous energy and passion go into the beginning of enterprises and new activities, especially those that demand courage and optimism. In the picture, there is warmth and energy in the main figures, as well as a sense of urgency implied by the clock. Things are happening!

The enormous vitality of this ace can have a passionate energy, although the card is primarily about any action, not just a physical or romantic one. However, it can indicate an enthusiasm that stems from assurance and achievement, and this kind of charged interest can easily be mistaken for budding romance. It's a common Wands issue – these cards can often indicate a situation in which a person who inspires strong and even passionate feelings in others is in fact too absorbed in their own activities to really notice – never mind returning the feeling. So use the fantastic energy of the Ace of Wands, but don't lose your head, and don't imagine that all this vitality is necessarily focused solely in your direction. When this card comes

up in a reading, it points to exciting times in which you will feel greatly energised and eager to get projects and enterprises up and running. The main thing is to put all this into something worthwhile, not just a fleeting passion.

Notes on the source material

The kitten is a mixed-breed European – of slightly uncertain background! The stone lion is from the Royal Palace Garden in Prague. The richly-coloured wooden lions are taken from an old house door in Prague's Old Town Square.

Lion from the Prague Royal Palace gardens

Two of Wands

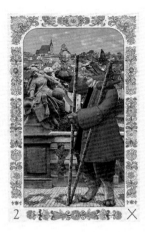

A rather wistful cat stands on a balustraded terrace, high above the roofs of a town. He holds two wands in his arms and in one paw a golden clock in the shape of a globe, by which he seems mesmerised. The statue behind is of a lively looking woman also holding a globe, but he seems oblivious to this feisty figure.

A Cat's Interpretation

When a mother cat finally sees her kittens leave to establish their own lives and territories she must feel both happy and sad. Many mother cats will be anxious for a short time once their kittens have gone and they are left alone, but it's often nature's way for grown kittens to leave to find their own space, and the mother must in some way know that it means that she's done a good job.

Keywords and phrases

Achievement within limits • "Is that it?" • An enterprise grows up and away • Satisfaction, but tinged with depression.

Keywords and phrases for reversed cards

Making a mental leap to escape your constrictions • Taking some risks that can result in both wonder and fear – but are certainly not boring.

The Two of Wands captures that moment of success when you finally see the results of your hard work beginning to make an impact. It gives you great satisfaction and happiness, yet oddly enough, it also makes you feel rather sad and wistful. Why is this? Well, maybe your project doesn't look as grand and world beating as you'd hoped, now that it's finally launched. Or perhaps you just feel that you are not so vital to it any more. Whatever is the cause of your "blues", try instead to recognise and take pride in what you've achieved and also to realise that it's only the beginning. Okay, perhaps right now you are asking yourself "Is that it?" But soon it will be time to ask instead "What comes next?" That's the exciting question.

The cat shown on this card stands on his rather enclosed terrace and holds up a golden globe that is, in fact an old-style "globe clock". It makes us think of the passing of time as well as, perhaps, the concept of widespread,

even global, achievement. But as the cat contemplates the golden sphere he may be asking himself why he suddenly feels trapped and listless. In contrast, the statue behind has her globe held almost casually at her hip. She symbolises someone who is not nearly so anxious about where all this is taking her– she will take it all in her stride. It's the cat who is the worrier.

The Two of Wands is about the contradictory emotions that come when a new enterprise grows up. It may appear in a reading when you have successfully launched a vibrant young project or product into the world, but instead of feeling totally satisfied, find yourself unsure of how much it really means, and what your next move should be. The feeling could be summed up as one of achievement, but with an underlying restlessness and uncertainty about how, and indeed whether, to carry on to bigger things.

Notes on the source material

The cat is an ordinary European tabby cat – if any cat can be said to be ordinary. He is standing looking out over a view of Český Krumlov, a beautiful small Renaissance city in southern Bohemia. The statue is from a building facade in the New Town area of Prague. The globe clock is adapted from one in the Museum of Decorative Arts in Prague. The original had a classic Baroque "blackamoor" figure pointing out the hours.

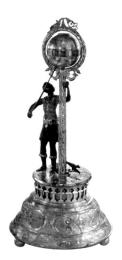

Globe clock from the Museum of Decorative Arts in Prague

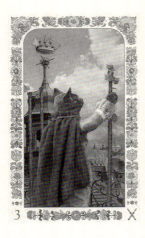

THREE OF WANDS

Head up, and eyes fixed on the middle-distance, a fine grey cat stands high up looking out over the rooftops. The weather vane behind shows a golden ship in full rigging, above a globe. The signs are of the winds of change, and new directions.

A Cat's Interpretation

Have you ever seen a cat standing on top of a roof and surveying his or her territory on a fine spring morning? That's the Three of Wands, especially when it seems as though territorial expansion is in the feline mind.

Keywords and phrases

Visionary and exploratory times • Looking for new areas of expansion • Leadership and direction • Launching your projects on the wider world.

Keywords and phrases for reversed cards

Wanting to hold back, being unwilling to go out into the world • Caution, and inward-looking conservatism, particularly in work or business.

The Three of Wands is about reaching that time when the ambition and drive that motivated a project or enterprise have resulted in successful achievements. With stage one completed, suddenly you have the desire to be more expansive, look beyond the horizon and see how far your energies can take you. You feel you can develop and expand – and who knows how far?

While in some ways there are similarities between the Two and Three of Wands, this card is much less restricted in its indications. Instead of the doubts of the Two, it's about having the willingness and self-confidence to explore new ground. When you compare the images on the two cards, you can see that in the Three the cat looks outwards, towards the horizon, whereas in the Two, he gazes only at the "world" in his hand. In the Two, the wands, while sturdy and even beautiful, are not living wood – but in the Three they burst with life, and the promise of new shoots.

When this card comes up in a reading, it probably points to business or work matters, but it can also refer to less material projects, perhaps to do with art, creativity or self-development. Whatever the mission, the indication is

that it will be achieved with leadership, ambition and a broad vision. It's a time to look outwards, and relish the next bold steps.

Notes on the source material

The cat is a Russian Blue. The weather vane is a small joke on our part. It's actually taken from the roof of Liberty's of London – a shop that originally established itself with a reputation for inventive, exploratory sourcing of goods. Bohemian in spirit, if not geographically. The rooftops are based on a view of Prague.

Weather vane from Liberty's department stor e in London

FOUR OF WANDS

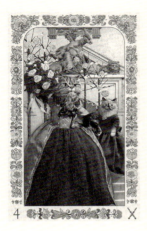

A faraway look in her eyes, and a bouquet of roses held in an outstretched paw, a young cat walks forward determinedly. Behind her four saplings burst into flower, a statue shows a smiling lion lying down with a lamb (a symbol of the paradise to come?) and all is celebratory. However a cautious-looking girl cat watches in a mixture of anticipation and anxiety.

A Cat's Interpretation

Cats don't like change. The one time when they will willingly set out to leave an old territory and establish a new one is when they first grow up and leave their mother. It's perhaps the only moment in most cats' lives when their actions really fit this card. In fact, when you look at the two figures on the picture, it's probably the cautious girl who is a more typical cat. Although you can meet cats that are very exploratory, most will want to keep a firm home base from which to make their forays – it's simply a cat's nature to be near to familiar territory at all times.

Keywords and phrases

A break from the normal habits • Celebrating a holiday or carnival • Kicking free from the mundane • Excitement and "buzz" • Fancy free.

Keywords and phrases for reversed cards

Wanting to take a break, but not quite doing it • Watching others who seem to be in holiday mood – and wishing it was you • Being stuck in a mundane situation, but dreaming of a change • Reluctance to take a risk.

This card is set in the springtime, and it's often at that time of the year that we finally decide to leave the old, safe routine behind and try something a bit more adventurous. In a way, it's a period of "spring-cleaning" for the mind and spirit. The cat at the front of this card looks most determined, as she stares into the middle distance, imagining all that is to come. Her companion, however, is altogether more nervous about the bold step that's being taken and has that "startled cat" look; will she follow or run?

The very word "Bohemian" has come to mean a more edgy, experimental and arty way to live, and so the Four of Wands is perhaps a particularly

good representation of "Bohemian Cats". It isn't simply about moving on to the next step (as in the Eight of Cups) it's actually about doing something that is rather daring, and in which you knowingly accept the need to trade security for freedom.

When this card comes up in a reading it can indicate an opportunity to release yourself from the mundane and open up new, and probably more "Bohemian" possibilities. It's about going beyond any boring or conservative limitations. This sense of freedom can be a thrilling experience as it may be the first step in a far bigger, exhilarating change in your life. It can feel wonderful when you deliberately step out from something that is safe but rather confined, and into something less permanent but more spontaneous and free. The change may be a major one or something that is really more of a rebellious gesture; but if you feel trapped in some way then take it as encouragement to consider breaking free. Don't worry too much about the reactions of other people, even if, like the little cat in the background of this card, they initially look worried. They may soon be inspired themselves when they see that you have the courage to strike out in unconventional directions.

Notes on the source material

One cat is a Persian, the other is a Siberian with particularly unusual markings. The statue of angel, lion and lamb (which is only partly visible) is from Troja Palace in Prague.

Statue from Troja Palace in Prague

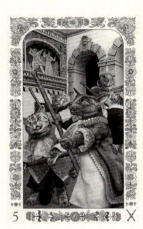

FIVE OF WANDS

Cat fight! A furious battle is being fought across a courtyard. All sorts of cats are involved, completely taken up with the struggle. But is it so fierce really? Don't some of the participants look as though they might quite be enjoying it?

A Cat's Interpretation

Some cats are quite capable of grumbling and being bad-tempered, and even spitting and scratching at nothing in particular. Often a cat that has had an insecure life can become grouchy and difficult. Once in a quiet environment, with few irritations and interruptions, many such cats will slowly settle down and become friendly and trusting. Given a chance, a grouchy cat may, with time and care, turn into a calm and good-tempered lap cat.

Keywords and phrases

Squabbles and trivial quarrels • "One of those days" – or weeks • Feeling like you are struggling with things that shouldn't matter • Enjoying competition and disputes, even when they're really silly • Giving in to anger over minor annoyances • Sheer hassle.

Keywords and phrases for reversed cards

Coming out of a period of petty annoyances • Overcoming irritating hassles • Refusing to take part in silly squabbles • Being a peacemaker in a minor dispute – possibly a local one.

This is one of those cards that looks more alarming than it in fact is. While it shows what seems like a pitched battle, there is also a sense of play about things. If you look closely, it appears that no one actually gets hurt, though there is a lot of sound and fury – and perhaps hissing and spitting.

There are two main aspects to interpreting this card in a reading. One is about the real difficulties of the day-to-day "struggle of life". The other is much more specifically about the silly and irritating things that happen, such as squabbles, minor annoyances and irritations, and small accidents and mishaps. These two strands do overlap of course: sometimes when we think about our everyday problems it can feel harder to cope with the petty stuff than the really big issues.

The cats shown in this card are fighting, but only with staves, not with any weapon that would be more likely to kill. They are serious about the quarrel, but probably, like most cats that get into fights, they are mostly yowling and posturing, rather than trying to inflict real injury. There may even be a suggestion of a theatrical nature to their poses, perhaps in a way it's all a bit of a performance, and they are quite enjoying it? Remember that this card is not about catastrophes; it's about things that are troublesome and irritating, and perhaps even ongoing annoyances, but which in truth aren't all that much of a problem when seen in perspective. In many ways we just have to accept the fact that every time we strive towards something better we will encounter obstacles, many of which will be trivial but demanding in their own way all the same.

The little sgraffito picture of a couple fighting that is tucked away on the wall above the cat fight is there to remind us that we can ruin a good relationship by letting petty things provoke us into a series of domestic quarrels. So he drops the towels on the floor and doesn't put the tube on the toothpaste? Let it pass amicably, it just isn't worth fighting over.

Notes on the source material

There is quite a mix of cats in this picture. The main figure is a Russian Blue, but the cats also include a ginger Siberian, and a British Shorthair. The wall picture is from the facade of a house in Český Krumlov, South Bohemia. The steps (with, just seen, a lion relief above) are from a corner of the Wallenstein Palace Garden in Prague.

Those who'll play with cats must expect to be scratched.
Miguel de Cervantes

Ignorant people think it is the noise which fighting cats make that is so aggravating, but it ain't so; it is the sickening grammar that they use.
Mark Twain

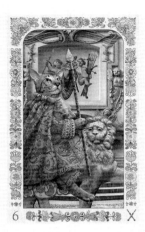

SIX OF WANDS

A proud, mature and rather gracious-looking cat rides a cheerful golden lion across a courtyard. The cat is dressed in the most sumptuous richly ceremonial robes possible. In the background two laughing cherubs hold both weapons of war and golden wands.

A Cat's Interpretation

Cats love praise. Telling them that they are beautiful and clever will usually be greeted with loud purrs. Even if some cats pretend to have no interest in human opinion of them, fundamentally they nearly all love to be admired. So next time your cat brings you some poor mangled hunting trophy, please remember that they are expecting praise, not horror - however difficult you may find it.

Keywords and phrases

Being justly recognised for achievement • Victory and triumph • Basking in the glory • Pride and self-esteem • Rewards and celebration.

Keywords and phrases for reversed cards

Not getting your deserved recognition • A victory, but only partial • Feeling a little let down - you've done well, but you aren't the hero you aspired to be.

The cat on this card looks justifiably proud but also somehow rather touchingly cheerful. He is riding a merry-looking lion (that as a mount is just a little too small for him), and though he is dressed very lavishly, his clothes are slightly theatrical, rather than grand or imposing. This is a likeable triumphant victor whom we can both smile at and admire. While this card is in some ways the Minor Arcana equivalent of The Chariot, it really is very much more friendly and down to earth. The Chariot is about triumph, drive and sheer willpower in shaping forces in the world. The Six of Wands talks of an individual victory and, importantly, usually one that has been well-deserved and is not resented. This card indicates a time to enjoy being recognised for an achievement, and there is a sense of fun and shared celebration about it, as well as pride and triumph.

The robes, spear and indeed the lion that this cat rides are all fundamentally ceremonial rather than practical. Obviously, the victories that are being celebrating are for battles that are now quite finished. This is a rather mature-looking cat and that too is significant. Often, getting to the point at which your achievements are recognised does take years. When this is the case, perhaps it is even more a moment to savour and enjoy?

Generally, this is a very positive card. In readings, the Six of Wands tends to appear at those points when things are just about to come to fruition and you will see the results of your hard work and, perhaps, struggle. Of course, it's easy to let all this go to your head, and occasionally the card can point to someone being too proud of themselves, but usually the advice is to enjoy the moment in the limelight, and celebrate it joyfully with others.

Notes on the source material

The cat is an Oriental. The lion that he is riding on is a very old house sign from Prague. House signs, which typically appear above the door, were used before the days of standardised street names and numbers as a way of identifying each house. Animals are a very popular theme. The wall painting of the cherubs is based on one from the ceiling of the Sala Terrana (a large hall in the palace gardens) at the Wallenstein Palace in Prague. Many of the paintings there have a war and battle theme.

Two battling cherubs from the Wallenstein Palace, Prague

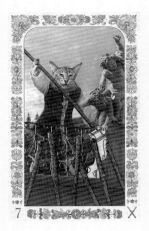

SEVEN OF WANDS

A snarling cat wields a wand, seemingly against aggressors attacking from below – though perhaps he is the one doing the attacking and the others are merely defending? The statue behind shows two cherubs riotously fighting, but they also seem to be half-laughing.

A Cat's Interpretation

The average tom cat is in many ways the typical embodiment of this card. Forever fighting alone, always willing to take on a battle for territory. In a way, dreadful as this might look to an observer, conflict is something that many tom cats enjoy.

Keywords and phrases

Struggling to win • Endless battles – but you sort of enjoy them • Feeling alone against the world • A determined competitor.

Keywords and phrases for reversed cards

Losing a battle, or at least not yet winning it • Getting sick of the competition and conflict • Feeling overwhelmed by struggling – longing to stop.

Holding his own against all comers, this cat looks fierce and confident. Maybe he is relishing the exhilaration of being able to fend off so many attackers at once? Or is he actually the one who began the aggression? Perhaps it doesn't matter who started it, as it looks as though the battle is now in full swing in any case.

When the Seven of Wands appears in a reading it often points to a situation in which you feel it's "you against the world". It may well indicate that you really don't want or need any help – you are managing just fine. However, remember that this can be both a great position and a dangerous one. Whereas in fiction we often admire the swashbuckling hero who takes on and defeats hordes of enemies, in real life things often don't quite work that way. There are times when the only thing to do is to take a lone stand, but of course in other situations you might do much better to get some help. The cat in the picture is obviously winning and perhaps even getting a buzz from doing so, but he is so outnumbered that he may not be able to win through forever.

When this card comes up in a reading, it's worth thinking carefully about the message it contains. Does it definitely indicate a situation in which you can defiantly make a stand and come out on top, or is the message that it's time to think about either ending the fight or getting some others on your side? If the battle is really worth it, then keep going, but if it's not, consider whether it's really worth all the energy you're expending.

[Among Celts it was believed that] **May kittens make troublesome,
ill–behaved cats.**
The Cat in Religion and Magic

**No matter how much the cats fight, there always seem to be
plenty of kittens.**
Abraham Lincoln (1809 - 1865)

Notes on the source material
The battling cat is an Oriental. The statue next to him is one of the very droll little Renaissance pieces from the Vrtbovská Garden in Prague (see illustration).

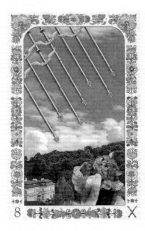

EIGHT OF WANDS

A ginger cat looks up to see eight winged wands flying across the sky. They may be flying up or falling towards him but in any case they are not threatening, rather they make an almost dreamlike flash of gold against the valley below. Yet he does seem worried; maybe he just isn't quite sure where all these wands suddenly came from, or where they are going?

A Cat's Interpretation

This card is all about speed, movement and activities. It's the card of the cat that is deliriously playing – hurling itself around at lightning speed and adoring the sheer thrill of the chase.

Keywords and phrases

Many things happening at once • Speed and activity • Things falling into place • The thrill of action • Events to do with love or – more possibly – with seduction.

Keywords and phrases for reversed cards

A lot going on – but none of it going anywhere • Frustration, things falling apart slightly • Progress, but at a snail's pace • Some blockage or hold-up in activities • Disputes, that never seem to get resolved.

The Eight of Wands is about those times in your life when you feel that everything is happening at once, and you don't know whether to panic or be totally exhilarated. Maybe the feeling is a heady mix of both and this is why you feel slightly light-headed? The events signified by the wands that fly through this picture may be either just beginning or coming to a head or a closure – you can't really tell if the wands are flying upwards, or shooting down. Often the Eight signals moments at which things are finally resolved, with some effort, and this brings a great sense that things are really being achieved at last.

Arthur Waite describes this card as meaning " the arrows of love" (or, reversed, "the arrows of jealousy"). This interpretation is rarely applied nowadays but it is one to be aware of in certain readings. If the subject of the reading seems to be about attraction and, maybe, seduction, then the

appearance of the Eight of Wands can suggest events moving quickly to a conclusion. This may or may not be a good thing.

Having said this, it's usually a positive card in readings. It shows excitement, a time when your life will be brimful of events and activities. Unlike the Ten of Wands, the Eight indicates that you will also have the energy and enthusiasm to cope with so much going on. However, be aware that it does show a situation in which it's easy to lose your head and get a bit carried away. Use this time well, and don't get swept off your feet.

Notes on the source material

The cat is a ginger British Shorthair. The scene behind him is of the Lobkowicz Palace (in fact one of four different palaces that were owned by the Lobkowicz family) in Prague, seen from the Petřín park. The wings of the wands were taken from a metal angel found at Vyšehrad cemetery, Prague (see illustration).

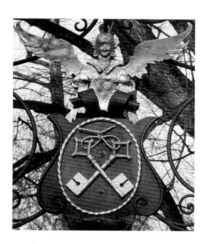

NINE OF WANDS

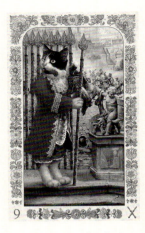

An alert, tense cat stands by a palisade of spears. He looks battle-worn, with torn ears and muddy clothing. Behind him, the smoke and chaos of a pitched fight rages; a little statue of a cherub offers weapons and soldier's boots, necessary if he is to rejoin the fray.

A Cat's Interpretation

Even the most seemingly dozy cat exhibits a continual alertness that can be very startling to a human. The minute something threatening happens, most cats will react in a split second – either to fight or flight. For a cat, such watchfulness is both normal and healthy.

Keywords and phrases

Staying alert – perhaps too much so? • Dealing with the pressure, but at some personal cost • Gathering strength for one last fight • A degree of paranoia, expecting the worst • Never giving up.

Keywords and phrases for reversed cards

Letting down your guard – depending on circumstances this might be good or disastrous • Understanding that you may not need to be so wary • Deciding not to fight again – taking a rest from it.

When you've been through a long struggle, it's sometimes hard to know when to stop and lay down your guard. The figure in this card is wary and endlessly on the alert, even though he is obviously tired, dirty and battle-wearied. Perhaps he is right to be so tense, as the fight going on behind him is still raging? However, what this card counsels is that we have to be able to distinguish between a real need to be guarded and the over-anxiety that can come after a long period of struggle. For our own health and well-being we must to be able to recognise the moments when justifiable defensiveness slips into paranoia or we simply become unable to stop anticipating the next battle. Sometimes, even if the fight is ongoing, we need to walk away from it and leave it to others, if not forever then at least for long enough to allow us the time for deep relaxation and recuperation –taking more than just a few moments out.

The Nine of Wands tells us that while it is admirable to be able to persevere throughout a long, hard struggle, it is also potentially damaging. We have to be wary not just of the conflicts around us, but also of more subtle threats to our own state of mind, and our health and happiness. None of us can, or should, keep going forever, however strong and brave we are.

Notes on the source material

The cat is a European that we photographed at the Prague Cat Rescue Home. The background is taken from a painted panorama of the brutal battle that happened on Charles Bridge when the Swedes invaded in 1648 (see illustration). It is in the "mirror maze" building in Prague's Petřin Park.

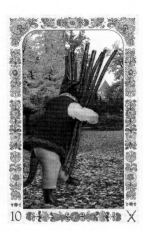

10 🂫 X

TEN OF WANDS

It's a glorious autumn, but this busy cat can't see the beauty. To him it's just a lot of leaves to be cleared up, an endless task. He keeps his head down and plods along with a huge bundle of sticks on this back, too intent on his duties to notice the scene around him.

A Cat's Interpretation

It's a rare cat indeed that takes on too many burdens. Freedom and independence are an essential part of the character of nearly all cats. So when a cat sees its people burdened down with obvious worries (about things like jobs, mortgages, finances – responsibilities of which a cat is happy to have no knowledge) it must seem as though those people are mad to behave like this. They should perhaps at times learn from the laid-back lifestyle of a cat.

Keywords and phrases

Taking on too much • Burdened with responsibilities • Letting your tasks get on top of you • Hiding behind your sense of dogged duty.

Keywords and phrases for reversed cards

Letting some of the burdens drop • Things falling apart – but perhaps this is not such a bad thing? • Allowing yourself some respite from endless duty • Coming out from behind the barrier you carefully constructed.

When you look at the figure on this card, plodding along clutching a large bundle of sticks, two things are immediately obvious. Firstly, the poor cat is doing his very best – head down, back bent, he's giving it his all. Secondly, in spite of his efforts it's quite possible that at any moment the sticks will begin falling out of his paws and dropping to the ground, because he's simply taken on too much. Although he is probably headed for the castle in the distance, it's unclear if he will ever get there, in spite of his efforts.

The Ten of Wands brings the typical Wands events and actions to the point where they have actually become a burden rather than an excitement. The card tends to point to a situation in which someone has taken on more and more tasks – perhaps out of enthusiasm and a misplaced measure of their own capacity, or maybe out of a sense of sheer duty and responsibility. For whatever reason, the inability to say no has left this person shouldering far

too much. However dogged, strong and persistent they try to be, sooner or later either some of these burdens will have to be put down, or they will in any case begin to be dropped involuntarily. We all know the kind of person who takes on too much, has some sort of crisis or breakdown, has to abandon everything – but then after a period of recovery is back again, once more taking on too much... The seasonal autumn leaves on the ground in this picture remind us both of the cyclical nature of this kind of behaviour, and also of the impossibility of ever really doing everything. No-one can pick up every leaf and stick on the ground, and no one can, or should, agree to take on every task that comes up.

I've talked about this card in the third-person, as something happening to someone else, but it's worth saying that it's good to be aware that if you are the "workaholic" type it can be particularly hard to recognise or admit it to yourself. Look at the little burdened figure. Does it remind you of anyone, and could that person be you? Are you in some way hiding behind all this duty and hard work and if so, can you now let some of it go?

This card is particularly evocative when it's reversed as it so obviously shows that moment at which it's suddenly all allowed to drop. This may either be a conscious decision, or one that is forced by ill-heath or some other circum-stance. The important thing is to try to drop tasks in a controlled way, letting go of those that don't matter and retaining those that do. If you wait until the situation is impossible then you will simply have to throw up your hands and let it all fall around you, which is not ideal.

Notes on the source material
The cat is a feral European tabby from the Prague Cat Rescue Home. The building in the background is the Daliborka Tower, at Prague Castle. The park is part of the Royal Castle Gardens in Prague – the planting is particularly good, with great Autumn colour.

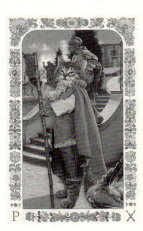

PAGE OF WANDS

This page is young, but he looks supremely cheeky and confident. The peacock at his feet reflects the same slightly immature pride. There is a real humour in the scene, and the eccentricity of the statue sporting a small lion on her head seems entirely in keeping.

A Cat's Interpretation

Young cats have a tendency to be scatterbrained and extremely keen on anything new. They will leap after a novel toy, only to be bored with it within a short time. This characteristic has a good aspect, as it keeps them constantly alert, enthused and active and, when they catch something impressive, also rather pleased with themselves.

Keywords and phrases

Keen to get going • News or messages that will lead to action • Enthusiasm about a new project or endeavour • Taking an innovative approach.

Keywords and phrases for reversed cards

An inability to get started • Some bad or disappointing news • Waiting for the action to begin – and feeling slightly frustrated • Finding that your enthusiasm for a new project is waning.

The Wands suit is about action and passion. This, combined with the typical eagerness and enthusiasm associated with Pages, makes the card a very energetic one. The Page of Wands bursts with life and also with a certain "attitude". He is somewhat cheeky and unconventional, but nevertheless appealing and attractive. This is a great card to see if you are at the "start-up" stage of a project that needs bags of energy, confidence and initiative.

In our image, the Page is responsive, flexible (like his wand, which is cut from a living bamboo) and able to think around a problem. He may often surprise with his approach to a new activity –and it has to be admitted that he rather likes the attention that this can provoke. The young peacock trying to flex his only half-grown tail tells us quite a lot about the Page himself. He is quite flamboyant, but in a less developed way than the King of Wands, and in a less selfish way than the Knight. The Page is co-operative and generous with both his ideas and his enthusiasms, but there is no doubt that

he likes to be noticed.

In a reading this card usually indicates action – most likely on something that is either new, or entering a new phase. In many cases this will be initiated by some news or an exciting message. Remember that the Page of Wands tells us that passion and energy is the way to succeed – this is not a time for too much introspection or caution. Of course there is no harm in a fiery enthusiasm, as long as it's tempered with some restraint and responsibility, and doesn't constantly seek only to attract attention.

Notes on the source material

The kitten is a European brown tabby boy. He is standing in a garden based on the Baroque Vrtbovská Garden in the old district of Malá Strana in Prague. The statue of the lady with the lion on her head was found in this garden. We are not sure what she represents; while she could be a depiction of "Africa" this seems a little unlikely because of her very European features. Vrtbovská is full of some very characterful statues, and although based on myths, the impression is that many of them show a great deal of "artistic licence".

There is no more intrepid explorer than a kitten.
Jules Champfleury

Statue of lady with a lion, from the Vrtbovska Garden in Prague

KNIGHT OF WANDS

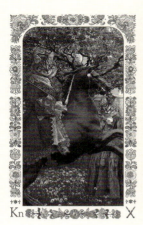

On a rearing horse a resplendently dressed cat rides past blossoming trees in a spring garden. A young female cat gazes on adoringly, and the scene is bursting with life.

A Cat's Interpretation

In some ways, this is the "Puss in Boots" card. It shows a character that we recognise in some cats – utterly charming, totally without scruples, and at the same time somehow impossible to be angry with. He is simply irresistible, even if deep down you know that he is out for himself. He may purr and gaze into your eyes adoringly, but probably mainly because he is hoping to charm you into handing over a dish of cream.

Keywords and phrases

A real charmer • A magnetically attractive person • Recklessness • "Just do it" – whatever the consequences • Someone of immense charm, but less commitment • Emigration, making a major move.

Keywords and phrases for reversed cards

An interruption in your activities • Some caution –deciding to look before you leap • Having doubts or conflicts around a person you once found charming.

The Knight of Wands represents someone who is full to the brim with a rather dangerous but attractive charisma. He can be a wonderfully energising force in life, but it's best to remember that he is also fundamentally irresponsible –not intentionally, but simply because his boredom threshold is so low. However, he is hard to resist and it's all too easy to get swept up in his enthusiasms. He is a person who tends to "go for it", especially when the challenge is new and exciting. But he can also be too sure of himself and too certain of his own charms. He may be thoughtless, and is unlikely to make a commitment to a relationship or to long–term, painstaking work. He is also capable of being reckless and irresponsible, and sometimes loses his temper. He certainly has little patience with anything that holds him back.

In this picture, the cat is exceptionally beautiful and dressed with great style and verve. He is obviously much admired, although he seems nonchalant

about this. The flowers all around – spring blossom and dandelions – are of the beautiful but short-lived variety. Clearly their beauty, and the Knight himself, may be here today and gone tomorrow.

In a reading the Court Cards nearly always stand for actual people, and this card may refer to an attractive but careless person (male or female) in your life. Don't forget however, that it can also refer to the way in which you yourself are behaving. Sometimes it's easy to get so carried away by our own charisma and energy that we forget the necessity of beingcaring and thoughtful towards others.

There is one odd little interpretation of this card that should be touched on. In the original RWS image, the Knight is seen riding past some exotic-looking pyramids, and this is seen as indicating emigration or major foreign travel. This is now an unusual way to read the card. It may however be indicated if it comes up in a spread together with other cards, such as the Six of Swords or the Four of Wands, that point to a journey or a break from home.

Notes on the source material

The cat is a Siberian (in real life he is the father of our own Siberian girl). He is riding a horse that is a Renaissance statue in the Wallenstein Garden, and set against a background of a corner of the Royal Palace Garden – both in Prague.

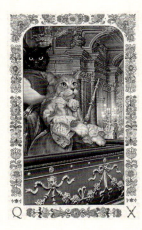

Queen of Wands

A striking pale ginger cat sits in her gilded box at the theatre. She carries a golden wand. Behind her stands a protective bodyguard. Clearly he will let no harm befall her.

A Cat's Interpretation

The young breeding "queen" sums up some aspects of this card. Healthy, sexual, attractive and at the same time down to earth enough to be able to enjoy the resulting litters of kittens. However, a true Queen of Wands cat would also be one with a great deal of character, a love of attention and an outstanding ability to perform to the crowd. This cat just loves to be the centre of attention, in the nicest possible way.

Keywords and phrases

Healthy sexuality • An energetic and attractive personality • A creative approach to practical and business matters • A sheer joy in living • A woman who attracts through her energy as much as looks or personality.

Keywords and phrases for reversed cards

Some depressing influence • A lack of imagination holds you back • Losing your normal spirit, feeling less attractive than usual.

The Queen of Wands on this card is found in her own box at the theatre, seemingly looking around her, as well as at the performance. She is beautiful and confident, and relaxed in this theatrical setting. She may be aware that she is being watched and admired, and if so, she is happy with this, though appreciative rather than vain. Like all the Wand Courts, the Queen is very much one of the people in most ways, but also has a distinctly theatrical and flamboyant side to her nature. When she comes into your life she may well take your breath away, but she will also simply be good fun and an energising companion.

This card signifies a person who is attractive not just physically, but also because of her spirited and original personality. She is approachable and likeable, and isn't at all a cold or forbidding aristocrat. People tend to enjoy being around her because of her abundant health, energy and enthusiasm.

She is also undeniably romantic and this of course attracts a certain following. She is neither flirt nor vamp though, and in fact tends to be very straightforward. Unlike the Knight of Wands she is responsible about her charisma, and does not use it unkindly or simply to amuse herself. This means that while she may indeed break hearts, it will never be a deliberate cruelty; in fact the Queen herself will usually be the first person to try to help someone to get over their feelings for her.

In the traditional Rider Waite image, a black cat sits in front of this queen. This is usually interpreted as a protector, a companion who keeps the queen from harm. In our image he is very much a loving bodyguard - he is used to his queen being a magnetic draw for admirers, and so he protects her from any unwelcome attention. In fact, he is so attentive to her defence that you have to wonder if he is not just a little in love with the Queen himself.

Notes on the source material
The queen is a Somali. Her bodyguard is a black British Shorthair. She is sitting in a box at the theatre in Český Krumlov Castle. This theatre is one of the most perfectly preserved examples of a Baroque stage in the world.

The cat is above all things, a dramatist.
Margaret Benson

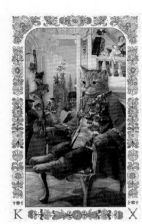

KING OF WANDS

This cat certainly knows he is a king. He sits resplendent and looks thoroughly regal and strikingly confident. His wand is alive and sprouting with leaves. Behind him can be seen a number of flamboyant and slightly bizarre wall paintings that depict the characters at a masquerade ball.

A Cat's Interpretation

This is the card of the show cat, the fabulous pedigree who not only wins prizes, but also adores the attention of admirers. He is confident, fully in charge and absolutely takes the recognition for granted. A supreme champion who can be a little scornful of other cats but who gets away with it through his sheer panache.

Keywords and phrases

Theatrical and charismatic – a showman • Unconventional and often inspiring • A communicator who can carry off eccentricity with panache • A leader who attracts followers with sheer energy • Someone who never follows the pack – always out in front.

Keywords and phrases for reversed cards

Less charismatic but more tolerant • A leader who has also learnt to listen to others • A little of the old charm has been lost.

The King of Wands is an odd mix of authority together with a rather unconventional panache. You might envisage him, for example, as the somewhat imperious but creative master of a theatre company, someone who wields an iron rod of control to get what he wants done; but who is also inventive, idiosyncratic and not afraid to buck the norms. He is often a bit of a showman, an inspired communicator who may at times exasperate his audience with his absolute certainty about his own right of leadership, but who is also likely to win them over with his power of oratory and style.

In our picture the King sits on a fairly plain gilded chair, rather than an elaborate seat or a throne. Perhaps this suggests that while he has authority, much of it comes from his own charisma, rather than his status or position? His wand is a living branch of ivy – one of the plants that is associated with carnival and the Lord of Misrule. Behind him are some lavish, and rather

odd, scenes of a masquerade ball. The people shown are aristocrats, but they are at play, taking a chance to be a little outrageous.

Notes on the source material

The cat is a ginger British Shorthair. He is sitting against the setting of the remarkable Masquerade Hall at Český Krumlov Castle. This hall is considered a masterpiece of Rococo frivolity. In 1748 Josef Lederer produced the wonderful and in some cases almost surreal pictures on the walls. They show aristocrats cavorting and intriguing at a masquerade ball at which classic Italian and French "Commedia del Arte" figures mix with guests wearing a whole variety of costumes. At the doorway are two figures of Castle Guards in their ceremonial uniforms. There is in fact a story associated with these. A servant at a ball is said to have seen a string of valuable pearls slipping unnoticed from a lady's neck. The servant was going to quietly pocket the pearls, but two painted Guards immediately emerged from the wall and stopped the theft. The man was so terrified that apparently he never attempted to steal anything again for the rest of his life.

There are no ordinary cats.
Colette

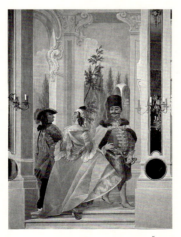

One of the wall paintings in the Masquerade Hall at Český Krumlov Castle

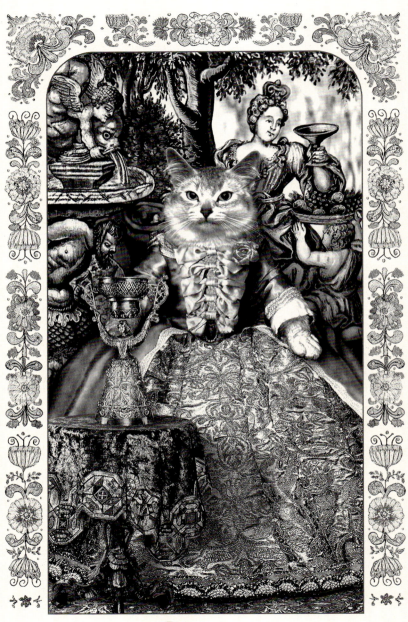

CUPS

Cups

The element of Cups is water, and because of the association between water and both depth and fluidity, this suit has come to signify emotions, inner feelings, creativity and aesthetics, rather than more practical material matters. Cups cards concern love, affection, sensitivity, intuition and compassion. In a reading they often stand for the humane and sympathetic in all of us. However, even these qualities can have a negative side. There are situations in which Cups point to a tendency to be too fragile or sensitive, or somewhat morose and touchy. At times they may also relate to a person who is overly introspective or even neurotic. Cups are focused on inner experience rather than outward action, so are inclined to be about emotions that are passive and sometimes apathetic.

The overall message of Cups? We can only make the most of life's potential if we are open to feelings and emotions, of others as well as our own. But we also have to remember not to let this become neurosis or over-sensitivity. To be at their best, imagination and intuition should be balanced with sound sense and the ability to take action, otherwise it's possible to slip into being too much of a "delicate flower". In ordinary life, deep emotions ideally need to be combined with both rational thinking and a good deal of sheer practicality.

The journey of Cups

You open yourself up to a new possibility. This is not something started by you, rather it's arisen from what's going on around you, but you are willing to open yourself to this chance, embrace it and let it enhance your life. It requires not only your commitment but also your sensitivity and sense of aesthetics (Ace). You feel full of life because of these great new opportunities to use your best qualities and the emotions that go with them, and perhaps this is the reason that you almost immediately meet someone who you know will go with you in this next phase of life (Two). With this person, and with others, you begin the "work" (which may feel more like a playful or artistic endeavour). You feel immensely happy to be part of a community which, together, is achieving wonderful things (Three). But then something happens. Perhaps a lack of confidence creeps in but more likely your great sensitivity turns against you. What seemed wonderful only a short time ago suddenly feels rather cloying and suffocating. You don't want to take part after all, and you begin to ignore the possibilities that were formerly so tantalising. Instead you withdraw, sulk and give in to sullenness and depres-

sion (Four). You move into a grey, flat period. In reality, beauty and imagination are still close by, but all you can see are the opportunities squandered, the friendships thrown away and the creativity that you failed to make into anything real. You move further into yourself, and into the beginning of neuroticism (Five). Just as it all seems to be lost, you have a dream. Maybe you are asleep, maybe you are in a waking reverie, the important thing is that you see a ray of light again. If you can give up your oh-so-adult neuroticism and instead become like a child again, then you can get away from scepticism, self-doubt and depression and simply enjoy working playfully with others again. But the dream is unclear and hard to hold on to. The figures in it seem sweet, but also distanced and a little unreal (Six) and as you begin to awake, you experience something in between hysteria and exhilaration. The sense of being stuck, depressed and sad has gone, but in its place you find yourself feeling somewhat bewildered. What next? You can see the possibilities, your imagination is on fire, but you have no idea which way to go next (Seven). So you stop. You simply decide to walk away from all this. You understand that you need time on your own, not to be morose or withdrawn, but to give yourself time to change. You require a period of solitude in order to make a transition from all these ups and downs and all this confusion, to the next stage – when you will finally find out what you really do want to do with your life (Eight).

The next stage is to stop living so much inside your mind. You become less introspective, you "get out more" and you learn again to enjoy very simple and basic things – good company, good food, a little wine and fun. These very mundane pleasures allow you to recover yourself (Nine). You achieve a balance at last. You find a partner again, and this time it lasts. You become less worried about yourself and more concerned with those around you and begin to understand how blessed you are. Now your sensitivity, imagination and creativity are finally balanced with some of the earthly but deep joys of ordinary life. This is true happiness (Ten).

The Cups Court Cards

The Page of Cups lives in a world that is full of imagination and romanticism but that is also slightly vague and misty. He often sees a rather idealised view of reality. Although he is studious, his studies are not aimed in any practical direction; rather he loves learning, and contemplating ideas for their own sake. The Knight of Cups has great creative potential and a joyous enthusiasm for life and love, but is essentially a dreamer, albeit a very attractive one. He rarely comes down to earth for long enough to make his

imaginings into something real. A typical Knight of Cups is the kind of person who is always about to write a great novel or create a work of art but somehow never quite gets around to it. However, the charm of the Knight is that he is an absolutely happy dreamer, oblivious to the fact that nothing actually gets done, and certainly not suffering because of it.

The Queen of Cups manages to balance some practical action with the same sort of seductive dreams and imaginings. She is a wonderful figure in the Minor Arcana, in many ways an approachable version of the Empress. She manages to be creative, emotional, and full of feeling and sensitivity, but at the same time able to act in the practical world. This Queen can put her creative ideas into being in a responsible and useful way.

The King also shares this practicality, but perhaps his sense of responsibility has gone a little too far for his own happiness. Acutely aware of his duties, he tends to suppress his own emotions and the wilder and more rebellious sides of his creativity so that he can reliably "deliver the goods". He always puts duty first, and although at times he dreams of simply dropping job, status and duty and running away to pursue his own artistic impulse, the reality is that it is highly unlikely he ever will.

ACE OF CUPS

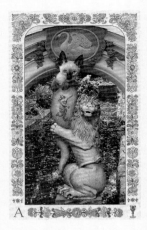

A Siamese kitten with big blue eyes sits in a deep cup that resembles a horn of plenty. It is decorated with a mermaid and held by a smiling lion. Behind is a quiet pool, covered with fallen spring blossom, while above is a relief of a calm white swan.

A Cat's Interpretation

When a new litter of kittens is born they are bursting with life. Within moments they are suckling their mother's milk and making little squeaks of contentment or protest, while the proud mum purrs happily. It's very much an Ace of Cups event – full of affection, pride in new beginnings, life, hope and happiness.

Keywords and phrases

Being open to new creative beginnings • Bursting with life and creativity • Accepting love and affection • Exhilaration about imaginative or artistic endeavours.

Keywords and phrases for reversed cards

Instability: things get turned upside down • Disruption, chaos or confusion Refusing to accept things calmly and instead reacting with anger or violence.

The Ace of Cups refers to the wonderful "my cup runneth over" feeling at the very beginning of an exciting, creative project or relationship. The card is particularly likely to indicate a new opportunity that will be both artistically and emotionally satisfying. This initial period is one in which you feel blessed, filled to the brim with creativity, and wide open to the ideas and wonders in the world – and the people – around you. The little kitten in this image is perched in a cup that is both goblet and cornucopia, the "horn of plenty" that signifies an abundance of good things. In the Ace of Cups it's rich creative rewards rather than material goods that are symbolised; the card shows a time when you will overflow with happiness and fulfillment in what you're doing, and feel exhilarated and inspired.

The Ace of Cups has often been associated with the Holy Grail – and all the mystery, sense of energy, life and wonder that is the Grail legend. Generally

seen as a particularly positive card, it rarely refers to the more oversensitive or inward-looking aspects of Cups. On the contrary, the Ace is about receptivity to ideas and to energies from outside, and all the enjoyment and happiness that these bring.

It's a great time to be working with others, so when you get this card in a reading it may well advise you to lose any fear of intimacy and allow an opportunity for an attraction or relationship to grow, whether it's a full-blown love affair or, more likely, a close and affectionate working collaboration. Alternatively, this Ace may also simply indicate the beginning of a project or plan that requires a high level of emotional openness and sensitivity.

Notes on the source material

The kitten is a seal point Siamese. His mother in real life is our Queen of Pentacles. The lion is a marble sculpture from the interior of St Vitus' Cathedral at Prague Castle. The mermaid on the goblet is taken from a relief in the Vrtbovská Garden in Prague (you can see more of this relief in our King of Cups). The swan is a door sign from Prague (see illustration).

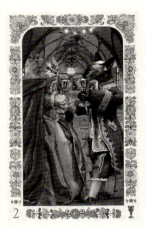

TWO OF CUPS

Two cats stand in a grand vaulted hall, toasting each other. The scene looks rather formal, like a betrothal, or perhaps the agreement of a treaty or alliance. However, there is also tangible warmth in the stance and gaze of these two. They really do like each other.

A Cat's Interpretation

For some cats their strongest commitment is to another cat, but for many, it's to the person or people they live with. When cat and person are curled up together, with cat purring in perfect trust, then you get a glimpse of what this card is about – a deep trust, affection and mutual support and understanding.

Keywords and phrases

A strong shared attraction • The beginning of an excellent relationship • Becoming friends again after a quarrel • A partnership, betrothal or possibly a marriage.

Keywords and phrases for reversed cards

A friendship or partnership under strain • Some awkwardness and suspicion in a new relationship • An unwillingness to form an affiliation or collabora-tion • An introduction that looks promising but may soon disappoint • Refusing an opportunity to settle a quarrel.

Although they are physically rather different, the couple on this card look very much in harmony with one another, and there is a certain mix of both formality and easy intimacy in their pose. The rather ceremonial toast represents the fact that the Two of Cards is often about new relationships – that time when you initially meet someone when things are still rather reserved and "proper". Yet the obvious sense of ease that comes across in this picture implies that the relationship, though new, is already likely to be a successful one. Whether it develops into a friendship, a working collabora-tion or something more romantic, it looks as though it will enhance the life of both parties, and bring both happiness and success.

Because the Two of Cups always indicates a positive relationship, it can also stand for peace and healing, and can mean the end of a quarrel, "burying the hatchet", and generally a willingness and ability to build bridges and

bring about reconciliation. Perhaps the two cats shown on the card are entering into an alliance that will put an end to an old quarrel? Certainly, their different cups remind us that they are bringing diversity to this new relationship. The gold and silver cups can also be read as a reference to Temperance (who traditionally carries two contrasting cups) and this is quite appropriate. Perhaps the good sense and moderation of Temperance should always be part of the foundation of any lasting relationship?

Notes on the source material

One cat is a seal-point Siamese, the other is a Siberian. These are very contrasting breeds, deliberately chosen to imply that it isn't looks, race, background or colour that determine whether a relationship will be success-ful, it's something far deeper and more about attitude and mental or spiritual chemistry between two people (or cats!) The hall they are standing in is in the Old Royal Palace at Prague Castle. We added the framed tapestries in the distance - the hall in reality is now stripped of all furnishings.

Oh lovely pussy, oh pussy my love
What a beautiful pussy you are, you are, you are
What a beautiful pussy you are
The Owl and the Pussycat, Edward Lear

If you hear or see a cat sneezing on your wedding day, you will have a happy marriage.
Russian folk belief

THREE OF CUPS

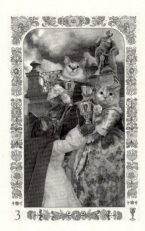

Three cats stand on a staircase, toasting each other in golden cups. Each is very different from the others, in both type and, indeed, clothing, yet the three form a harmonious, if rather formal, group. The statue above seems to smile down in good humour.

A Cat's Interpretation

Cats are more sociable than they are usually given credit for. A group of cats that live together will often be very friendly and cooperative towards one another, even if they do tend to have a definite hierarchy. It's even quite common to see two breeding queens helping to look after one another's kittens - and purring with pleasure as they do so.

Keywords and phrases

Teamwork and collaboration • Celebration • Mutual support • The joy of being part of a harmonious community • Co-operation and teamwork.

Keywords and phrases for reversed cards

The teamwork is still there, but maybe it's not quite working? • A good community is breaking up or is under pressure • It all looks harmonious - but are there some imbalances of interests and power? • Looking for support, but finding you aren't getting it.

This card is about not just cooperation, but a positive joy in teamwork and community, which nowadays often means a pleasure in diversity. It represents those times when you get a deep sense of pride and purpose from working with others, and fully recognise and rejoice in the fact that together you can do far more than any of you could achieve alone. In the image on the card, each of the cats is quite distinct from the others. They are a European tabby, a Siberian, and a British Shorthair, all of which have very different characteristics. They are also dressed in contrasting colours and style. Yet the three seem in harmony, and they look elegant and poised as they toast one another.

Because this is a Cups card the emphasis is very much on emotions and intuition, rather than the more businesslike aspects of teamwork. It may particularly apply to working together in the arts, in voluntary projects or in

some kind of socially-oriented organisation. It's of course an excellent card to see if you are wondering how any cooperation or collaboration will turn out, but it can also indicate social support, particularly if it is mutually given and taken.

Notes on the source material

The cats are shown against a background of a staircase and balustrade at the Baroque Vrtbovská Garden, in Prague's Malá Strana (see illustration below).

> **Both mothers cleaned the new kittens, and then settled down to suckle all eight. They never seemed to discriminate which kitten belonged to which mother, despite their differences in age and size.**
>
> *Dr John Bradshaw, describing the cooperation of mother cats in a group.*
> The True Nature of the Cat

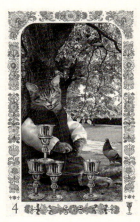

FOUR OF CUPS

The young cat sitting slumped against a tree looks bored and unenthused with what's around him. He is half asleep and yawning, not taking any notice even of the temptingly close pigeons...

A Cat's Interpretation

Cats love to be inert and to simply lie around doing nothing, and yet they do get bored if they get no stimulus. It's natural to a cat to have bursts of mad energy and alertness followed by periods of torpor and sleep. But left with no excitement at all most cats will become depressed and listless. Just like humans, they need a good balance of rest and activity to be really happy.

Keywords and phrases

An overwhelming ennui and depression • Bored with everything • Refusing to count your blessings • Feeling disengaged and listless • You've had too much, and you no longer want anything at all.

Keywords and phrases for reversed cards

Beginning to move out of a period of depression • Starting to see the bright side again • Being more able to respond to opportunities • "Pulling yourself out of it".

The appearance of the Four of Cups in a reading can indicate an unhealthy degree of self-absorption that brings with it a general lack of interest in the world and a sense of being "sick of it all". Often it indicates a time that comes after a period of overindulgence, when you suddenly feel sated and sickened and you react by turning away from all opportunities and former enthusiasms. The cat on this card is in a setting that is both beautiful and, maybe more importantly to a cat, also likely to be full of small birds and animals. There are even two pigeons within easy paw's-reach. Yet this bored little guy just sits there taking no interest at all. He really is sinking into an unhealthy lethargy.

This is a card about those periods of depression we can all fall into, when we feel horribly sorry for ourselves and tend to lapse into thinking that everything is hopeless. At times like this we risk becoming increasingly apathetic

instead of taking action to pull ourselves out of the gloom.

When we're depressed people often tell us to "get out more", yet the young cat on this card is already outside, and surrounded by vitality. It's just that he can't make contact with it. It's this feeling of being trapped in a bubble that can be so enervating when we're in this flat and disengaged state of mind. The answer may be just to begin, even in a small way, to shake yourself out of the listlessness, and begin to take an interest again. If this cat would even simply look at the pigeons, he might find some old excitements beginning to stir again.

It's worth bearing in mind that we often don't recognise when we are becoming depressed, so when this card comes up in a reading it can be a useful warning and wake-up call.

Notes on the source material
The cat is a young European tabby (in fact one of our own litter). He is sitting in a park that is based on one in Prague.

Cats are intended to teach us that not everything in nature has a function.
Anonymous

FIVE OF CUPS

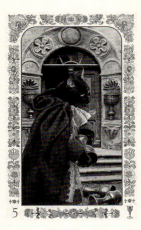

A black cat, heavily wrapped in a dark cloak, stands in front of a stone door, which though open, seems to lead only into darkness. Two cups lie spilled on the cobbles in front of him, and he is about to drop another. On either side of the door stand large stone urns that the cat simply ignores.

A Cat's Interpretation

Cats do experience loss of course, whether it's of territory, companions or simply the loss of prey they were hunting. However, it's the rare cat that seems to dwell on this for long. A cat's nature is to forget and move on, and perhaps we humans could learn a lot from that.

Keywords and phrases

Loss, but acceptance • Remaining hope • Unnecessary pessimism • Calm sorrow • Looking on the down side.

Keywords and phrases for reversed cards

Beginning to be optimistic again • Moving beyond some loss and starting to pick up the pieces.

This card is about loss and our reactions to it. However, it's important to understand that the loss indicated is partial, not total. In a reading, the Five of Cups does not usually signify a deep bereavement or anything as serious and absolute as a death. It is more likely to point to a situation that can eventually be rectified, like the loss of a job, a relationship or money, or of less tangible things such as opportunity or reputation. The card is associated with all the regrets and denials that come with the resulting feeling of sadness and inadequacy. But it also advises us to be aware that this is only a phase, and one that will pass more quickly if we don't give way to pessimism.

It might seem like a gloomy card, but the Five of Cups carries a message of hope. While two of the cups have been knocked over and their contents spilled, and another is just about to be dropped, if you look closely you will see that two still stand – although this last pair is not nearly so obvious as the cups that lie on the ground. The large cups that remain upright and presumably full, are completely unnoticed by the cloaked cat, who seems

106

instead to be unhappily contemplating the one that he is just about to let fall. The image tells us that in the midst of sorrow it can be hard to look on the brighter side and search out the good things that remain. The picture is reminiscent of the old saying that pessimistic people are those who tend to see a cup as being "half empty" rather than "half full". Sometimes, our perception of the state of affairs can make things appear much worse than they really are. Realising this is a crucial part of beginning to recover our optimism after a time of loss.

Notes on the source material

The cat is a black European. The door behind him is from the centre of Český Krumlov, we added the stone urns as in the original the niches are now empty.

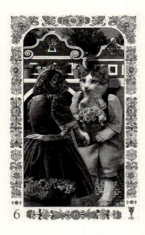

SIX OF CUPS

A bright sunny scene in which two kittens stand in a garden in front of painted toy houses. The pair look at pots of flowers in the sweetly serious way that young cats sometimes have.

A Cat's Interpretation

Kittens are known, and loved, for their sheer fluffy and wide-eyed innocence. It is appealing, but it's as well to remember that they will grow up to be adult cats. Cats are beautiful animals at all stages of their lives, and perhaps we shouldn't be too nostalgic or sentimental about finding only kittens cute.

Keywords and phrases

Allowing yourself to be as open and trusting as an infant • A period of nostalgia and sweet memories • Sharing and caring • Children and childhood.

Keywords and phrases for reversed cards

Looking to the future, rather than the past • Being taken advantage of because of your trusting nature • Finding it hard to open up and share - although you want to.

The Six of Cups is about the oddities and magic of childhood, and is a reminder of innocent games and imaginings that are now only half-recalled. The image on this card probably looks more like an illustration from a young child's book than any other card in the deck. The colours are bright, the two kittens are dressed quite simply and the little houses behind are toys or models with colourful painted facades. This all helps to convey that the Six of Cups symbolises the straightforward simplicity and openness of the very young. It can be seen as a kind of naivety, but more often this card indicates good-hearted trust and a willingness to be open to others in the way that children are.

The Six of Cups is a positive and emotionally warm sign in a reading. It stands out as a small shining light against the distrust, selfishness and suspicion that we often see around us. However, it can, of course, also warn of the dangers of being too innocent in a cynical world. These little kittens do look very defenceless and perhaps they don't realise that things are not

always so sunny? Sometimes this card, if surrounded by "darker cards", can represent the small but vulnerable light that shines in an imperfect world. The small patch of protected ground that you create for yourself may not really be able to shield you from all threats, and there are times when too much innocence can be a dangerous thing.

But while this warning is one part of the Six of Cups, by far the most common interpretation is the simpler and lighter one of good memories, good friends and good deeds. This is not usually about children or childish things as such, but more a certain openness of attitude. The cats in the picture are sharing the pleasures of pots of flowers – they know that nurturing growing things can be the source of a very simple, but profound pleasure. Sometimes a basic, honest life is the best, and sharing and caring actually bring more pleasure than competition and ambition.

Notes on the source material
The young tabby kitten is a European. Her friend is a young Turkish Van cat. The background is based on the decorative market stalls that are erected in Prague's Old Town Square for the Christmas, Easter and summer markets.

Who would believe such pleasure from a wee ball o' fur?
Irish Saying

My kittens look at me like little angels, and always after doing something especially devilish.
Jamie Ann Hunt

Seven of Cups

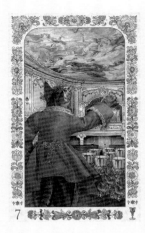

A scene in an empty theatre. Is this cat rehearsing for his real performance? He gestures towards the ceiling on which is painted a riotous scene of a flying chariot. It's enchanting, but all out of reach to him. On the stage are seven golden cups.

A Cat's Interpretation

Young cats will frequently "chatter" at birds or other prey that is just out of reach. Excited by the opportunity they see, but frustrated by its unattainability, their hunting instinct comes out in the strange noise of teeth-chattering that is only heard in this situation. So near, and yet so far, what to do?

Keywords and phrases

Daydreams of desire • Wild fantasies • Bewildered by choice • Wishful thinking • Decisions, decisions, what to chose?

Keywords and phrases for reversed cards

Knowing you have options, but that none of them will come to anything • Feeling your options are limited • Being unwilling to see the possibilities in front of you • Refusing to be seduced by illusions • Being sensible and down to earth – maybe too much so?

The Seven of Cups is about choice – in a bewildering and bedazzling variety. Having many options is wonderful in some ways. It can be exhilarating, but of course it can also be confusing and a source of anxiety. Decisions are often hard.

When you are faced with a huge array of options, it's important to try to distinguish clearly between those that are real and others that are merely attractive mirages or wishful thinking. It's fine to enjoy contemplating both – sometimes day-dreaming and a little make-believe is good for us. But try not to put energy into pursuing apparent opportunities that are actually unlikely to come to fruition.

The actor cat in this picture is rehearsing for a part – who will he be, and how will he perform? The idea of slipping into other roles and trying out other ways of being is one of the thrills of acting. But again, we need to

make sure that we don't lose ourselves in the fantasy. Adopting roles and daydreaming – whether actually or purely in the mind – is great fun, as long as we understand that it isn't real.

Notes on the source material

The cat is a European tabby. The wonderful background picture is made up of two original Baroque paintings on the ceiling of the Clam–Gallas Palace in Prague's Old Town.

Dreaming of Cats
If you dream that you are eating a cat it means that someone is being unfaithful to you.
If a cat bites you in your dream, you will get ill.
If a cat bites someone else – someone you know will get ill.
From a Czech dream book published in 1968

Ceiling painting from the Clam-Gallas Palace in Prague

Eight of Cups

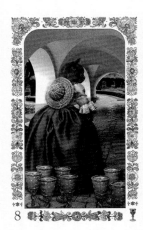

A small grey cat turns back sadly to look at the cups left on the cobbles behind her. She is walking in a cloisterlike passageway, a closed off, rather claustrophobic place. But it leads to a sunnier, more open garden, and that's where she seems to be going - if only she can stop looking backwards.

A Cat's interpretation

Conservatives in territorial matters, cats do not like to move on, even when there are a lot of reasons to do so. Most will cling to old territory even if it's changed and become uncomfortable or unsuitable. They may also try, seemingly illogically, to return to their old home, even if the new one offers more comfort and excitement.

Keywords and phrases

Leaving one thing to move on to the next • A sad parting but a new beginning • Mingled regret and anticipation • Making the steps that are necessary, even though it's difficult.

Keywords and phrases for reversed cards

Refusing to move on, though perhaps it's time to • Choosing not to make a move • Stuck in a rut or depression.

Time to move on, but it's hard to do. This card indicates a period in which a step that is probably long overdue is finally taken - but with some regrets and hesitations. The cat shown on this card seems half-prepared for a journey, she is dressed in plain clothes and has a large sun-hat to help protect her against the elements. However, she is obviously feeling some sadness at what she leaves behind. The cups, when you look at them closely, are engraved with cosy-looking houses - perhaps she's walking away for a safe, domestic environment?

Cats hate to make any major changes in their routine - and in many cases people find it hard too. The Eight of Cups shows both the difficulties and the rewards that this can bring. The cat on the picture is walking through a, literally, cloistered place towards a much more open and inviting one. Her journey will lead her to a much better place, but initially the sheer sense of freedom and wide-open opportunities may feel a little daunting.

In readings, it's important to distinguish between the reluctant but necessary move signified by the Eight of Cups, and the much more joyful, celebratory and rebellious one that is at the heart of the Four of Wands. The Eight of Cups tends to point to a step that you know has to be taken, but which you have been putting off. In the end, it's also a move that you have to make alone, and perhaps this is the central reason that it's so difficult. When you see this card in a reading it may well tell you that the time to move on has finally come. Yes, it will be a wrench, but remember that the journey that you are about to make in life will lead on to far better things.

Notes on the source material

The cat is a British Shorthair. The "cloister" in which she is walking is in fact a covered walkway in Prague's old Malá Strana district. She is walking towards a corner of the Baroque Vrtbovská garden. The glasses are adapted from a glass on display in the Museum of Decorative Arts in Prague. If you look at them closely (see illustration) they show a homely house and garden.

NINE OF CUPS

A somewhat portly, and obviously very satisfied cat sits on a barrel in the public room of an inn, licking his lips. Behind him, carved in wood, can be seen a scene of general merrymaking.

A Cat's Interpretation

Most cats can be quite contented when they simply have the basic good things of life – food, a warm place to sleep, companionship and a bit of territory. Looking at humans, cats must often wonder why they can't simply enjoy curling up on the sofa after a good breakfast and sleeping through the day – what could be better?

Keywords and phrases

Pleasure from good, basic things • Simple contentment and happiness • Satisfaction and well-being • Enjoying yourself in a straightforward way.

Keywords and phrases for reversed cards

Going beyond surface values • Thinking about others, not just yourself • A new health-consciousness, care for the mind and body • Freeing yourself up from a little too much focus on material or physical pleasures • Holding on to the important values in life, even if times become hard.

The expression "Looking like the cat that ate the cream" pretty much sums up the picture on this card. The plump and content cat does look a little smug, but he is also obviously not in the least concerned about this. Surrounded by the warmth and bustle of an inn scene, he sits foursquare planted and confident. He has obviously just enjoyed a good meal.

This card is sometimes known as the "Wish card" as it's about the fulfillment of very basic, down-to-earth wishes, such as having plenty to eat and drink, some straightforward good companionship, security and a comfortable life. For those of us who live in the more prosperous parts of the world, such wishes can seem rather shallow and lacking in spirituality. But remember that for people who don't have such simple things, a desire for physical comfort and well-being is very strong and immediate. We sometimes forget that simply to be safe, to have food on the table and a roof over our heads is a very real blessing that we should sometimes celebrate unashamedly.

This card may seem a little self-satisfied at times, but not in a really dislikeable way. It tells us sometimes it's great to just have a good time and relish it without shame. The Nine of Cups may imply a short period of "letting your hair down" while you feel the satisfaction of your wishes being granted, or it may mean a more extended period of pleasure. Whichever it is, just relax and enjoy it.

Like all the cards, the interpretation of this card depends on the context. Even the "wish card" can carry a slight warning, and in this case it's simply "be careful what you wish for". Though this card is about getting what you want and enjoying yourself, it doesn't mean that you should throw away all sense of responsibility, or allow yourself to over-indulge or to become too full of yourself or complacent. However, if you avoid these pitfalls everything the "wish card" promises can be enjoyed fully and deservedly.

Notes on the source material

In the Tarot of Prague, Puss in Boots was featured on this card, now he has taken over the main role. The cat is a male British Shorthair. They have a tendency to become a little broad in girth! The background scene is taken from the door of a carved cabinet on show at the Prague Museum of Decorative Arts.

> Even overweight cats instinctively know the cardinal rule: when fat, arrange yourself in slim poses.
> *John Weitz*

> Cats seem to go on the principle that it never does any harm to ask for what you want.
> *Joseph Wood Krutch (1893 - 1970*

> To live long, eat like a cat, drink like a dog.
> *German Proverb*

10

TEN OF CUPS

Two happy cats stand with their arms around each other and look out over a city. In the sky is a rainbow, and all looks green and lovely.

On the railings ten little golden cups can be seen. They are somewhat heart-shaped, and the railing itself makes up yet another heart.

A Cat's Interpretation

Safe and warm territory, an affectionate family group (of cats, people or both) and a plentiful supply of food and amusement – these are the simple needs that fulfill nearly the entire wishes of a cat, and what's wrong with that?

Keywords and phrases

Recognising the joy in life • Counting your blessings • Happiness in domestic and family matters • Pleasure in simple, homely achievements.

Keywords and phrases for reversed cards

Some lack of harmony in domestic or family matters • Quarrels or even violence in the household.

This is usually a very easy card to interpret, as the Ten of Cups is one of the most straightforwardly happy cards of the entire deck. Unlike the Nine of Cups it isn't just about immediate gratification, but refers much more to happiness that's been built up over time, especially in family and domestic matters. While it can indicate prosperity and good fortune in a material sense, it's more about the joy of finding a way of living that brings fulfillment, comradeship and a lasting happiness. It's very much the card of the "Good Life" in a broad sense.

The picture is of two mature cats with their arms around each other. They are not rulers of all they survey; rather they are just a very happy and harmonious couple enjoying the glad sight of a rainbow over their city. They look thoroughly domesticated – the gentleman cat even seems to have his tail neatly tucked into his trousers! But perhaps the rainbow signifies that the current contentment has come after a period of some storminess? Certainly, this card is not about pleasure or luck that simply drops from the skies, it's about the good fortune that you make for yourself through good relation-

ships, patience, compassion and co-operation.

This doesn't mean that the happiness shown is mundane – far from it. It may be an unmelodramatic, easily understood kind of happiness, but this doesn't make it any less wonderful. The rainbow can also be read as telling us that profound beauty and magic can be found in the most natural, familiar relationships and domestic achievements.

Notes on the source material

The cats are a European tabby and a Siberian. The scene that they are looking on to is a view over the Malá Strana area of Prague and across the Vltava river.

I love cats because I love my home and after a while they become its visible soul.

Jean Cocteau

[In Egyptian households] either alone or together with the Cat of flesh and blood, the stele [amulet of a cat] protected the household from all ill.

The Cat in Religion and Magic

The original grid from a building in the old part of Prague

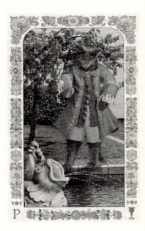

PAGE OF CUPS

Another garden scene – all the Pages in our deck are set in a Baroque garden. In the case of the Page of Cups, he stands in front of a gloriously flowering cherry tree looking questioningly at a fish fountain. What does he see in the fish? A symbol of creativity or just a source of some rather entrancing jets of water? Whatever his thoughts, he seems lost in contemplation.

A Cat's Interpretation

Young cats are endlessly curious and creative, constantly exploring and experimenting. They may occasionally get themselves into trouble, after all "curiosity killed the cat" we're told. But usually it's just all part of a healthy process of learning – and watching it can be very charming for us humans.

Keywords and phrases

A wild and creative imagination – perhaps a little immature? • The beginning of an exciting artistic project • Seeing all the things that you are capable of doing creatively • The beginning of a deeper intuition – a willingness to develop this • Innovations – a new approach • Some new intimacy in life – perhaps love, but maybe a deepening friendship.

Keywords and phrases for reversed cards

Creativity used to deceive or mislead • Feeling that the start of a project is in some ways blocked – creative frustration • Wanting a more intimate relationship in life, but finding this hard to achieve • An immaturity that overwhelms real creativity • Too concerned with being seen as "cool" rather than being truly intuitive.

The Page of Cups is a great card to see in a reading when you are beginning a project or a relationship that needs a rather light but intuitive approach. It's about emotions that are gentle rather than dramatic. This card tends to signal a time of romance, inspiration or emotional growth. This Page is not the most serious character in the deck, but neither is he irresponsible. He is willing to open up and allow his feelings to show but he is not driven by his passion. He's a little less dreamy than the Knight of Swords, because

although he has all of the Cups inclinations to be rather otherworldly, he is perfectly capable of getting things done. Altogether a pleasant and gently inspiring influence to have in your life.

In many ways, this Page, although playful, is quiet and unshowy. He can be very absorbed in the things that he's becoming involved in and willing to channel his creativity towards them, but always in quite a light-hearted way.

Notes on the source material

The young cat is a Russian Blue. The fish fountain that he is looking at was found in central Prague. The golden cup with the wonderful lid showing a ship in full rigging is on display in the Museum of Decorative Arts in Prague (see illustration).

KNIGHT OF CUPS

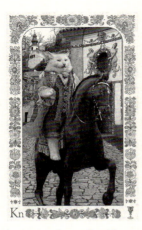

With floral buttons, embroidered saddle and lashings of lace, this is a fabulously decorative Knight. He rides his horse across a lavish, yet wintery garden. He seems bedecked with flowers and lace, although this is perhaps not the most practical costume for the time of year. Behind him smiling mermaids seem to point the way to a window in the wall; we can only wonder what it may lead to.

A Cat's Interpretation

Cats do a lot of dreaming in their sleep, and in fact it's a little-known fact, recently discovered by researchers, that kittens dream almost all the time that they're asleep. When you watch a happy cat dreaming you can see by the twitches and gestures it makes that the visions are mostly about successful hunting and delicious meals – though it's nice to think that a cat's imagination may sometimes extend beyond these very material concerns.

Keywords and phrases

Breaking through barriers to find fantasy • Escapist dreams and longings • Creativity that lacks some practicalities • Dreaming your life away • Living in "cloud cuckoo" land • Happy imaginings – that may come to little.

Keywords and phrases for reversed cards

Losing touch with some of your fantasies – this may be good or bad • Coming down to earth with a bump • Realising that you need to combine some action with the dreaming.

This magnificent knight looks utterly at ease, confident and gorgeously attired. The garden that he rides in is a winter one, its decoration coming from pretty architecture rather than plants. Yet oddly he wears flowers liberally on his clothes, almost as though the season in his imagination is different from the actual one. He seems to be dreaming of summer, and for him maybe that makes it real enough?

His mind is probably at another time or place, and he is quite self-absorbed, apparently not even seeing the mermaids behind him who, laughing, point to a window in the wall. The knight's mismatched eyes, one blue and one yellow, are another subtle indication that he sees two worlds at once. One is

the solid world of practical matters, the other is his own place of fancy and reverie. This knight can never move entirely into the waking world, he loves to dream even in the daylight.

The Knight of Cups is the most emotional, romantic and imaginative of all the Knights of tarot, but he is also the dreamiest and tends to be detached from reality. While he has the sense of purpose that is shared by the other Knights, he tends to be poor at putting his imaginings and daydreams into any kind of action. At times, this can show itself in frustration; he can be moody and rather over-sensitive to anything that he regards as criticism. In his own mind he is always just on the verge of putting his plans and dreams into action, and he may resent any implication that contradicts this. At the same time, there *is* sometimes a lot to criticise, as well as to adore. He is one of those people who are loveable but irritatingly hard to bring down to earth. This knight in your life will bring a great deal of feeling, creativity and intuition, and perhaps much beauty too. But be aware that he is a rather frail flower in many ways, and you really can't look to him when it comes to handling the more mundane, less picturesque but nevertheless necessary aspects of day-to-day life.

Notes on the source material

The cat is a Norwegian Forest cat with the mismatched eyes that are sometimes seen in white cats. In real life he is almost totally deaf – which perhaps makes him a particularly suitable figure for the rather dreamy and detached Knight of Cups. The shattered wall is a painting on one of the garden rooms at the Baroque Vrtbovská Garden in Prague. The horse, like all the horses we have used for the Knights in this deck, is a small (cat-scale in fact) bronze statue from the Wallenstein Palace Garden in Prague.

Artists like cats, soldiers like dogs
Desmond Morris

QUEEN OF CUPS

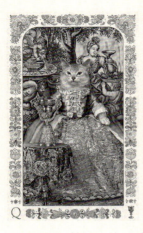

A strikingly beautiful and delicately poised cat sits in a richly furnished room. Behind her is a tapestry showing a fountain on which an angel and a merman play. The main figure is a laughing woman toasting herself with a raised cup. The whole background scene is lively and fun, though the Queen herself looks calm and composed.

A Cat's Interpretation

Occasionally a cat comes along who really does seem to have balanced her life extraordinarily well. Able to relate to people as well as other cats, fond of kittens but also of playing and – the truth be told – hunting, simply because its her nature and part of living. A cat that can chase a silly bit of fluff one minute, but be serious and dignified when called for. These tend to be the cats (and they can be male or female) that the people who live with them remember forever. "I had one cat that was very special," they will tell you years later – that's a Queen of Cups cat.

Keywords and phrases

Sensibility matched with common sense • A productive creativity • Intelligence that is combined with warm emotion • Harmony – and ability to combine artistry with real-world success • A love of beauty and the arts A person who inspires and lights up your life.

Keywords and phrases for reversed cards

A good person with a rounded personality, but perhaps not totally in harmony with themselves and the world • An "almost" encounter with the Queen of Cups, perhaps someone who briefly achieves that balance • A love of aesthetics and arts, but in a popular, rather than profound way.

The Queen of Cups is often seen as the most balanced and, in many ways, happy card of the Minor Arcana. Creative but grounded, emotionally open, but at the same time never neurotic or out of control, the Queen represents a state that many of us would like to achieve in life. She isn't quite the equivalent of The World card – which represents something like a spiritual nirvana – but instead she demonstrates a more real-world, and very desirable, version of reaching a state of bliss and balance.

The picture on this card shows two slightly different aspects of the Queen. In the background is a beautiful but perhaps very slightly disheveled Queen. She looks happy and fun, but not at all serious. In front, the main figure of the cat sits in a rather more controlled and balanced pose. Between them, they remind us that the Queen of Cups is not just about gaiety, love of beauty and a warm emotionality - though she is all of those. She is also about moderation and emotional synthesis –an ability to be calm when necessary, and to combine her feelings with practical action when she needs to. She *is* good fun, but she can also be serious, and a good listener when required. Welcome this queen when she comes into your life, she is a wonderful, positive influence to have around.

Notes on the source material

The queen is a white Somali. The hanging behind her is made up from two pictures, one part (the cherubs and fountain) is taken from an old Baroque tapestry. The other, showing the drinking queen, is actually a painting on a Baroque wine glass found in the Museum of Decorative Arts in Prague (see illustration).

King of Cups

A grand white Persian stands rather stiffly in a garden, holding a golden cup. Behind him is a pool of water in the centre of which is a fountain that shows a cherub wrestling to subdue a dragon.

A Cat's Interpretation

Not many cats will repress their desires and longings in order to show responsibility, though you may sometimes see this behaviour in a nursing mother cat who stays home to look after her litter when she'd rather be out exploring. Fundamentally though, cats expect self-control and a sense of responsibility from their humans, not from themselves. It seems perfectly reasonable to a cat to expect a human companion to cancel a trip or a holiday if no one can be found to look after the feline heads of the household. Similarly while the human may long to forget all about endless opening of tins and cleaning of litter trays, basically they know it's impossible. Duty calls – with a loud meow!

Keywords and phrases

Holding back your creativity • Being rather "buttoned-up" • Repressing desire in favour of responsibility • Longing to buck your duties – but knowing you can't • Occasional outbursts of anger as a result of emotional repression.

Keywords and phrases for reversed cards

Not just repressing yourself, but actually deliberately being "economic with the truth" too • Loosening up – letting some of your feelings out, but this may show itself as anger • Abandon or irresponsibility – a good or a bad thing • Expressing your repressed creativity, if only in a brief or small way – this might feel unpleasantly domineering.

It's hard not to feel a little sorry for the King of Cups, even though at times he does show a tremendously bad temper. Like all the Kings, he is dutiful and responsible, but in this case, the duties sit heavily on his shoulders. The King of Cups is as creative as the rest of this suit's Courts, but he has repressed this and instead put his duties first. He is like the father who became an accountant for the sake of his family's security but who always

wanted to be a painter. Or the person who wanted to study creative writing but instead became a mechanic. These are not bad choices, indeed for those who are dependent on this King they may seem very wise. But they leave the King himself with a lasting feeling of dissatisfaction. Really, he isn't the careful conservative that other people think him, and in his heart of hearts he longs to kick off his self-repression and do something wild.

In the picture on this card, the cat is a white Persian - arguably one of the most romantic-looking of breeds. But in fact he seems rather stiff and "buttoned up". The statue behind, showing a cherub madly wrestling a wormlike dragon may give us a clue as to what is going on in the King's head. He too is internally wrestling a dragon - that of his own repressed desires. He would love to give way to it, but dare not.

It's worth noting though that the meaning of the King alters when he is directly associated with the arts. In that context, he can indicate a fulfilled and thoroughly mature creative artist who is well-known and respected in the community. He may to some extent be someone who is seen as having "sold out" to convention and establishment in some people's eyes. But in fact, in his own estimation, he will have successfully managed to combine material and social responsibilities with his own creative ends. In this context, the King may be a much happier individual.

Notes on the source material
The King himself is a white Persian. The garden is based on the Wallenstein Garden in Prague. The statue of the boy and the dragon is from the Baroque Vrtbovská garden in Prague. We have used the statues from Vrtbovská repeatedly in the deck, as they have a very distinctive character.

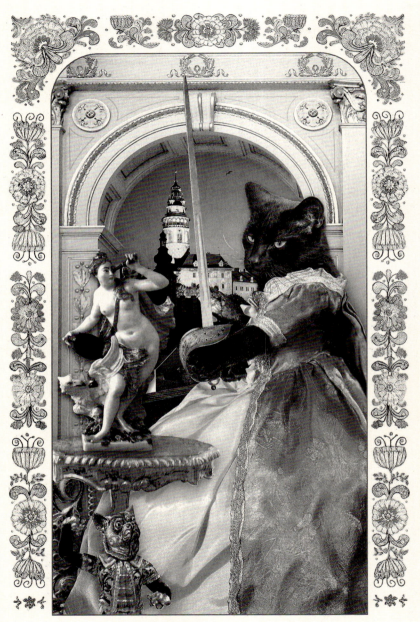

SWORDS

Swords

The element of Swords is air and this suit is about the higher forms of intellect, the mind and mental force. However, and notoriously, Swords is also the unsettled suit of the tarot, and the cards can refer to conflict, struggles, particularly psychological ones, willpower, pain and anger.

Swords are associated with all aspects of the mind, both good and bad. In their positive aspect they point to the ability to be analytical, dispassionate and reasonable. Swords also demonstrate honesty, objectivity, fairness and, on occasion, a fair amount of sharp wit. However, the suit does have a distinctly negative side. Swords can be so cool and logical that they easily become insensitive and thoughtless. They are usually very self-assured and confident that they are right, to the extent of being opinionated and dismissive of any differing points of view. They are often somewhat confrontational or dramatically forceful about getting their own way.

Swords is often seen as the "bad" suit of the tarot, and it does indeed contain more cards with a predominantly negative reading than any of the other suits. However, the interpretation of most of the cards does very much depend on context. Even the rather dreaded Three and Ten of Swords are not all bad or doom-laden - every card in the tarot can potentially show a good or a bad side, depending on the reading.

The overall message of Swords is that incisive, intelligent thinking is vital — life can't be based entirely on intuition and emotions. However, the down side is that this kind of intense thinking can turn inward and become rather neurotic and hostile towards others. It needs to be balanced with more earthy practicalities, and of course, and essentially, also with some feeling for others.

The Story of Swords cards

You feel alive, energised, and that your mind and your wit are both razor sharp. Just now, anything is possible, and you see the world as a whole new terrain to be conquered - intellectually if not actually (Ace). But this feeling of utter confidence passes and you become aware of all the threats and oppositions. Your main concern becomes simply to protect yourself. You withdraw, erect mental barriers and keep the world at bay (Two). But you can't keep all the dangers away forever. Some of them touch you - and deeply. You feel what true sorrow is and it hits you not so much through your mind, as through your heart - which feels as though it's breaking

(Three). Time passes, and the hurt fades, as even the worst pain does. But it leaves you exhausted and drained. You don't even have the energy to put those barriers back up (and perhaps you realise how useless they often are). Instead you simply take some time to rest, recuperate and recover yourself. (Four). Afterwards, you get back to life's struggle again and take part with a vengeance. Re-energised, you feel you can take on all comers – and win. It's intoxicating and you don't care who you damage or what you have to do to come out on top, all you're interested in is the thrill of the fight, and of putting the enemy down (Five).

But now an odd thing happens. Something intervenes and you find yourself alone again. You have to undertake a journey, which may be more mental and spiritual than physical. Perhaps what you need to find is actually your real self? (Six). But never quite able to entirely separate yourself from fighting, battle and struggle, you pause and instead of quietly traveling deep within your mind, you go right back into the world and take some silly actions of spite and vengeance, which in fact do you no good whatsoever (Seven). Next thing you know, you are once more exhausted, embattled and, this time around, showing many signs of paranoia and obsession with violence. Be careful, you are beginning to display both mental and physical scars (Eight). This is the point at which you feel the onset of nightmares and frightening imaginings. The world seems to be a threatening and outlandish place. You react with a degree of fear, panic and hysteria. Your vulnerability comes to the surface (Nine) and your mind finally feels as though it's cracking. Brought low by your own insistence on seeing all of life as a conflict, you feel that the swords have now been decisively turned against you. Unable to fight back, you sink into yourself and feel drained of life and unable to think clearly (Ten).

The Swords Court Cards

In Swords, the qualities of the Courts are applied to the intellect, reason and mental willpower. The typical energy of the Page is directed toward being watchful and alert. He is ever vigilant and, uncharacteristically for Pages, conscientious and responsible beyond his years. However he may also be too guarded and suspicious and this can make him hostile or even deceitful at times. Perhaps he shouldn't think quite so much about everything?

The Knight of Swords is in some ways similar, but he is less watchful and more a man of action. He's a brave figure and this can be very inspiring, but he is also inclined to charge headlong into situations, often without even considering whether discussion and restraint would be more effective than

pitching straight in. He is a wonderful ally in a battle, but has no sense of restraint or diplomacy and tends to see conflict where none is intended – partly, one suspects, simply because he enjoys a good battle.

The Queen of Swords is much less warlike. She has every bit as much courage as any of the other Swords Courts but it manifests itself with restraint and thoughtfulness where necessary. She isn't one to rush heedlessly into a fight. Perhaps this is because she has already seen too much conflict and pain in her life. She has experienced trouble, and may well have been involved in fighting and struggle in her past. However, instead of giving in to bitterness or hostility, she has turned this experience into wisdom. She uses her intellect not to make plans for battle, but to work out how to solve difficult situations. In many ways she is the ideal negotiator of a peace settlement – she will always be fair and clear in her opinion, straightforward and honest, even in situations when the people around her may not really want to hear the truth. Of course what she has to say may well hurt at times, she has a cutting tongue. But she will always use it with the intention of being "cruel to be kind".

The King is altogether less benign and conciliatory. He uses his razor-sharp mind primarily to exert his own authority. This can be a very good thing – this king is a wonderful leader in situations that call for a clear, fair but diamond-hard control. However, in less extreme times he can be a difficult and oppressive person to be around. His intellect means that he is nearly always right in strictly rational terms, but his inability to see how his actions effect other people emotionally or to recognise any need for practical compromise means that he can easily slip into being a fearsome dictator.

> **Swords generally are not symbolical of beneficent forces in human affairs**
> *A R Waite*

ACE OF SWORDS

A young black cat stands at an open window and gazes up at a stone lion that holds aloft a golden sword. Above there is a shield showing devices of battle, and a golden lion rampant. Near the very tip of the stone lion's crown a little blue butterfly flies off.

A Cat's Interpretation

Some cats are just born with a lot of sharp intelligence. These kittens are often the ones that dominate the litter. While they can be the most charming animals, and their cleverness can be entrancing, they can also turn into a real handful – the kind of cat that gets into everything and refusing to take no for an answer. Such a demanding cat can be great to live with, but may require an equally sharp human companion.

Keywords and phrases

Forcefully applying your intellect to something new • Finding tremendous mental energy • Seizing a new opportunity to develop your powers of thinking or learning • Exerting your force of mind – perhaps to excess? • Triumph, winning an important argument.

Keywords and phrases for reversed cards

Hunkering down intellectually, maybe focusing inwards and missing the wider opportunities • Deciding to give up the argument • Using your mind, but for a comparatively small purpose.

Like all the Aces, the Ace of Swords promises new energies, renewed vigour and excitement and significant opportunity. Being the Swords Ace, this is all in the area of intellectual pursuits and ways of using your mind, so the possibilities on offer are likely to be in areas that call for clear analysis, willpower and mental agility. However, while the Aces are usually very positive cards in a reading, it's worth remembering that the Swords Ace does carry some of the double-edged characteristics of the suit. At times the opportunity to triumph and shine intellectually may mean that there is a lack of sensitivity towards others.

The picture on this card combines many of the qualities of both the Aces and the Swords. Like all the Aces in this deck, the scene shows a young,

unclothed cat together with a lion that holds the emblem of the suit. This particular juxtaposition combines a new-formed openness and innocence that is full of potential (the kitten aspect) with the timeless lion. His role is to point more grandly to the opportunities that lie ahead.

In this image, the other elements signify both the admirable and the troubling aspects of Swords. The blue butterfly is pure intellect, light and unfettered by more worldly concerns – the butterfly is an emblem used repeatedly on the images of the RWS Swords Courts. The stormy skies that can be seen through the window graphically suggest the dramas, conflicts and struggles that the suit so often represents.

Notes on the source material
The adolescent cat is a black European. The stone lion is a Renaissance statue at the entrance to Zemský Dům in Prague's Malá Strana district.

Relief sculpture from the entrance to the Lobcowicz Palace in Vlašska Street, Prague

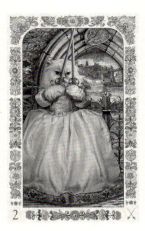

TWO OF SWORDS

A feisty-looking white cat holds two swords in a gesture that looks like a mix of defiance and defence. She is clearly on guard, and takes up a fighting stance that contrasts oddly with her delicate features and lavish clothing. Behind her a high fence suggests that even her surrounding environment is fenced in and protected.

A Cat's Interpretation

When two cats get into a stalemate in a fight, you will see them "blocking" each other. Putting up their defences, but without really wanting to come to blows. It isn't a stance that they can keep up for long, but it does give them enough time to take a moment to consider whether flight or fight is best.

Keywords and phrases

Holding the world at bay • Making sure you are safe and secure, but at a cost • Feeling defiant and defensive • Putting impenetrable barriers around yourself • Refusing to let down your defences.

Keywords and phrases for reversed cards

Allowing yourself to be vulnerable – which could be good or bad • Laying down your defences and being more open • Feeling unprotected.

This is quite a contrary card – appropriately it's very double-edged in its meanings. On the one hand it shows a potentially vulnerable little figure who is defending herself with grace and determination. But on the other, one might ask whom she is defending herself against? Is it all comers, or is there anyone who she would trust enough to allow near her? Would she be happier if she let down that barrier or is her defensive posture really the only way of keeping herself safe?

When this card appears in a reading the interpretation needs to be thought about carefully, because of its potential contradictions. You need to decide if it indicates a situation in which someone is advisedly keeping themselves secure, or if, alternatively, it's warning of a situation in which there is needless – and exhausting – defensiveness. It all depends if you focus on the balance typically indicated by the "Twos" or on the actual posture of the little figure with the swords, which looks rather awkward and hard to maintain.

In the traditional RWS card the figure is blindfolded. although oddly enough in the interpretation given by Waite he seems to ignore this and describes the meaning in rather positive terms as "conformity, courage, friendship... tenderness, intimacy" (Waite). We have removed the blindfold in our picture to show more explicitly the expression of "fight or flight?" that the cat is caught with. Right now, it's clear that she is someone who is holding her ground well. Both her swords and her posture say firmly "Don't mess with me". But can she stay like this for long? Sooner or later she may have to put down the swords, and then she will need to find a more sustainable way to maintain her security.

Notes on the source material

The cat is a Persian. The background is made up of a scene from part of a Renaissance tapestry combined with a very old archway from the Malá Strana district of Prague (see illustration).

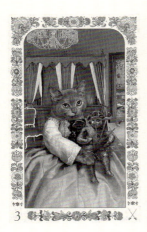

Three of Swords

Weeping, a cat sits alone in her bedroom, in front of a large empty bed and an empty chair. She holds a slightly tarnished angel, which in turn holds a wand pierced with swords. The poor little cat looks quite devastated.

A Cat's Interpretation

Cats can experience deep loss and distress, and in some ways in this situation they are worse off than humans, who at least know that bad times do pass and healing comes. Sometimes you meet a cat in a shelter that has obviously been deeply scared and hurt. It takes a great deal of kindness and patience to restore such an animal to serenity and trust.

Keywords and phrases

Emotional pain • Feeling stabbed in the heart • Sorrow • Grief over someone or something you love • A betrayal that shocks you to the core.

Keywords and phrases for reversed cards

Something that should hurt you deeply, but in fact doesn't • Emerging from an emotional pain – beginning to shake it off.

This card is probably one of those that are least welcome in most readings. It signifies pain and suffering, usually of an emotional rather than a physical kind. The figure shown on this image is weeping, and also clutching a rather tarnished little gilded angel who in turn holds a pierced heart. The scene is one of lost dreams, damaged love, loneliness, and painful memories. The bed, so obviously built for two people, is empty and abandoned. The cat can only sit and mourn.

So how should you react when you see the Three of Swords? Throw up your hands in horror and give up? No, of course not, and if you look at the image you may see a few redeeming features. Although the cat looks horribly sad, she is in fact still in one piece and in what appears to be her own rather lovely home. All is not lost. Once this period of sorrow is over, she should be able to pick up the pieces and continue once more. Perhaps this experience will leave her changed, but it will not break her.

The fact is that this sad card of the tarot tells us the honest truth – that we

may all experience heartbreak at some time in our lives. However, it can also counsel us to go through such sorrow calmly. Nothing lasts forever, and although there may be a lot to bear, there are bound to be happier times ahead in the end.

Notes on the source material

The cat is a young cream and blue British Shorthair. The bedroom in which she sits is one in Česky Krumlov Castle. It features this spectacular double four-poster bed. Incidentally, part of the same room can be seen on our Wheel of Fortune image.

A meow massages the heart.
Stuart McMillan

Stone relief showing a pierced heart from Český Krumlov (the world emblem is used on our World card)

FOUR OF SWORDS

Lying across a stone pedestal in a church, a
contented ginger cat sleeps deeply. He looks
dead to the world, and completely oblivious of
both the magnificence of the setting and,
indeed, of the sculpture of a happy dog with
lolling tongue that's just below him.

A Cat's Interpretation

Taking time out to rest and recuperate is
something that cats are naturally good at. After
a fight or a fright, most cats will wash them-
selves and take a nap. It's the best way for them
to recover both physically and mentally.

Keywords and phrases

Time out from the fray • Rest and recuperation • Mental silence and
stillness • A pause to retreat and reflect.

Keywords and phrases for reversed cards

A return to the world • Being awakened and brought back to real life •
Cautiously emerging from retreat.

It's in every cat's nature to be active and alert, but they are also supremely
good at sleeping and taking "cat naps". We can learn from this by recognis-
ing that the only way to maintain high levels of energy is to know when to
stop and recuperate. Certainly, most of us don't need to take resting to quite
the degree that cats do (the average domestic cat is believed, incredibly, to
sleep seventeen hours a day) but we all benefit from taking time out from
our hectic lives and simply doing nothing from time to time.

This card is traditionally set in a church and in the original commentary by
Arthur Waite it has a darker association with tombs and coffins as well as
with simple rest and relaxation. However, over time these more sombre
meanings have tended to fall out of favour Perhaps to a modern eye the
church setting suggests a respectful stillness, peace and meditation, rather
than a place of tombs? Certainly, although we show our sleeping ginger cat
on a stone slab, it looks more like part of the architecture than a funereal
stone. The laughing dog on its base can be read as a symbol of the day-to-
day struggles that a cat may face (though the dog does not look terribly

fierce). If so, then these are struggles that can temporarily be forgotten about during sleep.

All in all, this card provides an image of some really necessary time out from the furious thinking and battling of the rest of the suit. A welcome and healthy respite.

Notes on the source material

The cat is a young ginger tom that we photographed at the Prague Cat Rescue Home. In real life he had had some hard experiences and in fact had lost an eye. However, when we met him he was curled up happily sleeping seemingly without a care in the world.

The stained glass window is from the St. Vitus' Cathedral at Prague Castle. The stone slab is actually based on part of a carving on the wall of the Jesuit Clementinum, again in Prague (see illustration below).

> **Like a graceful vase, a cat, even when motionless, seems to flow.**
> George F. Will

FIVE OF SWORDS

A very wide-eyed young cat stands holding a bird cage and some swords in his paws. Other swords lie on the ground. At the far end of the passageway a forlorn tabby looks back dejectedly – obviously his bird has been stolen, and probably his swords too?

A Cat's Interpretation

Cats can be sneaky, and they can also be vengeful, at least over a short period. We've all seen a cat who appears to have finished a fight and lost interest – but who then sneaks in a final quick bite when his opponent is walking away. To a person watching, this seems really mean, but to a cat, all's fair in territorial disputes.

Keywords and phrases

Meanness and sneakiness • Defeat by dubious means • Selfishness • Dishonour and disgrace • Enjoying an unkind and unjust victory.

Keywords and phrases for reversed cards

More dishonour, perhaps of quite a brutal sort • Being willing to be really cruel to get your own ends • An almost pathological attack on another.

The Five of Swords shows a particularly nasty – though not necessarily very destructive – aspect of Swords. This card is about selfishness, sneakiness and ruthlessness in achieving your own ends. In some readings it can imply, more positively, that there are times when it is necessary to be "selfish like a cat" and act in your own interest, but even with this interpretation it also carries a strong warning that if taken too far that selfishness can become hostile, self-defeating, and can lead to a self-centred view of the world that won't make you happy.

The scene in this card is interesting because as we look at the images our sympathies are much more likely to be with the poor defeated tabby than with the triumphant, but rather hysterical-looking bird-thief. The tabby does not look angry – just dejected and wistful, whereas the tortoiseshell victor looks spoiling for the next fight and, in fact, not at all content with his gains. Looking at this you have to ask yourself who will be happier in the long run?

So if, in a reading, the card seems to show behaviour aimed at you, rather than your own actions, try not to feel like a defeated victim. Instead, see that the person who "wins" and gets one over on you may in fact in the long term be the one to be pitied. Nasty spiteful actions rarely result in a contented life. The message of the Five of Swords is that you should not sink to this level, however tempted you may be.

Notes on the source material

Both are European cats. In fact the tortoiseshell at the front is probably a female –in fact, nearly all tortoiseshell cats are female. However, we felt this cat had the right character and expression (in real life she was a very energetic, and also rather domineering animal).

The alleyway in which they stand is one that runs between two of the older streets in Malá Strana, Prague. In our card it leads to a view of part of the Prague Castle buildings.

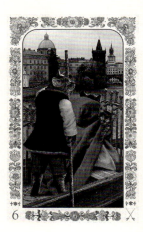

SIX OF SWORDS

A hooded cat holds her kitten tenderly and patiently as a quiet ferryman takes them across a broad river. All is peaceful but the scene is somehow a little melancholy.

A Cat's Interpretation

This card irresistibly brings to mind a cat that's been put in a pet carrier and taken on a journey. Realising that there is absolutely nothing that it can do to prevent this, many cats will simply glaze over – seemingly deciding to get through the unwelcome experience by going into a state that is detached and stoical.

Keywords and phrases

Taking a journey, maybe a mental one • Feeling blue • Going quietly and unnoticed through a troubled time • Acceptance of difficulties • A period of calm – but one in which you feel a bit flat and tired rather than rested.

Keywords and phrases for reversed cards

Feeling rather exposed to publicity • "Rocking the boat" – maybe inadvisably • Struggling against trouble, but without much benefit.

Sometimes this card is interpreted rather simply as indicating a journey or travel. This isn't wrong, and is certainly one of the possible meanings of the Six of Swords, but it's in fact a complex card and can mean a great deal more than physical travel. It's also about the need, at times, to pass through a journey of the mind or soul. It can also symbolise the recuperation period after an illness. Often, the implication is that this period will feel rather flat and depressed – it's primarily a phase you have to get through with patience and acceptance, rather than by taking any definite action.

The cats in the boat look calm, almost tranquil, yet have a slight aura of melancholy. In most ways they are in a transitional state, and so can't do much except quietly wait for the boat they are traveling in to arrive at its destination. The three in the boat may be a family, or the mother and kitten may be unrelated to the boatman. If he is not a father figure, then he may be seen alternatively as representing a figure similar to Charon, the elderly ferryman who used to row souls across the Styx, one of the five rivers that separated Hades, world of the dead, from the world of the living. The Styx

itself was the river of hate. The others were, Acheron, river of woe; Cocytus, river of lamentation; Phlegethon, river of fire (passion), and Lethe, river of forgetfulness. All describe aspects and phases in the process of letting go.

One notable aspect of the Six of Swords is that the image leaves us to decide whether to identify with the ferryman or the passengers. If with the ferryman, then we may take it as an indication that by taking at least some routine action (as symbolised by the effort taken to ferry the boat) we can help ourselves to get through this rather flat period more quickly and safely. But if we identify mostly with the passengers then not even that level of exertion is indicated; the message is simply to sit quietly and wait to arrive at your destination, whether this be a geographical destination or a more subtle mental change of state.

There is a wonderful old Irish word "thole" that means a state of patiently putting up with something while waiting for it to end. The Six of Swords really does epitomise the advice that you still sometimes hear from older Irish people, "You'll just have to thole it".

Notes on the source material

The ferry-cat is a European. The kitten is also European, both were photographed in the Prague Cat Rescue Home. The seated cat is a Siberian. The river that they are on is the Vltava in Prague, the Old Town bank of the river can be seen, as can the Charles Bridge.

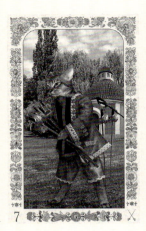

SEVEN OF SWORDS

Holding five swords, and ears slightly back, this cat looks quite furtive. Behind him a magpie, a bird that has the reputation of being a thief, perches on the remaining two swords.

A Cat's Interpretation

Sometimes a cat just can't help being a bit stupidly selfish or even a little vengeful – slapping that noisy kitten when no one's looking, or sneaking in to steal a piece of chicken from the kitchen table. Most cats will get away with what they can. After all, who's to know?

Keywords and phrases

A petty revenge • An impetuous act that achieves little • Impulse with no real thought behind it • A refusal to take advice and reconsider • An act that is a little dishonourable – though temporarily satisfying

Keywords and phrases for reversed cards

Realising that you should get some advice • Looking before you leap • Pausing before an impulsive act • Deciding to forgive and forget after all.

It's no coincidence that we have an expression "selfish as a cat". You don't hear it that much in fact, but it's been around for years and it means a situation in which you should be selfish without conscience – simply taking what you need, in the way that a cat will happily steal food the minute your back is turned. I referred earlier to the fact that in some exceptional circumstances the Five of Swords can be read in this way. The Seven is generally a lighter card than the Five, and so this interpretation of guiltless selfishness is a little more common in readings. However, the basic fact is that this card also tends to indicate a rather less positive kind of selfishness – someone who is inclined to be vengeful and self-serving in a rather petty and unconstructive way. Unfortunately, when we see it in readings this less pleasant interpretation is more likely to be the true one.

The cat in this picture does not look really unkind or sneaky, but he is rushing off with his ears rather laid back (a sure sign of tension in a cat) and carrying five sheathed swords. Although everything around him looks

tranquil, the presence of a magpie perched on two other swords in the background does make us think of theft. Magpies are known for stealing shiny objects that they don't particularly use in any way - they tend just to hoard them. The indication is that the cat is also stealing something that may not be of real use to him. It's likely he is doing this deed on impulse as much as from any deliberate plan or purpose.

In this card, the swords stolen by the cat do not necessarily represent actual objects. The card can equally point to the threft of information, trust, friendship, or indeed to any silly and petty act of revenge. According to an old Netherlands' belief, cats were regarded as untrustworthy spreaders of gossip and so were not allowed into rooms where private family discussions were going on. The Dutch believed that any cats overhearing sensitive information would broadcast scandal around the town. This belief was probably based on a suspicion that some cats were in fact ill-intentioned witches in disguise.

Although this card does not indicate anything very serious, it does point to the kind of act that makes the guilty perpetrator wonder sometime later "Why on earth did I do that?"

Notes on the source material

The cat is an Abysinnian. The small building behind him is an old garden-house in the Petřín Park in Prague. Nowadays it is largely unused.

A Cat's motto – Whatever you do that's wrong, make sure that the dog gets the blame

Anonymous

I am indebted to the cat for a particular kind of honourable deceit.

Colette

Honest as the Cat when the meat's out of reach.

Old English saying

I am as vigilant as a cat to steal cream.

Shakespeare [King Henry IV part 1]

Eight of Swords

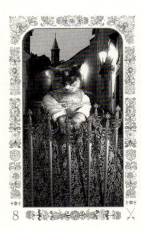

A nighttime scene in which a cat stands with eyes shut and head down, surrounded by swords and with paws bound. Is she helpless? Perhaps not, because in fact she could probably manage to pick up one of the nearby swords and cut the cords that bind her.

A Cat's Interpretation

There is nothing a cat loathes as much as being trapped or confined. While most domestic cats will put up with being put in a box for transport, they usually make it very clear that they dislike this. Being free is part and parcel of being a cat – to a cat, liberty is an essential.

Keywords and phrases and Phrases

Trapped, either mentally or physically • Being controlled by circumstances Blaming everything around you and refusing to help yourself • Not opening your eyes and seeing your true situation.

Keywords and phrases for reversed cards

Making an effort to free yourself • Refusing to be a victim any longer • Understanding that you have choices – you are not so stuck.

This card shows the figure of a small tortoiseshell cat who at first sight seems to be tightly bound. However, look again and you'll see that she that the cords are in fact not that substantial and with a bit of effort she might well be able to pick up one of the swords in front of her. If only she was determined to cut her bonds then there is really nothing to stop her from walking away free. But will she? In a way she still looks cowed, though there is also the dawning of some determination on her face.

This card is much more about the mental bonds that we subject ourselves to than about any physical restrictions. Although the figure is bound with cords she is also in an ideal position to release herself – it would just take some serious resolve and a little exertion. In a reading this card can indicate that someone really is trapped, but more often it points to a trap that is the result of a mental state rather than a physical or social one. The person who feels tied down may seem to be too lazy to do anything about it, but more

likely the truth is that they are either scared or depressed.

How many people do you know who stay in a situation – be it work, lifestyle or a relationship – that they constantly say they want to get away from? Typically, the cry is "Oh, if only I could" and yet, to the objective observer, there is often in fact nothing much stopping such a person from breaking free and making the changes that they say they long for. The reality is that we often can liberate ourselves quite easily, but the thing that holds us back is that deep down we don't really want the change. It's easier not to make the effort and instead simply to sit and blame things on other people, some external force or simply on bad luck.

The trick is to take it one step at a time. First look around and see that those swords can be turned into a useful tool of escape. The very things that seem to pin you down may in fact be the means to liberation. But first you have to summon up some willpower, that's the real key.

Notes on the source material
The cat is a female British Shorthair. The scene around her is a street in the very old and picturesque Nový Svět district of Prague. Nový Svět means "new world" and we like the implication that the "new world" is at hand in this image, if only the central figure could recognise it.

NINE OF SWORDS

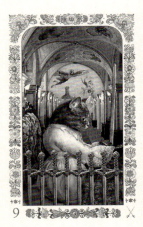

Is this a nightmare or reality? A little cat sits up in bed and stares at nothing. Behind her a long corridor stretches away, crowned by a painting showing Icarus falling from the sky. For no obvious reason, there are swords all around her, and she holds one, unsheathed, in her paws.

A Cat's Interpretation

Cats are not prone to hysterical imaginings, but there is no doubt that they dream, and that they also sometimes appear, when awake, to "see" things that aren't there, and to be alarmed by them. A truly spooky spectacle for their human companions, who may feel afraid long after the cat has lost interest and gone on to other things.

Keywords and phrases

Anxieties and nightmarish thoughts • Despair, often about a loved one • Hysteria – seeing the worst side • Huge disappointment • Victimisation, self-blame.

Keywords and phrases for reversed cards

Shame and fear – based on something that's really happening • Assailed from all sides, but frozen into inaction • Self-doubt, anger turned inwards when it should instead be turned on the attacker.

The image on this card looks half real and half imagined. Is the cat really sleeping at the end of a corridor? Why is she holding her sword in such a guarded, but nonsensical way? Is it a scene from waking life or is it all just a fantasy or nightmare? It certainly has the quality of some nightmares. We can imagine the little figure in the white nightgown running endlessly down the corridor...

The Nine of Swords represents a heart-felt despair, often about a loved one. Yet, when the card is right-side up, the indication is often that this despair and dread is in actual fact irrational. It's the sort of hopelessness that we have all felt when we wake in the darkest hour before dawn and believe that things are appalling and that there is no way out. But often when we wake again in the morning the state of affairs doesn't look nearly so black after all and we

wonder why it all seemed so terrible. The thing to bear in mind, when reading this card, is that it does not usually indicate a situation that is really hopeless, but rather a mental state that makes things look that way. However awful you feel about your circumstances, what may in fact be needed is simply a calm, objective look at your options, rather than giving in to hysteria or self-pity. This is sometimes a hard message to accept, but one that is central to the Nine of Swords.

This card also has a related implication, and that's of a fear that stems from psychological immaturity. In some readings (though by no means all) it indicates a rather attention-seeking, histrionic view of a situation. This is an interpretation that fits with the picture of Icarus and Daedalus on the wall behind the frightened cat. In this classic Greek legend, Daedalus made wings from wax and feathers for himself and his son Icarus so that they could escape from Crete and return to mainland Greece. However, Icarus was over-confident and flew too close to the sun, which caused the wax to melt, and resulted in the boy plunging into the sea. This is an apt metaphor for the way in which a mind that is immature and prone to wild ups and downs, can end up leading to entirely avoidable disasters. Again, the Nine of Swords tells us to look at situations calmly without submitting either to hysteria or depression. Things may not be as bad as they seem if you keep a cool head.

Notes on the source material
The cat is a grey and cream British Shorthair. The corridor behind her is taken from the Wallenstein Palace in Prague, as is the painting of Icarus and his father Daedalus. As mentioned earlier, Wallenstein is very much associated with war and death and also with having a certain nightmarish interest in the grim sides of fate and fortune.

Some women can change their soul into a black cat, which seeks out homes where there are sick people. This cat phantom miaows in a strange and disturbing way.

Bengali myth

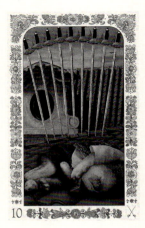

TEN OF SWORDS

A bleak rooftop scene. A cat is curled up with a paw over his eyes. The window behind him looks abandoned and derelict. Against a stormy sunset sky ten swords fall through the air.

A Cat's Interpretation

Unfortunately, cats can of course get to the point of being broken and despairing. You see it particularly in those that have been physically hurt or are ill. But they do have a wonderful capacity for healing and given time and care, they can often pick themselves up from a low point in their health and happiness and make a remarkable recovery.

Keywords and phrases

Reaching the lowest point • Feeling betrayed, stabbed in the back and left for dead • Great pain and sadness • A psychological breaking point.

Keywords and phrases for reversed cards

Some relief from the pain – fighting back mentally • Temporary improvement – use it to make real change

When you read the keywords for this card it seems like a list of extreme negatives with no way out. Often the first reaction to seeing the Ten of Swords turn up at a significant point in a reading is alarm and fear. But it's important to remember that the Swords always refer, to some degree, to a process in the mind as well as in the world around us. The card can often be a well-timed warning, rather than a harbinger of doom and gloom.

There is sometimes a great deal of confusion between the Nine and Ten of Swords. The difference between them becomes clearer when you remember that the Ten of each suit is always about a fulfillment of the suit's qualities – a closure that comes before the enthused new "beginnings" of the Page. So the Ten of Swords should be thought of as the fulfillment of both the intellectualism and the pain of Swords. To an extent this card represents the fact that the event that was dreaded in the Nine of Swords has actually happened. Ironically, when we encounter a black period we often find that the dreaded anticipation of it is worse than the reality. Faced with the event itself, our mental strength may help us to begin the recovery process.

So the Ten is a turning point. The thing you may have been worried about has now occurred – maybe you've lost your job, your business, a relationship, or you've suffered betrayal or even some form of mental crisis or breakdown. Yet the very fact that there is nothing more to dread now brings a degree of peace. It's not by chance that in some versions of this card the figure appears to be in a state of meditation rather than death. This is a moment when your ability to journey through the crisis and on to the new beginnings that will follow, depends totally on your mental strength and abilities. If you give up and fall to pieces then the black period represented by this card may go on for a long time. If you "rise above it" and become wiser by the experience, then you will get through it much faster, and perhaps with some surprisingly positive outcomes.

There is one last thing to say about this card, which is that when it appears in a reading, the temptation is often to hurry the querent past it, with the best possible intentions. But if you look at the image itself you'll find it has a remarkable stillness about it and we should take note of this. At these difficult points in our lives it's important that we give ourselves the time to acknowledge what's happened, and let things sink in. Only then can we really feel ready to pick ourselves up and move on. Don't try to hasten this process. It does take time.

Notes on the source material

The cat is a European who was photographed (in fact asleep) at the Prague Cat Rescue Home. The roof is based on several photographs of the famous red tiled roofs of the Malá Strana district of Prague.

> **There are two means of refuge from the miseries of life: music and cats.**
> *Albert Schweitzer*

Page of Swords

An alert young cat stands on guard in the middle of the road leading to a castle. His sword is drawn, and he looks lively and at the ready – but the battle has not in fact commenced, and who knows, it may never happen. Beside him a butterfly drifts lazily past.

A Cat's Interpretation

There is a touch of the Page of Swords about most healthy young cats. Ever on the alert, and lightning fast to respond to any threat, they are quick, clever and have very acute senses. Of course, they also love to fight, but at this age, it's nearly always "play fighting" in which no one gets hurt.

Keywords and phrases

Ever watchful • Staying on the alert, a faithful guard • An acute sense of vision • Clever and quick • An ability to see what's really going on • Enthusiastic – but also wary • Fairness – and fortitude in defending justice • Championing a cause.

Keywords and phrases for reversed cards

Letting your guard down • A lapse in your usual courage • Turning a blind eye to some injustice.

The Page on this card has the largest pair of eyes you could possibly imagine – which he needs to maintain his constant state of alertness and wariness. It isn't that the Page of Swords is a brooding or suspicious type. Far from it, in fact he tends to be enthusiastic and direct. But he does tend to see life in terms of conflict, and himself as the true guardian of all that's honest, just and rational. He is a wonderful person to have on your side if there really is some battle to be fought – and if you really are on what he considers to be the ethical side. He is endlessly faithful, will take on the necessary responsibilities with energy and fervour, and will do everything in his power to ensure that he never lets you down.

However, on the down side, in situations in which things are going calmly and peacefully, this Page can get bored and even disruptive. Left without a cause to champion he may simply make up a threat that doesn't really exist.

When the Page of Swords comes into your life it's best to think about how to focus him towards the areas that can really best benefit from his courage and quickness. If you really are under some kind of threat, then his presence will bring security and support, and he will show you a touching faithfulness.

There is an interesting tradition – drawn from the original RWS deck – of showing a butterfly on the Swords Court cards and we have followed this on our image of the Page. Although in the RWS the exact meaning of the butterflies is not spelled out, our interpretation is that they represent the lighter, more mercurial and abstract sides of thought – and like an idea, a butterfly can be gone and forgotten very quickly.

One final thing to add is that one interpretation of the Page of Swords reversed is that it can show sickness. This is sadly especially easy to understand if you think of what happens when a young cat gets ill. The very first thing that happens is that they tend to lose interest in their surroundings and both their alertness and their agility vanish almost overnight. The reversed card – when it refers to illness – is particularly about the kind of illness that causes apathy and depression.

Notes on the source material
The cat is a European tabby kitten. He is standing against a background adapted from two different areas in Prague.

Even a sleeping cat is always alert
Old Irish saying

KNIGHT OF SWORDS

Mouth open in a triumphant shout, the Knight of Swords shows both his teeth and his blade and goes charging straight into the battle. He is never happier than when engaged in a tough fight, and undoubtedly, whether the fight is an intellectual or a physical one, he is good at conflict and will nearly always come out as the victor.

A Cat's Interpretation

There are not many cats that really relish a fight, but it's something you do see in some tomcats at the peak of their powers. If such a cat has had some bad experiences that have made them somewhat paranoid and suspicious they can turn very aggressive. Although such cats are redeemable, it's best to keep them in a kind, loving and understanding environment with no other cats – as any companions are likely to be attacked at every opportunity.

Keywords and phrases

Exerting your own opinion and wishes beyond all • Relishing a fight • Sharp intellect – combined with utter self-confidence • Being certain that you are always right • Putting force over feelings.

Keywords and phrases for reversed cards

Pausing before charging in • Being uncharacteristically willing to listen to others • Allowing your feelings to influence your decisions – for once • Experiencing doubt about whether you are really always in the right.

This Knight is problematic simply because he combines a very aggressive and arrogant approach with a really sharp analytical mind and so he is the sort of person who tends to be convinced that he is always right. But in fact, just because he is very smart, logical and willing to exert his strength to its utmost doesn't mean that he should be followed without question. This is something that both he and his associates need to learn.

The Knight will try to exert his dominance in all situations, often without bothering to question his own snap decisions or to look around for alternative opinions. The result is that in spite of his capacity for sharp, incisive thinking, he can actually quite often be mistaken in his judgements.

Remember though that he would never, ever admit this. The Knight is essentially an embodiment of the idea that "might is right", and he is capable of being utterly ruthless in his dealings and totally impervious to criticism – and even sometimes to experience.

Is he always a negative character? No, like all the cards in the tarot he can be read in various ways according to the situation. If you really are in a battle – either intellectual or actual – then the Knight is a wonderful ally. In our image he is cutting down a green serpent, which represents envy, malice and deception; when the Knight of Swords is on your side he can be extremely effective against such enemies. Just bear in mind, however, that like many of the best warriors, he can find it hard to settle down to a peaceful life and may quickly become a liability when the battle is over. Welcome this Knight into your life when you really need him, but at other times, be wary of allowing him to dominate you or lead you into unnecessary conflict.

Notes on the source material
The cat is a Siberian. In fact, like several of our "male" cards in this deck, it's a female. The wall painting is from an old Jesuit monastery, now a hotel, in Český Krumlov.

The Cat and the Serpent must be numbered among the most ancient glyphs of Egypt, and in its original form, seems to have been identical with the symbol of the Virgin and the Dragon
The Cat in Religion and Magic

QUEEN OF SWORDS

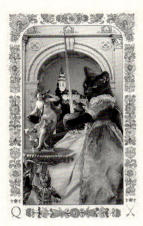

Sitting in her castle room she thinks back over her memories and sees clearly what they have taught her. Wise, and perhaps a little sad, this queen has nevertheless not lost her sense of wit and fun. The little table and ornament that sit beside her clearly demonstrate that.

A cat's interpretation

Not the card of a young cat, this relates to the kind of older female that hasn't had an easy life, but has nevertheless survived and remained friendly and open (if a little cautious). You can meet this kind of cat frequently in cat's homes. A bit battered physically and showing all the marks of her experience, she nevertheless mixes in harmoniously with the others, but also keeps her wits about her. If really threatened, can certainly defend herself and lash out – although she does this only if she has to.

Keywords and phrases

Wisdom gained from experience • A sharp wit, sometimes cutting • Inability to "suffer fools gladly" • Some suffering that's resulted in lessons learned • Astuteness and clear thinking • A farsighted and intelligent judge.

Keywords and phrases for reversed cards

Still balanced, but tainted with a trace of bitterness • Intelligent and astute, but not quite trustworthy • Wit that is turned to sarcasm.

The Queen of Swords has a striking grace and a stern beauty, but she is not an altogether happy figure. She has seen some sadness in her life and may even have been through mourning and loss. However, her enormous mental strength has enabled her to persevere and rather than becoming bitter she has gained tremendous wisdom as a result of her experiences. She is an intellectual, but unlike the King of Swords she has no tendency to be overreliant on her powers of reasoning. She draws equally on both her "book learning" and the knowledge gained from the challenges of life.

This makes her astute, and the possessor of a sharp wit. She has a mature personality, is forthright and continually honest, but has learnt not to take things too seriously. If you need some straight advice, she is an excellent person to turn to. However, while she can be very witty with words, and in

some ways quite light and airy in her manner, don't forget the basis of her strength. She is not someone who will take kindly to foolish questions or behaviour, and she can be positively cutting if she sees irresponsibility or sloppy thinking. Enjoy her company, but treat her with respect.

In our image of the queen the porcelain figure who sits on the table beside her is a Baroque depiction of the sense of "Sight" This is a pretty, flirtatious little figure who gazes intensely through her telescope – in the other hand holding a mirror in which she can see herself as well as reflecting the outside world. A hawk is at her feet, eyes keenly fixed on her. All this represents aspects of the sharp sight that is such a strong attribute of the Queen of Swords. The figure of the Queen herself shows another side of her character. She is calm, and she gazes into the heavens with some sense of reflection and sadness. She is slightly withdrawn from the world and gazes at it through the window of her fortified castle. However, while she has gained her wisdom through hard experience and is in some respects "sadder and wiser" she has not lost her sense of humour. Her keen wit and ability to deal sharply with enemies, are seen clearly in her use of a bulldog as the leg of her little table!

Notes on the source material
The cat is a black European. The room in which she sits looks out onto a view of the old centre of Český Krumlov. The porcelain ornament of "sight" is on display in the Museum of Decorative Arts in Prague (see illustration).

Intelligence in the cat is underrated.
Louis Wain

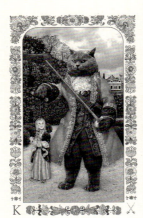

KING OF SWORDS

A stern cat stands full-square in his garden, dangling a little puppet woman in one paw, and holding his drawn sword with the other. The monarch playing manipulative mind games perhaps? Or can we read this less seriously simply as a picture of a cat who knows how to control his people?

A Cat's Interpretation

The main problem most cats have with their human companions is the difficulty of training them satisfactorily. Cats can be surprisingly determined and cunning about achieving this. As anyone who lives with a cat can tell you, feline willpower is not to be underestimated!

Keywords and phrases

High intelligence and rationality • Taking command • Making the judgements • Being confrontational and destructive • Using your cleverness to dominate others • Fair, but capable of being vengeful • An implacable enemy but a firm friend.

Keywords and phrases for reversed cards

Domineering, but not in a particularly rational way • Unfairness, some cruelty.

As I discussed at the beginning of this section, Swords is a problematic suit, often seen as negative and even at its best usually with some sort of edge to it. As the highest card of the suit the King is in many ways the epitome of Swords. His positive aspects are his keen intelligence, clear thinking and his ability to be decisive when it matters, but the negative side of this is that he is prone to arrogance, intellectual dominance and a belief that he is entitled to manipulate and control others.

This image on this card shows a stern, yet attractive and confident cat holding a little puppet of a woman. It's a slightly uncomfortable picture and one that clearly symbolises the fact that because he can out-think most people - and knows it - there are times when the King won't hesitate to be manipulative. If you are willing to let him pull your strings (and perhaps

there are times when this might actually be a good thing) then it's fine, but if you want to do your own thinking, then beware of the King of Swords in his "puppet master" aspect.

Notes on the source material

The cat is a blue British Shorthair. He is standing in the gardens of the Wallenstein Palace in Prague. Duke Wallenstein is a historical figure who is an obvious character to associate with Swords – he was both ferociously intelligent and a ruthless general. The puppet is from a puppet museum in Český Krumlov, Southern Bohemia (see illustration below).

A cat may look at a king
Old English proverb

I have studied many philosophers and many cats. The wisdom of cats is infinitely superior.
Hippolyte Taine

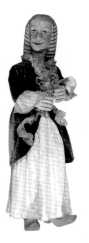

"Baroque" style puppet from Bohemia

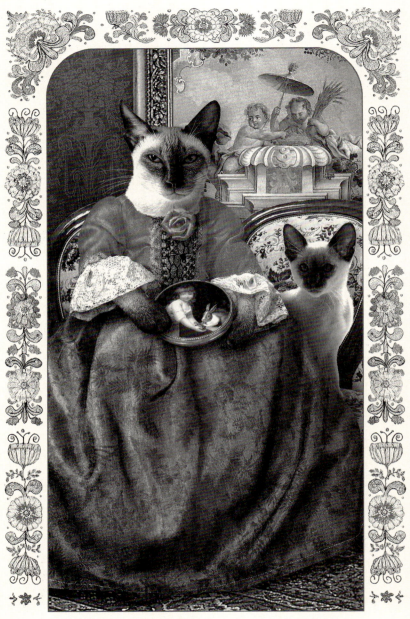

PENTACLES

PENTACLES

Earth is the element associated with Pentacles, and the suit concerns the more down to earth aspects of life - work, practical matters, money and material concerns. This makes Pentacles both pragmatic and well-grounded, sometimes even to the extent of being rather unimaginative.

People sometimes have a slightly dismissive attitude to this suit because they see it as being all about money. This is understandable, as in pre-RWS decks it was usually called "Coins". However, it's become usual to interpret it much more widely now and to see Pentacles as being about all practical matters. This can encompass technical and manual skills, work in its many aspects, property, and, in a broad sense, a general attitude of sense and pragmatism. Pentacles are in some ways the "salt of the earth". Without them, none of the intellect, action and emotion of the other suits would actually show themselves as anything in the real world. Even at the most exciting times of our lives, we do need to keep at least one foot on the ground.

It's easy to relate to the Pentacles message, which tells us that most achievements demand a degree of common sense, hard work, and a good deal of prudence and practicality. There is a certain warmth about this suit - in most ways it talks to us about things that we are very familiar with in everyday life. However, having said this it is also true an overabundance of Pentacles in a reading may indeed indicate rather too much concern with material matters. As ever the tarot tells us that finding a good balance is always the best way to live.

The Story of Pentacles.

A great new opportunity comes along and offers the promise of immense reward. So if only you have the skill, the organisation and the common sense to take advantage of it - there's gold in them there hills! (Ace). But once you begin, you quickly realise you'll have to juggle many things to make this work. For you, that's not a problem, you can keep a lot of plates spinning at once (Two). What's at the forefront of your mind all the time is your goal - to have mastery of your craft, a pride in your professionalism and recognition from your peers (Three). But you are so determined to get there that maybe you become too defensive of both your skills and your material possessions - you feel that as you worked for it, it's all yours, and you're not intending to share (Four). This attitude doesn't lead you to riches, in fact it leads to quite the opposite. You've been so busy refusing to distribute any of your fortune that you've cut yourself off from others. Suddenly, you and

those close to you are in trouble, but it never occurs to you to look for help; instead you, and they, suffer alone. Your isolationism has come back to haunt you (Five). But charity does come. Maybe you find it difficult to accept it, as it seems to be given in a rather high-handed way. But you need the help, and you swallow your pride and accept it (Six). From there, things begin to look up. Calmer now, and the crisis over, you take time out to really assess what you've achieved so far. In fact, it's not bad at all, and you realise that even with all the struggle, you have a firm foundation to build on (Seven). So you begin again. This time you accept that to reach your goal you will have to accept a long, and at times unglamorous, apprenticeship. This time around, that's fine, and you settle down to work and to learn (Eight). It pays off. One day you realised that you've finally arrived – at least on a material level. You are content, prosperous and confident. Life feels good (Nine).

But this isn't the end of the story. Although in one sense you have it all, and basically you are happy and grateful for your good fortune, one small thing niggles at the back of your mind. In this entire struggle for material and professional achievement, did you perhaps miss out on some of the chaotic, less practical, but more magical aspects of the world? You look beyond the confines of your home, and you can't help wondering...(Ten).

The Pentacles Court Cards

In Pentacles, the qualities of the Court Cards show themselves in a very down-to-earth way. The Page is about new opportunities for projects and tasks, and in this case these projects may well lead to prosperity and material gain. In the Knight of Pentacles the enthusiasm of the Page gives way to a rather exaggerated sense of responsibility. For the Knight, projects have to be pursued with a dogged persistence. This can make him rather stubborn or, on occasion, obsessive. In his allegiance to duty and practicality he often entirely forgets about the need for enthusiasm and pleasure in the work.

The Queen of Pentacles is an altogether lighter and happier character. Like all the Queens, she manages to balance the Pentacles tendency towards 'workaholism' and materialism with the more positive sides of practicality and skill. She is also a worker, but she loves her work, which is likely to be of a rather sensual nature, and the work she does is often specifically oriented towards making others comfortable and happy. She will always invite you in and cook a superb meal, and she will apparently do this effortlessly and often with great joy.

The King also shares this practicality, but with a less balanced sense of his own needs. Instead, he worries about his dependants and the community around him. He is probably the consummate businessman and provider, and a real rock to lean on. However, he smiles less often than the Queen and will often drive himself harder than he would really like, simply because he feels that it's his responsibility to do so.

A painting of "sutumn" from the summerhouse in the park of Český Krumlov Castle

ACE OF PENTACLES

A small kitten stands on a rock and holds a golden pentacle in his paws. Opposite is a stone lion, also firmly planted on a rock. Behind is a lush green garden, and above, the sign of a solid-looking elephant.

A Cat's Interpretation

The practical protection of a comfortable, secure domestic life must seem like heaven indeed to the homeless cat. This is the card of the abandoned animal in the local cat's home who suddenly finds itself being adopted into a responsible, caring and loving home. It brings the promise of security and contentment at last.

Keywords and phrases

Opportunities in practical or business matters • Tremendous creativity in some manual or hands-on field • A promise of prosperity and contentment • Finding huge joy and creative fulfillment from a craft or skill.

Keywords and phrases for reversed cards

Wealth will come, but will it really make you happy? • News of opportunities that may not lead where you hope.

Like all the Aces, this card is about beginnings and opportunities. Being the Ace of Pentacles, these opportunities are likely to be in areas involving money, business, material comforts, or worldly issues. This indicates that you have a great chance of beginning to be more productive in a very "real world" way. It may be a process that will lead to actual financial prosperity, or it may be about wealth other than the strictly material kind. Maybe you will gain something that increases your standard of living, even if it doesn't have a definite financial value. Any magic in this card is of a very ordinary kind — it's about finding happiness from down-to-earth comforts, a good environment, and a feeling of security. But this shouldn't in any way diminish the importance of the Ace of Pentacles: sometimes these simple things can bring enormous joy.

Notes on the source material

The cat is a tabby kitten. Appropriately, he was born during the making of this deck. The lion is from the main gates to Prague Castle. The elephant is a door sign from a Baroque house on Vlašská Street in Prague's Malá Strana (see illustration).

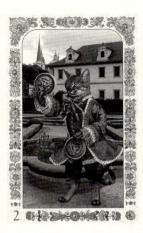

TWO OF PENTACLES

Stylishly dressed and looking confident, a smart tabby cat juggles two gold pentacles on which are gleaming lions' heads. On the pond in the garden behind, a small golden sailboat moves across the ripples.

A Cat's Interpretation

To a cat, juggling is a physical activity, rather than a mental one. Cats love to juggle objects as part of playing, and you can often see young cats throw a small toy between their paws in make-believe that it's alive.

Keywords and phrases

Juggling many things at once • Having to keep on your toes, but actually enjoying this • Using your instincts, rather than your logic • Feeling energised and able to take on a lot • Throwing everything up in the air – just for the fun of it.

Keywords and phrases for reversed cards

Whoops, you've been juggling too much and something had to drop finally Feeling unwilling to trust your instincts • Wanting to have fun, but not quite daring to • You're only pretending to be enjoying yourself.

The little cat who juggles the two discs in this card looks confident and focused. With smart bow at his neck, and splendid golden Pentacles in his paws, he gives the appearance of being able to manage anything with assurance.

This card has two contradictory meanings that, appropriately perhaps, you may need to balance during a reading. It can often be about juggling and playfully "keeping the plates spinning" while having a good time. But it can also indicate sudden and demanding news that brings worries and agitation. This in turn may provoke the need to reshuffle, reorganise and generally manage a lot of things at once, in a way that will be far from fun – a very different way of looking at this card.

So how do you decide which interpretation applies? As always, the key to working out which should predominate in a reading is to look at the whole situation. This card can often come up when someone is managing to juggle

164

a lot of things at once and is actually enjoying doing so. But alternatively it may be obvious that the querent has taken too much on and is slavishly tied to trying to keep everything going singlehandedly. In both cases, the Two of Pentacles indicates that the tasks are being done successfully - the balls stay in the air. But in the first instance, there is pride and joy in achieving this, while in the second, it has become a chore and an anxiety.

In some ways, the Two of Pentacles is related to The Fool of the Major Arcana, although it doesn't have the spiritual depth of the "wise fool" whose footsteps seem protected by a higher power. However, it does carry the rather similar message that the way to meet a challenge or a risk is often simply to relax. It's when you tense up and worry that things may begin to fall to pieces. In the traditional RWS image of this card, a boat is tossed on waves in the background. We have shown a similar boat, in full rigging and shining with a golden light, bobbing about on a pond. This little boat is a useful piece of symbolism to remember in relation to this card - if you remain emotionally bouyant and "go with the flow" you are likely to keep on top of anything that rocks your life and routine.

Notes on the source material
The cat is a European tabby. The garden in the background is based on the Wallenstein Garden in Prague. The pentacles were originally brass reliefs from a door in Prague's Old Town district (see illustration).

THREE OF PENTACLES

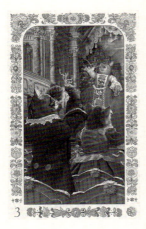

Diva! In a gorgeous Baroque theatre a cat is performing to an enraptured and enthused audience. She is obviously at the height of her powers – and her voice. The audience applaud wildly, entranced by her skills.

A Cat's Interpretation

Some cats really do achieve mastery of certain "crafts". Hunting is the obvious one – although in fact this peaks early and many cats lose interest even as they become older and more experienced. Skills like opening cupboard and window catches are a different matter. Many a wily old cat becomes a real maestro at theft and escape – and of course it's always best to be able to do both!

Keywords and phrases

Mastering a skill or craft • Becoming known for what you do • A justifiable pride in your attainment • Creating a masterpiece • Understanding that "overnight success" takes years of work.

Keywords and phrases for reversed cards

An inability to master your chosen craft • Pretence at real skill – but without foundation • Being ignored by the world, toiling away in obscurity • Feeling frustrated – you want skills to come faster.

This card is about the accomplishment that comes through hard work and teamwork. It isn't about effortless natural born genius or indeed, overnight success. Instead it tells us that most accomplishments come after a long period of learning and apprenticeship to the chosen craft or skill. Although the image shows an opera-singer – a very public and flamboyant form of technical and artistic skill. the Three of Pentacles may equally indicate any trade or skilled labour, especially if it involves teamwork, planning and a lot of practical know–how and knowledge.

Whatever the field of achievement that this card points to, it is likely to be something that needs a distinct level of technical or manual ability as well as a purely artistic or intellectual one. It isn't about purely abstract work, but more about tangible skills.

Although the Three of Pentacles primarily indicates a very high level of competence, it can also, in a reading, be about the recognition, renown and respect that can be achieved through hard work.

Notes on the source material

The theatre setting is based on two real Baroque theatres in the Czech Republic. One is the Estates Theatre in Prague, where Mozart premiered "Don Giovanni". The other is the perfectly preserved Castle theatre in Český Krumlov Castle. The performing cat is an Abysinnian. The audience is made up of a European tabby and a Siberian.

It's also worth adding a note about the flowered panel on the front of the singer's dress. This is a hand-embroidered piece that forms part of the belt of a traditional Southern Bohemian folk costume. The skilled workmanship makes it particularly appropriate in this card.

Theatre cats were part of the creative, bohemian life of the stage, providing numerous unscripted moments when they wandered casually out in front of the audience, mid-scene.
Andrew Parsons (The Times Newspaper - United Kingdom) 30ᵗʰ December 2000

Up there, warm and cosy in my coat of fur,
I'll practise my solo, "miaow, purr, purr, purr."
Anonymous

Four of Pentacles

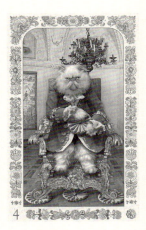

Holding a golden pentacle tightly in his lap a cross white cat glares out at all comers. He is obviously a figure of considerable wealth, but judging by his expression his property is more a source of conflict than joy.

A Cat's Interpretation

Cats are great believers in the principle that what's theirs is theirs, and what's yours is theirs also. This means that all sofas, beds and comfy chairs in any household automatically belong to your cats, who usually have no intention of giving them up to a mere human – though they may occasionally agree to a loan.

Keywords and phrases

Holding on to what you have • Taking possessions too seriously • Saving and investing • Anxieties about money, which may or may not be justified.

Keywords and phrases for reversed cards

Learning to loosen up a bit, especially around material possessions • A need to be a little less spendthrift • Losing your grip on your finances.

The Four of Pentacles shows a glaring cat who is holding on tightly – probably too tightly – to the golden pentacles that represent his possessions. This card usually refers to material property or money, but it may also indicate someone who is relentlessly holding on to power or position. But one problem is that by hanging on to anything so tightly you can quickly cut yourself off from other people, and from new opportunities. In this image, the cat's expression is hostile, suspicious and very unapproachable. In spite of his wealth, he looks far from the happiness and ease that is shown, for example, in the Nine of Pentacles.

However, it's important to recognise that this card is not always negative – it can have a very positive meaning in some readings. Remember that there are times in life when you do need to save, be frugal and hang on to what you've got. It isn't always a bad thing. As long as it's necessary, and not motivated by sheer meanness or, for that matter, anxiety, some care in looking after what you have can be a good thing.

The figure on this card is obviously rich, but also thin and somewhat hunched and tense. Indeed the whole card does have a general aura of tension and anxiety about it. Perhaps the need to hold tight to money and possessions so tightly often comes from worry and insecurity rather than any conscious desire to be mean?

Notes on the source material

The Cat is a white Persian. The room in which he is sitting is an inner chamber at the Wallenstein Palace in Prague. We added the Japanese hanging on the left (actually a very old silk tapestry) to emphasise the richness of the decoration surrounding the cat.

Wall painting from Wallenstein Palace, Prague (just glimpsed on this card)

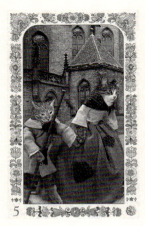

FIVE OF PENTACLES

Two cats, probably mother and son, make their way past the front of a church. They look really down on their luck, although they hold each other's paws and by no means seem completely despairing. However, life for them is obviously a struggle right now.

A Cat's Interpretation

A female cat left with a litter of kittens and without the protection of a group around her is the epitome of this card. Perhaps the handsome tom she mated with in the balmy days of early autumn has vanished and now it's winter and she and the kittens are cold, wet, hungry and with nowhere to go. But hopefully close at hand is a kind person with a warm kitchen, a well-filled larder and a love of kittens and cats. Help may be given if she only has the confidence to look for it.

Keywords and phrases

A cry for help • Anxiety about practical matters • Feeling run down and exhausted • Mutual support in tough times.

Keywords and phrases for reversed cards

Confusion, an inability to solve a crisis • Your support network feels as though it's breaking apart • Falling through the social "safety net".

This card is about difficulties and struggle, but also about the need to ask for help, and to give support, when necessary. The cats shown are going through hard times, but they are also together, and close to one another. When things are going badly and you feel that you are struggling against the odds you may feel that you are battling all alone. But in fact, there is usually some help and support to be had. Whether you are facing a downturn in your work, a poor financial situation, some illness or anxiety, you will probably find that there is someone willing to lend a hand or simply provide a sympathetic shoulder to cry on. But you need to be prepared to look around, see what assistance is available, and bring yourself to request it.

Two very different sources of help are shown on this card. One is the support that comes from close family members or friends. The two cats here touch each other, holding paws affectionately even as they plod along.

Clearly there is great warmth and trust there, and together they are much stronger than they would be alone. The other possible source of help is the church behind. Churches and other places of worship, Christian or not, are traditionally also places of charity. Perhaps rather than struggling on their way and ignoring the solid and rather reassuring church behind them, these two little cats should consider knocking on the door?

Notes on the source material

The church is in central Prague. Architecturally it isn't a particularly exceptional building, we chose it rather because it looks approachable and even rather homely.

The cats were both residents of the Prague Cat Rescue Home when we met them. The boy was quite young, but had already lost the sight of one eye somehow. In fact, the helpers at the home said he was quite happy and healthy even with this disability. The other cat was in many ways a typical street cat – nothing exceptional about her, and showing some scars of a hard life, nevertheless she was also quite settled at the home. These cats that have survived through difficulties can make terribly affectionate pets – they sometimes seem almost grateful for the hospitality and love that a new home can offer.

> **I once was a cuddly kitten,**
> **But now I am a stray,**
> **'Cause when I was no longer fluffy,**
> **They sent me on my way.**
> *The Christmas Kitten,*
> *Anonymous*

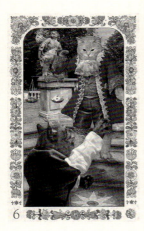

SIX OF PENTACLES

A cat in rough clothes stretches up towards a sumptuously dressed lord who is scattering coins on the ground. In one paw he holds a pair of scales in which, surprisingly, the cups filled with flowers seem to perfectly balance those filled with coins.

A Cat's Interpretation

To most cats, it is almost always okay to take treats from a friendly human. However well fed they are at home, many cats feel that it's good to have one or two extra benefactors to hand. Of course, many people like attention from cats – so to trade some purrs and smiles in exchange for some tasty morsels is perhaps to everyone's benefit?

Keywords and phrases

It is better to give than to receive • Social responsibility • Charity – maybe of a rather high-handed kind? • Begging or accepting charity • Feeling yourself a little above others?

Keywords and phrases for reversed cards

Refusing to be charitable • Envy and resentment about "hand outs" • Taking charity when you really don't need to • Ceasing to rely on charity, becoming more self-reliant.

This is another of those cards that appears to have particularly contradictory meanings. Perhaps that partly reflects the fact that we often have very mixed feelings about charity, whether we are on the giving or the receiving end.

The Six of Pentacles is about all aspects of charity – and for that very reason it can be a problematic one to interpret in a reading. Is the rich cat handing out alms really a kind and charitable figure? Or is he simply being patronising and using his donations to show off his own power and wealth? We've all seen situations – and perhaps participated in them – in which charity seems to be more about making the donor feel good than really selflessly trying to do good. On the other hand, even help given in the wrong spirit is usually better than no help at all. But as giver, ideally you need to be humble enough to listen to people when they tell you what would really help them best.

The scales carried by the cat in this picture are traditional on this card. We added the flowers and the coins to show that charity is not just about money, it is also about less material things, such as kindness, caring and compassion.

The black cat and the white kitten.

When I was thinking about the whole question of cats and charity –and whether or not cats can show altruism to one another – I remembered this remarkable true story that a friend of mine who lives in Warsaw told me.

Her father was not a cat lover, but felt so sorry for the feral cats in the Polish winter that he used to dutifully if rather reluctantly feed one of them with left-overs. It was a thin black cat, that was always hungry and so it got into the habit of coming to be fed every day. One day the man put down the usual leftovers, which happened to be a sausage, and the cat ran to eat it. But before it began, a tiny white kitten rushed across the frozen ground. It was more than hungry, it was starving and obviously hadn't got long to live if it couldn't find food. But it was no match for the black cat. Astonishingly, something strange happened. The black cat, hungry as she was, stepped aside and let the kitten eat the sausage. The man watched in amazement - this was actually an act of charity by the cat. He said afterwards that it was as if the black cat had said "I am hungry, but your need is greater". He felt ashamed, that his kindness had been nothing compared to that of a tattered feral cat. Although he didn't like cats, he picked up the white kitten and took it indoors and cared for it.

When my friend told me this story I asked her what happened to her father and the kitten and she laughed and laughed. "Now they are inseparable," she told me "he even takes the kitten to his country cabin for the summer". It's a wonderful story, which belongs with the Six of Pentacles.

Notes on the source material

The cats are a Btitish shorthair and a European. They are in a setting adapted from photographs of the Vrtbovská Baroque Garden in Prague.

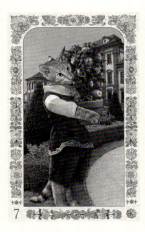

SEVEN OF PENTACLES

An eager, if somewhat anxious young gardener is proudly carrying an apple tree in a pot across the garden of a grand chateau. He has paused at the beginning of the pathway – which direction to go next?

A Cat's Interpretation

After you have spent months shredding the sofa, it can be rewarding to sit back, contemplate your work and consider which piece of furniture should be honoured by your attention next. Don't just rest on your laurels – see the sofa only as a beginning. There are still shredding opportunities galore – the curtains, some nice rugs and of course those tapestry chairs – onwards and upwards!

Keywords and phrases

A pause to review and reflect • Quietly rethinking tactics • Recognising new strategies • Satisfaction from a job well done • Thinking through the next steps.

Keywords and phrases for reversed cards

Anxiety that what you've built up may be wasted • A tendency to rush in rather than to reflect.

Time to stop for a minute, reflect on what's been achieved, and see where you stand. Sometimes this card is simply about pausing to take stock and enjoy some of the fruits of your labour. At other times, it's about ac,tively considering change, thinking out the next moves questioning what you've done, and generally being able to stand back and make some good decisions. The achievement is all yours, now it's time to build on it.

Unlike some of the other cards of the tarot, the Seven of Pentacles, doesn't signal momentous change but is more about gently readjusting your tactics and strategy. It typically refers to a time when a certain amount has been achieved, but more could still be done. The card urges you not just to stand back and admire what's been done to date, but also to think carefully about where you want this to take you.

The picture shows a proud little gardener who is holding a bounteous apple

tree. Clearly, he's done a great job in growing this fruit. But as he pauses at the edge of the pathway he must be asking himself what he should do next. The apple is an ancient symbol of knowledge, and perhaps he just needs to stop scurrying around and take some time to think about what he's learnt and work out carefully the best way to go forward with his newly acquired knowledge and skill.

Notes on the source material

The cat is a ginger Oriental. He is standing in the grounds of the Troja Palace in Prague.

> Alice came to a fork in the road and saw a Cheshire cat in a tree. Which road do I take? she asked. Where do you want to go? was his response. I don't know, Alice answered. Then, said the cat, it doesn't matter.
>
> *Lewis Carroll*

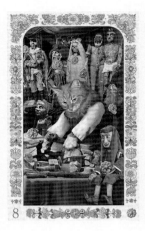

Eight of Pentacles

Hard at work at his carpentry bench a ginger cat is concentrating on the puppets that he is making. Behind him several finished pieces are already hung up. There is quite a variety, some more accomplished than others.

A Cat's Interpretation

Some people who don't understand cats think that they act purely out of instinct. This of course is not quite true. Most young cats learn their skills by trail and error, patience and of course by listening to their mother's advice. Just some of the many skills that cats have to acquire by practice are:

• The right moment to jump on to the kitchen work-top. Try to time it just as someone is putting a large piece of roast chicken on to the waiting plates.

• How to sleep on a bed correctly. Curl up innocently at the very foot of the bed to begin with – but move on to the pillow in the middle of the night.

• What to bring in as a present. A slightly tattered mouse is usually accepted gratefully by humans. You can tell how pleased they are by how loudly they scream in delight.

Keywords and phrases
Apprenticeship and craftsmanship • Learning a skill • The rewards of hard work • Satisfaction in a job well done.

Keywords and phrases for reversed cards
Unwilling to put in some necessary hard work • A false vanity about your own abilities • Failure to learn a skill, or perhaps it's the wrong skill for you? • Bored and frustrated by the long process of apprenticeship.

The serious young ginger puppetmaker sitting at his workbench shows both the creative side of learning a skill and the sheer hard slog of it too. Living in a time when we often want things to come to us instantly, it can be hard to settle down to the long, slow and sometimes tedious process of a long

apprenticeship – in any field. Yet it's usually only by sticking to the repetitive and mundane sides of learning a skill that we can ever get to the point of being able to master it and become creative.

This card is about the need for the kind of patience and application needed for any real mastery. It also reminds us that apprenticeship is not always just hard slog – there is also real pleasure in the gradual improvement that you experience as you get better. It isn't an instant gratification, far from it, but it does bring a really deep satisfaction and sense of purpose. The puppet-maker on this card is probably getting a lot of fun as his technique slowly improves and he becomes ever more accomplished.

Notes on the source material
The puppets are all traditional Czech puppets from a variety of sources. Many are antiques and were photographed at the Museum of Puppetry in Český Krumlov.

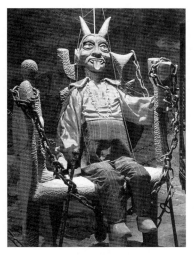

A handmade Bohemian puppet depicting a humorous Devil

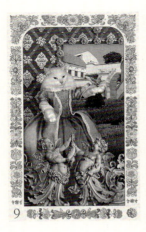

NINE OF PENTACLES

Elegance, grace and prosperity. This white cat has all of these, and also a calm self-assurance. Standing in front of the gates to her beautiful house she looks welcoming and happy. She is prosperous enough to keep a golden bird on her wrist – it's purely a pet, not prey. As the cherubs playing with fish at her feet signify, she has more than enough food and material comforts. A picture of civilisation indeed.

A Cat's Interpretation

Security and territory are high on a cat's list of priorities. It is sometimes said that a cat considers that it owns everything it sees. This is correct – any successful cat does in fact own not only the house and garden in which it graciously allows its people to live, but also probably most of the gardens around. Humans should remember this at all times.

Keywords and phrases

Material prosperity • Comfort and contentment • A refined and privileged way of life • Independence and self-reliance • Achieving a civilised lifestyle.

Keywords and phrases for reversed cards

Some insecurity – are you being deceived? • An enterprise fails to come to fruition.

A refined white cat with beautifully brushed coat stands at the door of her estate. Perched on one hand is a golden bird – Madam Cat is obviously much too civilised to eat him – while in the other she holds a shining Pentacle, which in this scene is very much a symbol of prosperity. In front of her are a pair of well-fed golden cherubs sharing a fish, an abundance of fish being, of course, very much a cat's idea of true prosperity.

The comfortable scene traditionally shown on the Nine of Pentacles is really quite self-explanatory. It is not a complicated card and is usually quite straightforward to interpret. It is about the achievement of a civilised, refined and independent life. The female cat on the card is not a deep searcher after truth or someone who is still in the throes of making choices about her life, instead she is simply happy and content.

The Nine of Pentacles isn't a particularly exciting or adventurous card, but it is very positive, indicating the attainment of a comfortable and maybe even enviable lifestyle. It's also about being in control and able to act with independence and self-confidence. It can indicate an escape from the coarse or vulgar, and the adoption of a more cultured and refined approach to life. This card is always a picture of tact, diplomacy and calm maturity.

Notes on the source material

The cat is a Norwegian Forest cat. She is standing in front of gates that are actually on Karmelitská Street in the Malá Strana district of Prague. The cherubs are from the passageway leading to an old apartment house in Prague's New Town (see illustration).

TEN OF PENTACLES

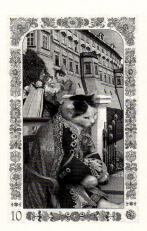

A happy couple and a thoughtful elder cat. The scene is one of contrast, as the pair in the background seem absorbed in one another while the solitary cat in the foreground looks rather dejected and alone. He certainly seems rich, but for him, perhaps this is not enough and something is missing.

A Cat's Interpretation

However domesticated and comfortable a cat is, it never quite forgets its connection to the magical and mystical. Inside every sleek plump fireside-loving lap-cat there is a tiny piece of Bast - the wild Egyptian cat goddess. At night, when a bright moon comes out, even the most civilised cat sometimes feels something untamed and thrilling calling from outdoors. For a cat, there is always Magic at the Gate.

Keywords and phrases

Affluence and material well-being, within conventional limits • Choosing material success over art and imagination • Seeing (or failing to see) that there is "Magic at the gate".

Keywords and phrases for reversed cards

Allowing the magic that's always been at the fringes of your life to finally come in • Being very comfortable materially, and yet feeling oddly dissatisfied • Losing some of your wealth - perhaps a robbery?

This card is one of the more difficult to interpret accurately, as it has some rather complex layers of meaning. As the highest card of the numbered Pentacles, it shows success in work, finance and business, together with contentment in family or a relationship. In this way it is quite similar to the Ten of Cups, although focused less on emotional and more on material aspects. However, quite unlike the Cups card, this Ten also has a strange sense of both melancholy and mystery. To interpret it well, it's particularly important to look carefully at the context in which it appears. in a reading.

On the one hand, the Ten of Pentacles is simply about the aura of affluence and well-being that can surround any material success. The two cats in the background are at ease, content, and obviously well-off. Yet the card also

180

shows, importantly, that over and above this they are happy with one another. One look at them tells us that they are close friends or partners. The cat in the foreground looks equally well-to-do and in fact is dressed in a rather fantastic and gorgeous manner, but he is alone, and seems lost in some sad musings or memories. For him, wealth has not brought total happiness.

On first appearance, this is a conservative card about maintaining a state of prosperity and security. It's also, on the surface, about working towards a sustainable goal and arriving at a lasting contentment. Yet the cat that sits outside the gate is clearly not content. He looks both older and sadder then the others, and is somehow very separated too. Perhaps he has some regrets? This all points to the second meaning of this interesting card, which is about feeling a lack of magic and enchantment in your life. The sad cat may have worked all his life to establish himself successfully – maybe the huge palace behind is actually his (he is dressed richly enough for this to be true). But pehaps along the way he has neglected other, less material aspects of life. Now, older and wiser, he may wonder if all his security and status is really enough. Where has the magic and wonder gone?

In a reading the Ten of Pentacles may simply point to material success, but it can, alternatively, warn us that there may be other things in life that in the end count for more.

Notes on the source material
All three cats are Europeans, and were photographed in the Prague Cat Rescue Home. The building in the background is part of Prague Castle.

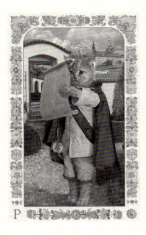

PAGE OF PENTACLES

Standing in an enclosed, but beautifully kept garden, the Page rather solemnly reads his scroll. While he looks studious, he is not by any means a penniless student. In fact, with his beautiful cloak and sash he gives the impression of being well-groomed and rather well-to-do.

A Cat's Interpretation

Nearly all cats are essentially pragmatic in their nature, though young inexperienced cats will often have a naive enthusiasm that gets in the way of sound common sense. However, they are also very quick learners and soon work out what is or isn't possible and practical.

Keywords and phrases

Being sensible and effective, even in youth • Studying and learning • An opportunity to be prosperous • The sheer love of finding new skills to acquire.

Keywords and phrases for reversed cards

Luxury - perhaps extravagance and lack of caution • A lack of groundedness in your studies –difficulty in focusing and concentrating.

The Page of Pentacles is very practical and in many ways businesslike, and in this way conforms to his suit. However, he is also studious, and someone who loves to learn. This may sometimes be at odds with his practical nature, and in fact he will often choose to learn for its own sake, rather than in the expectation of some practical or monetary outcome.

However, it's important to realise that he does not represent an airy dreamer – although at this point in his life the Page is in love with learning merely for the pleasure and satisfaction of it. In fact the knowledge he acquires is likely to pay dividends in some very real-world ways. Whatever he is studying is likely, sooner or later, to turn into an opportunity of a practical nature, and may even bring much success and prosperity.

If this card turns up in a reading to indicate someone who has flung themselves into some seemingly rather esoteric field of study, you may be sure that it implies that sooner or later the work will pay off - even if this is

not what the Page himself intends. To give some examples of this, you might see this card if someone is thinking of going – or returning – to college or university. If so, it would indicate that they are doing this seriously, with the expectation of working hard, but also very much because they simply want to learn. However, the slightly more hidden meaning is that this new period of studentship is likely to result in material prosperity down the line. It's the card of the person who says, years later "I never imagined when I went to study art history that I would end up running my own successful gallery", or "All I wanted was to follow my love of programming, I never imagined becoming the new Bill Gates!" It's a card that can, in fact, have a certain sense of playfulness in a reading. Although the Page is utterly serious, fate may play some games by providing an unexpected outcome to his work –and mostly to the good.

Notes on the source material

The cat is a young British Shorthair. The garden in which he stands is one corner of the Baroque Vrtbovská garden – one of our favourite places and one that we used many times in this deck. The scroll is a miniature one that we constructed, but the image on it is taken from a medieval illuminated manuscript on display at the Strahov library in Prague.

> A speckled cat and a tame hare
> Eat at my hearthstone
> And sleep there;
> And both look up to me alone
> For learning and defence
> As I look up to Providence.
> *William Butler Yeats (1865-1939)*
> *"Two Songs of a Fool."*

A medieval seal of the Bohemian Emperor

183

KNIGHT OF PENTACLES

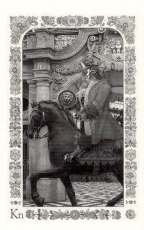

A well-dressed and beautiful Knight rides an elegant horse across a courtyard. It's a rich and attractive scene, and yet compared to the other Knights, this is a less lively image, and the figure on horseback, while beautiful, seems somewhat static. Behind him, the gates of a palace are sumptous and decorative, but stand locked, rather than open.

A Cat's Interpretation

Some cats actually are rather "obsessive compulsive" and can build up quite rigid rituals and routines. We all know cats who refuse to eat until they've been stroked, or who insist on sleeping in the same spot each day. With a few cats this even extends to becoming fixated on specific foods, something that can be a headache for the person providing the meals. The important thing with this kind of cat is to gently introduce some variety and not to let the habits and demands become too fixed.

Keywords and phrases

Methodical to the point of obsession • Sensible and solid • Predictable and faithful • Patient • "Not seeing the wood for the trees".

Keywords and phrases for reversed cards

Some stagnation caused by being over-cautious • Becoming rather unpredictable in a bad way, perhaps a little silly? • Doing something careless – usually but not always for the worse.

All the Knights of tarot are in some ways about action and impetuosity. In the case of the Knight of Pentacles, the issue is lack of action and a fear of doing anything that isn't planned and predictable. This is one of the most solid and reliable of all the Court Cards and while that can be a huge advantage, it can also lead to considerable rigidity and over-caution.

If you have to undertake a routine job that relies on method and an attention to detail, then this Knight is the ideal influence to have. He is the guiding spirit of the checklist, the spreadsheet and the project plan, and he will always play safe. However, when initiative and imagination are needed, he will be less than helpful. He is incapable of risk-taking and at times this can be frustrating or at best rather boring. He is also horribly stubborn, and will

dig his heels in if you try to get him to change. So he's not the best guidance in our life if you need either to take risks or focus on a broad view.

However, looking at the positive sides of this card, you can see that the image is one of both orderliness and prosperity. The Knight's horse is not about to bolt off anywhere; it walks with a stately gait, while the rider himself appears calm and sufficiently in control to be able to balance his large pentacle with ease. All this indicates that this particular Knight will rarely have to worry or struggle in money or business matters – those will nearly always be well-organised and steadily successful for him. He is also very unlikely to hit any sudden dramas or crises.; life for him is very well-planned with all the possibilities predicted and taken into account.

Whether you welcome the appearance of this card in a reading will very much depend on your current need for rigid order and a methodical approach. Perfectionism and obsessive planning can actually be great enablers at certain times, but in other circumstances they can hold you back and even leave you feeling bogged down and depressed. The trick is to know clearly when the Knight of Cups is or isn't an appropriate influence.

Notes on the source material
The cat is a Maine Coon. He is riding against the backdrop of a façade from Old Town Square in the Old Town district of Prague (see illustration).

QUEEN OF PENTACLES

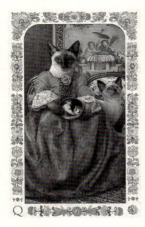

Elegant, assured and content, this prosperous Siamese queen sits in her comfortable salon with a mischievous kitten by her side. In her hands is an exquisite small picture of a child feeding her pet rabbit. Behind her is a harvest picture showing cherubs with corn and fruit. All seems safe, warm and cosily domestic.

A Cat's Interpretation

When we think of the way in which mother cats are often called "queens" it conjures pictures of a very domestic and maternal queen, much like the Queen of Pentacles. The image is of the kind of cat who purrs as she washes her kittens, and who loves to provide for them. At the same time, she is not just all softness and warmth. She'll defend her family if she has to.

Keywords and phrases

Generous and sharing • Down to earth and natural • Intelligence and good sense • Nurturing and kind • Hard-working, practical.

Keywords and phrases for reversed cards

Some mistrust creeps in to the usual "caring and sharing" • Doing someone down, though you know you should be kind.

The Queen of Pentacles is the most domestic of the four tarot queens. She is both comforting and comfortable to be with. She's the kind of person who would always welcome you into her home and offer some good food and good down-to-earth conversation and fun. She doesn't have the drama or impressiveness of the Queen of Swords and she is neither as physically attractive as the Queen of Wands or as perfectly compassionate and creative as the Queen of Cups. She is simpler than any of these others, but she has her own homely and heartening gifts to offer.

The image of this card makes a deliberate link to the Empress card, they both share similar background images. In fact, in some ways the Queen of Pentacles is a less archetypal, more day-to-day version of the Empress. Both are connected to nature and to fertility: though while the Empress is in part a generic fertility symbol, the Queen of Pentacles is more likely simply to be someone who loves to be with children, whether they are her own or those

of her friends. Of course the other big difference is that the Queen of Pentacles is far from wild. In fact she is really rather domesticated, and happy to be so. She is a great influence in your life when you need some simple homely comforts and good sound commonsense.

Notes on the source material

The queen is a seal-point Siamese. Her kitten is also Siamese of course, a blue-point. The charming enameled box that the Queen holds is on display at the Museum of Decorative Arts in Prague (see illustration). The picture behind is one of four paintings depicting the Seasons that are on the ceiling of a remarkable old summerhouse in the park of Český Krumlov Castle.

Pussy–cat, pussy–cat, where have you been?
I've been to London to look at the Queen.
Pussy–cat, pussy–cat, what did you there?
I frightened a little mouse under the chair.
Old English nursery rhyme

KING OF PENTACLES

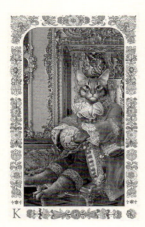

Gold, gold and more gold. The King of Pentacles sits on a gilded chair wearing shimmering lace in a dazzling hall. Everything glints and glistens in the light. Yet the King himself does not seem particularly preoccupied with all this wealth. In many ways, he actually gives the impression of being quite an unflighty sort of cat, and one who is not afraid to look you straight in the eye.

A Cat's Interpretation

This is the card of the tomcat who is "Leader of the Pack" – as long as the pack is an established, settled family group (which in cat terms does not, of course, mean a nuclear family!). He is solid, sensible, will lead predictably and will avoid anything likely to result in trouble. Though he might seem a slightly dull cat, it is surprising how he'll fight for the group when the need arises. At those moments, he will protect them at all costs.

Keywords and phrases

A consummate businessperson • Grounded, responsible "Head of the family" • Knowing what is right • Very sensible, and a little boring? • Seeing things from an accountant's stance - looking at the figures • Good with money, but not obsessed with it.

Keywords and phrases for reversed cards

Still focused on money, but may be willing to resort to corruption or crime to get it • Being weak in business matter, being lead rather than leading • Allowing some selfishness to overtake sense and responsibility.

The King of Pentacles is in some senses a slightly contradictory character. Although he has the "Midas touch" (in Greek myth King Midas was of course the king who turned all he touched to gold) he is not at all focused on money, or even particularly concerned with it. Unlike the Four of Pentacles, a card that sometimes indicates someone who values possessions above all else, the King of the suit tends to see money and possessions more as the means to an end, a way of taking care of those close to him. He is probably the most responsible of all the Kings of the tarot deck. He takes his duties extremely seriously, and this concern with doing "the right thing" can

188

make him seem, on the surface, rather dull and proper. However, get to know him a bit better and he has a heart of gold to match his golden surroundings. If ever you need advice about business or financial matters you will find him a wonderful source of sound sense, and also support. He may not be effusive or very good at expressing himself emotionally, but he won't let you down.

Notes on the source material

The King is an Abyssinian. He is sitting in a French Baroque palace hall (which we have adapted considerably). The gilt chair he is sitting on and the console table to his right are both 1:12 miniatures made by the master miniaturist, John J. Hodgson. It seems very appropriate to have these superb and lavish pieces of craftsmanship on the image of the King of the Pentacles suit – Pentacles are so much about skill, craft and also material goods and concerns.

By associating with the cat, one only risks becoming richer.
Colette

Miniature Baroque style console table (made by John J. Hodgson)

READING WITH THE CARDS

Are tarot readings mystic and magical? Try reading in a serious way and you'll probably be amazed at how well tarot works for many people, and in a variety of situations. A sensitive, careful reading can be not only enlightening but is also often surprisingly accurate about current and future events. But does this really prove that the cards are some magic key to our fate and fortune? Well, many people believe this, but nowadays most serious readers would say instead that the power of tarot lies in the vivid imagery and symbolism of the images, which provide powerful metaphors for stimulating the imagination and insight that we all have inside ourselves. Seen in this way, there is nothing mystic about Tarot, and it is not so much a way to foretell the future as a means of taking control of it by enabling us to see our options and feelings clearly, honestly, and in a fresh light.

Follow the book, or use your intuition?

Traditionally, the meanings of the cards were seen as rather cut and dried. Reading some of the earlier writing on tarot can give the impression (not altogether fairly) that you are simply being told to learn the meanings by rote and apply them correctly. Certainly, those who nowadays read Arthur Waite's hugely influential "The Pictorial Key to the Tarot" are often surprised by how limited and brief some of his explanations are (though in fairness he does point out that these are not the sum total of what tarot is about). This is particularly true of the Minors, and even more so when they are reversed. An example of this is his description of the Seven of Pentacles reversed: "Cause for anxiety regarding money which it may be proposed to lend".

Nowadays, serious readers will nearly always to some extent go with an intuitive interpretation of the cards, based partly on the generally agreed meanings, but also on the look of individual images, their pattern in a spread, and the way in which certain elements can spark associations and ideas. Rachel Pollack, in her book *The Forest of Souls* has recently described this approach as being the tarot equivalent of jazz improvisation. Of course, a good reader may also pick up some cues from the querent, and will know, for instance, how the visual nature of the cards makes them such an excellent way of sparking creative insights into situations — literally letting you see things in a new way. Sometimes issues that are hard to face honestly or objectively are easier to think about through the medium of the cards, which on the one hand can be very graphic and blunt, but also have the advantage of not feeling personally confrontational.

This doesn't just apply to negative indications from the cards. Many of us don't readily recognise and take pride in our own abilities and good qualities. Again, a Tarot reading can be a great way of coming to see the positive aspects of a situation. Learning to acknowledge and appreciate good things about ourselves and our circumstances is an important part of building a better future, and one that's often overlooked.

Learning to read well

The main way to become a better reader is simply to practice. With each reading, whether for yourself or others, your knowledge and feeling for the cards grows, particularly if you take time afterwards to consider how it went and think through your interpretations.

To give you some assistance, many books and online courses are now available. There are also excellent online forums and chat rooms in which you can exchange information and, in some cases, even exchange free readings as a way of learning through doing.

There are three main systems that people follow for readings. The first is based on the old "Marseilles-type" decks. The long history behind these decks is appealing, but many people find that the fact that the Minors (which in these old decks should properly be called the "pips") are like ordinary playing cards, rather than being illustrated with symbolic pictures, can make it hard for a beginner to learn - there isn't a great deal to stimulate the imagination.

A more popular, and much more recent system is based on the "Thoth" tarot designed by Aleister Crowley and Lady Frieda Harris in the 1940s (though not published until 1969). Some people do find that Crowley's popular associations with black magic make them wary of using this tarot, in spite of the fact that the Thoth is not, in itself, a particularly "dark" deck. In the Thoth deck the Minor Arcana Court Cards are fully illustrated, and the other suit cards employ some significant colour and styling, rather than having full pictures to illustrate their meaning.

Most beginners' courses and books use a symbolic system based on the "Rider Waite Smith" (also called the Rider Waite or the Waite Smith) deck. This is a deck originally published in 1909 by followers of the Golden Dawn esoteric society. As an early deck intended primarily for divination (rather than for playing card games) it was very influential. The fact that the Minor Arcana cards are evocatively illustrated is a great help to beginners, and

indeed for many experienced readers this continues to add a useful range of nuances to possible interpretations.

The Baroque Bohemian Cats' Tarot is based on the symbols and meanings used in Rider Waite Smith, so it is an easy pack for a beginner to start with. However, it still incorporates enough twists and variations on the RWS tradition to allow a more experienced reader to use both intuition and improvisation based on the visual imagery.

Learning the cards

There are many approaches to learning Tarot, but of course the first step is simply to get to know the cards and the range of interpretations that can be applied to them. At first, this can look like a daunting task. Seventy-eight cards may sound a lot, especially as each has a number of possible meanings depending on where it appears in a spread and, of course, the question being asked. However, don't be put off by all this, learning the cards actually isn't as difficult as it might seem.

Firstly, the principle meanings of the Major Arcana often relate very closely to their names (though the names shouldn't be taken too literally, e.g. the Death card is not usually about physical death at all). As these twenty-two cards are very distinct from each other, and have very separate and clear meanings, it isn't too hard to acquire a basic understanding of all of them.

Don't be too daunted by the fifty-six Minor Arcana cards. The easiest way to familiarise yourself with them is to remember that they are grouped in various ways. Firstly, each suit has particular characteristics that apply to all the cards in that suit (summaries of these are given at the beginning of each suit). You will also find that cards with the same number will have some similarities. These can be very briefly outlined as follows:

King. Social and familial responsibility. Power and authority. Success, authority, maturity, discipline. Self-restraint. Duty.

Queen. The qualities of the suit blossoming in a well-rounded way. Creativity, balance, openness to others and a real-world wisdom and intelligence. Good communication and social skills.

Knight. Drive, forcefulness and responsibility – or the lack of these. Issues around action, inaction and impetuosity. Self regard.

Page. Exploration, new study, enthusiasm, risk-taking, beginnings, news and

messages. Issues around experience and effectiveness, both of which may be a little lacking.

10. Completion, for better or worse. Ending a phase or an activity in preparation for going beyond it. A peak or trough.

9. Making compromises. Struggle, burdens. Growth and maturation through experience – for good and bad.

8. Issues around movement, speed and change. Collecting ideas and tasks.

7. Victory, recognition, individuality and a period for pausing to make important choices.

6. Communication and social responsibilities. Doing the right thing, even if it's not the easy option.

5. Loss, conflict, challenges, hard choices. Fighting with yourself and others. Struggling, both mentally and materially.

4. Structure, stability, caution, boredom. Balancing security against risks, or excitement against safety.

3. A strong expression of the element – this can be good or bad. Cooperation or conflict. Strong feelings of either satisfaction or sorrow.

2. Union, balance. Taking decisions between two distinct options. Dealing with emotional forces that seem to be pulling in different directions. Trying to juggle opposing desires and impulses.

Ace. Beginnings and new possibilities. Creativity, forcefulness (usually in a good way). Energy, opportunity, fresh starts.

KEEPING A TAROT JOURNAL

Keeping a journal is a great way to learn about how your reading ability is progressing. Of course, nowadays this can be on or offline – there's nothing wrong with a tarot blog! The process can be very simple, just a matter of writing down some notes about the spreads you try so that you can review your progress. You will see that over time your understanding of the "standard" meanings will improve and, just as importantly, that you will begin to develop your own intuitive interpretations of the cards. Good readings depend a great deal on being able to recognise a coherent pattern in the spread. You will gradually learn how to choose from the range of possible meanings so that the readings make sense and feel "right".

Another good way of practising is to draw one card each day (or once every few days if time is tight) and simply consider it in detail, writing down your thoughts as you go. Again, you will find that if you do this regularly, over a period of time your knowledge will become both deeper and broader. This can add tremendously to the potential sensitivity and subtlety of readings.

The Baroque Bohemian Cats' Tarot is a deck that sets out to create an entire fantasy world. You may find it helpful to look at each card as though it is the illustration from a story about this place. If you imagine this story, its situations, characters, how it begins and ends this may also help give some insights to extend your intuition about the possible range of interpretations. At this stage, don't edit your ideas too much, let your imagination and intuition lead, and see where it takes you.

Remember that the journal is a private learning tool, not something that has to be presented to others, so it doesn't have to be beautifully written. Work in the way that makes most sense to you. If you want to sketch, scribble or add pictures to your journal (or links if it's on-line), that's great. Equally, there is no right or wrong form for a physical journal — you can use a cheap notebook or a very special and lavishly decorated book, you can throw it into your bag or keep it wrapped in precious fabric on a special shelf. It really doesn't matter what you choose, as long as it's evocative and meaningful to you. Simply do what feels best – there are no rules.

SPREADS

Nowadays there are a huge number of "spreads", or ways of laying out the cards for a reading. Some of these, like the Celtic Cross, are traditional and widely used, while others are much more recent and less well-known. The old traditional spreads have been well tested, and I think they tend to work well and give useful readings. Though I should also say that you will find many people who question the usefulness of the Celtic Cross and find it a rather opaque and vague spread. However, there is nothing magical about the old spreads and if, over time, you decide that your own personal methods work better for you, well, why not? Whatever you feel comfortable with will probably, in the end, give you the best readings. Don't feel you have to confine yourself to the "classic" spreads, or for that matter to spreads that someone else has taught you. It can be a creative and useful exercise to design your own. Apart from anything else, it can provide a refreshing new "take" on the cards, and in itself, that is often very valuable.

The only way to decide which spreads work for you is to try some. Many people advise that you begin with some very simple spreads — so simple that in a way they are more like exercises in reading individual cards — and then slowly progress to the more complex layout made up of many cards. If you are interested in seeing the wide range of spreads in use, looking at some of the online Tarot forums is a good place to start. Many of them have whole sections in which spreads, old and new, are discussed. To get started, though, at the end of this section are examples of spreads that are popular.

Using a Significator

It's traditional to begin a reading by asking the querent (the person asking the question) to choose a Significator card. This is simply a card chosen to represent the querent him- or herself. It's meant to be the card that best stands for the querent in the situation they are asking about, not a card that represents them in any longer term way. There are many ways of picking the most appropriate card for this purpose. Some readers will simply ask the querent to pick a card at random, or choose any card that seems suitable (probably judging mostly by the picture on it). However, the most common method is to show the querent all the male Court Cards if he is a man or boy, or all the female Court Cards if she's a woman or girl. The querent is asked to look at the proffered cards and choose the one that they feel fits them at this particular time.

You can, if you like, modify this method. Sometimes it seems appropriate to

take out only the Page cards for a boy, the Knights for a young or early middle-aged man, or the Kings for an older man. Similarly this means that you can select only the Page cards for a girl or a young woman (although in the Baroque Bohemian Cats' Tarot the Pages are all boys, they can of course stand for girls too), and the Queens for an older woman. Personally, I prefer not to stereotype by age in this way, but many readers would disagree.

One big issue is that this can all seem rather gender biased. After all, in a reading the tarot cards should not be taken to refer to a person of any particular gender, regardless of the person shown in the picture (e.g. the Magician and Hermit can refer to a woman, the Empress and High Priestess to a man). So why should the Significator card be chosen only from the Court Cards that show a particular gender? It's a good question, and an interesting example of the way in which modern thinking is questioning some of the traditions of the tarot. In fact it's entirely acceptable (and nowadays the practice of many readers) simply to pull all sixteen of the Court Cards out of the pack and present these to the querent, with instructions to choose one based only on intuition, rather than by whether the card happens to show a man or a woman. This often produces interesting results, and certainly gives the querent a good range of images from which to choose. By the way, the Baroque Bohemian Cats' tarot manages (sometimes intentionally, sometimes not!) to do a lot of gender mixing. We've used tortoiseshell cats for several male characters, even though they are usually, in fact, female cats. This means that if you want to, you can interpret the whole deck as a piece of pantomime, in which girls dress as boys, and boys as girls. For some people, this will be fun and liberating, for others it will seem confusing. You decide what suits you best.

Although the Significator takes no explicit part in most readings, it is well worth taking a moment or two to think about the card the querent has chosen, and perhaps to discuss it with them. This can give some very useful information about their particular concerns, and especially into how they see themselves in their current situation.

How to begin a reading

After the querent has chosen their Significator, put the other cards carefully back into the pack. Shuffle the cards well. Place the Significator on the table so that it is clearly visible and hand the pack to the querent. Ask him/her to quietly focus on the Significator and think hard about their question. It sometimes helps if you point to the Significator card and say something like

"This is you. Please look hard at yourself and focus on your question." Ask them to gently shuffle the cards while they do this. Explain that they should keep shuffling until they feel the time is right to stop. At this point, ask them to cut the pack into three stacks and place each stack on the table. Pick these up in whatever order feels right to you (don't shuffle again) and lay out the cards.

Seeing a pattern, making a story
The main issue in interpreting any reading is to be able to recognise and express patterns. These can come up in a number of ways. I've seen readings that are mostly composed of a single suit, readings that contain a high proportion of Major Arcana cards, readings that have three of the Aces, or an unlikely number of nines and tens. All these can be read as being signifi-cant. When you first look at a reading you may sometimes get the feeling that it is just a jumble of cards and doesn't make sense at all. But look again, and begin to search for patterns. It can be quite surprising how these can leap forward and suddenly reveal some significance that was not apparent at first.

A few suggestions to help recognise such patterns:
Look at the proportion of each suit in the spread. Are there an unusually high or low number of any one suit.
Count the number of Majors, and number of Courts.
Are there a lot of cards of any one number? e.g. a lot of tens, or fives, or aces?
Look at the pictures – are they making up a pattern? For example, which way are the figures and faces turned, do certain elements or colours seem to stand out or be repeated?

Take a little time to scan the whole spread and, in a relaxed and unpressured way, see if you get any hunches or insights into the meanings. Look at the pictures – maybe you notice that they seem to make up fragments of a story? What could the story be? What does it tell you? What do you *feel* about this spread?

Reversals
Should you use reversals in a reading? In other words, should your interpre-tation take into account whether cards are laid out upside down? Well, this is a major point of discussion among people who read tarot. Certainly, the practice of reading reversals – or "ill dignified" cards is not new. Arthur Waite gives meanings, albeit very brief ones, for all the cards in reversal. But for

new readers, it can seem very daunting "What? I have to learn not just 78 meanings, but 78 times two?" In fact, it isn't that hard to learn the reversed meanings. To begin with, they all, to a greater or lesser degree, relate to the usual "right ways up" meaning of the card. Sometimes the reversed meaning is actually the opposite of this, but more often it just provides a different slant – almost literally a way of looking at the card from another angle. If you gradually begin to use reversals you will find that they can add a whole new depth of meaning and nuance to your readings. The reversals keywords given for each card in this book are really only a beginning. Reversals often come into their own when the reader is willing to be really intuitive and really consider the full range of possible meanings when a reversal appears. Again, it's very much about going with your feelings.

The Reader in a position of trust

Having talked about the sheer practicalities and methods of reading, I'd also like to add a crucial point. You will find that when you do any reading that's at all serious in intent, your words may be given a lot of weight by the querent. I've seen querents intently noting down everything said, and going over all aspects in the minutest detail. In some situations the reading is seen as a lifeline for a querent, seemingly offering predictions about situations that are otherwise totally unfathomable. This often puts the reader in a position of some power. Please remember that this power should not be abused. Readings are not about showing off your skill, impressing the querent or exerting authority over them. A good reading simply aims to offer help and guidance. Try always to read with compassion and a high degree of consideration and respect. Your effort will be much more effective and appreciated.

Some short spreads

One of the most classic and frequently used spreads is the 11 card "Celtic Cross". It is so common (in so many distinct variations too) and is so easy to find information on that I decided that in this short introduction to concentrate instead on some shorter spreads. These are all very good day-to-day spreads besides being an easy and unintimidating place for beginners to start.

The Three–card Spread

This is a good beginner's spread as it is simple and straightforward. However, its use isn't just limited to beginners. Many people continue to use this spread, often as an "everyday" spread, finding its quickness and clarity very appealing. It comes in various versions, this is a simple one.

The cards are simply laid out in a row – it doesn't matter if it's vertical or horizontal. Their basic significance is:

1. The situation underlying the question.
2. Problems, or issues that may hinder.
3. Opportunities, or things that may help.

Five-card spreads

Five-card spreads are very popular. For many readers they seem to offer a good compromise between a very short spread – which inevitably lacks some detail – and one of the long, but sometimes rather complex spreads. In fact, the five-card spread is so useful that many readers, even experienced ones, will use it most of the time as their spread of preference.

There are many variations on the five card spread – you will find a great number on any reputable tarot forum or on-line discussion group. Indeed, as you get accustomed to using five cards, you may well want to devise your own variation (inventing your own spreads is often a great way to come up with a method that really suits a particular situation well). I'm giving just one classic and one new variation on this spread here. The new one is the spread I devised for our first tarot deck, *The Tarot of Prague*, and it's particularly useful to use if you are considering making a distinct change or step forward in your life. It works very nicely with any deck. But first a simpler classic five-card spread.

A classic Five-card spread

This is often a good spread to use if you want to do a fairly quick reading that still covers most of the important information about a situation. The cards are simply put in a row, horizontally or vertically, as you prefer:

1. Factors in the past that have influenced the situation.
2. Significant issues in the present.
3. Hidden or unconscious influences that should be considered.
4. Advice, and/or possible actions.
5. Probable outcome if the advice is followed.

The Prague "threshold" spread

The Prague "threshold" spread is a slightly more specialised five-card spread originally devised especially for use with our first deck, the *Tarot of Prague*. It is designed to give insight when you are on the threshold of a significant change in your life. It focuses on the issues surrounding this step, and the probable outcome. Lay the cards out in the order and shape shown:

2

4

3 5

1

1. Where you are now. The current situation
2. What lies on the other side of the gateway, i.e. the outcome of this step.
3, 4,5. The gateway.
3 and 5. Issues you need to consider or actions you need to take (the two pillars of this gateway). The left-hand card (3) is more likely to refer to mental or intellectual processes. The right-hand card (5) to actions.
4. The influence that lies over the steps being taken (the lintel of the door).

A longer spread – the Cat's Tale

This spread was devised partly in honour of the "Mouse's Tale" poem in *Alice in Wonderland*. This is a much-loved little piece of whimsy in which the words are laid out in the form of a tail – which then turns out to tell a tale. Thinking about how this might adapt to become useful and interesting, I decided to do something quite different from most tarot spreads. It's normal, when designing a spread, to assign specific meanings to each card, but as the Baroque Bohemian Cats' Tarot is so easy to read as a story, I wanted to try out a narrative approach. This spread only uses the conventional assigned meanings for the first and last card. Apart from that it asks you to look at cards 2-6 as a whole, by studying their pictures, using your intuition and making them tell a single story.

It's not a good beginner's spread as it does demand some existing ideas about possible layers of meaning for each card. But it is great for someone who already uses conventional ways of reading and wants to try out something a lot looser. This spread will encourage you to simply look, feel, use your intuition and tell a tale – all vital elements in becoming a good, sensitive tarot reader.

Lay out the cards so that they resemble a cat's tail (you can be creative about the shape you make):

Lay out the cards so that they resemble a cat's tail (you can be creative about the shape you make, and can see a couple of examples in the next two example spreads.) The way the cards are read is as follows:

Card 1. The current situation (the one that you are asking about).
Card 7. Where you need to get to – the real goal or outcome.
These cards can be read largely using the "conventional" meanings.
Cards 2, 3, 4, 5, 6 The story of what will happen and what needs to be done in getting there. These cards are read, as far as possible, as a narrative.

You do need to allow yourself to read this sequence very much as though each of these five cards (cards 2 to 6) is an illustration in a story book. The aim is to link them together to see some clear narrative that makes up an appropriate "tale". It doesn't work very well with many decks, but does come to life with a deck that, like this one, seems to show scenes from a whole coherent world. Here are a couple of examples of this spread in use, one more serious than the other. By the way, they are shown exactly as the cards came up, they are genuine readings not altered in any way.

The Cat's Tale: Our Cats

This reading was in answer to the rather light-hearted question "Do our cats like us?" The cards drawn were (see also the picture of the spread):

The Queen of Wand
The Four of Cups
The Seven of Wands
The Ten of Pentacles
The Nine of Pentacles
The Emperor
The Knight of Wands

First, I took card 1 and 7 and read them "conventionally" using the more standard meanings.

Looking at this spread, it makes me smile, because the first thing that stands out is yes, your cats like you. It's an amusing spread that really seems to answer the question well, because the two Wands Court cards that appear at the first and last positions are both cards that indicate people who are admired. I think that in this spread it is obviously you

who's the admired person. In fact, if you look at the Queen of Wands, the card that represents the current situation - in other words, how your cats feel about you now, I would say that this indicates that your cats definitely like you, and feel rather protective towards you. Maybe they want to keep you to themselves? Does that ring any bells with you? Do they seem anxious about you or want to keep you with them more?

The last card should show the real goal and in this spread it's the Knight of Wands. Now at first I was a bit surprised by that, because this knight has some characteristics that on the surface seem less positive than those of the Queen, so I had to ask myself why you might want to move from being the Queen to being the Knight. Well in fact it makes sense if we take it that this card as the outcome indicates that it would be better if your cats admired you but didn't feel so possessive about you. The knight is not "owned" by anyone, in fact he is extremely fancy-free. Are your cats a little too demanding and would it be better if they were less so? If so, why do they feel the need to cling to you and what can you do about it? In summary, these two cards ask how you can

make your cats still like and admire you, but feel less as though they have to constantly try to stay close to you?

Let's look at the "story" contained in cards 2-6 and see what it says. At this point I'm going to let the standard meanings take a back seat and instead I'm going to look more closely at the pictures and use my intuition.

First, here is the Four of Cups, showing a bored little cat sitting in a garden. He should really get up and go hunting, or at least run around, but it looks like he can't be bothered. However, on the next card - the Seven of Wands - we see a cat who is very active, fully alert and in the middle of a fight. I think this pair of cards is saying that the answer lies with making sure that your cats are less bored - they focus too much on you because there isn't enough of interest in their lives. They need more challenge, even if this might sometimes mean that they get into conflict. So what are the challenges open to your cats? Well, the next cards rather neatly show three of them:

The Ten of Pentacles shows one cat sitting alone sadly while two others are happily together. Maybe your cats feel a bit locked away while others are out enjoying themselves? The main figure in this picute sits at a gate while the other pair enjoy themselves in a garden.

The Nine of Pentacles looks as though it's about establishing territory - this cat has a wonderful garden that she clearly "owns". However, the interesting thing, when you look at the picture, is that it again shows a cat at a gate looking into a garden rather than actually wandering around it. Between them, these two pictures do strongly point towards a feeling of being right beside a garden or open place, but unable somehow to get into it. You've just told me that your cats can see a park from the flat windows but aren't allowed to go out into it, so maybe that's one of the things they really want to be able to do?

The next card turns to another matter. It isn't about gardens and parks, instead the Emperor is inside, but he is also active, using his brain on a difficult issue. The picture shows us a cat who is sitting doing math-ematical calculations - really challenging his brain.

I think the advice is clear. This sequence of cards tells me thatyour cats

should be allowed out more. *They may well get into fights, but in fact, maybe this is what they need in order to begin to win territory, explore the outdoors and become more well-balanced. They may meet opportunities to find their own food and use their brains in doing so. They will, in the process, lose some of their focus on you, but in fact, they will still look up to you and admire you, and for them the outcome will be better.*

You know, in one way this is just a "fun" reading, but it just might have some useful advice in it too. Do think carefully about giving your cats a bit more space to roam - even if you worry that it might be a bit dangerous for them (you can always keep a close eye on them). The reading does indicate that they may need a bit of freedom at this point.

Just a note of caution. This spread is recorded here exactly as it happened. It is not intended to be taken as general advice about indoor/outdoor cats.

The Cat's Tale: What should we do with our farmhouse?

The next reading is not at all cat-related. It's in response to the question: "What should we do with our farmhouse?" The querent had bought a very old run-down farmhouse at what had seemed a good price, but had then realised that it might cost a small fortune to renovate it. So, should he go ahead and raise the money, or sell the house again? The cards (see also picture) were:

Eight of Cups
Knight of Swords
Seven of Wands
Ace of Swords
Wheel of Fortune
Four of Pentacles
Ten of Cups

This is certainly an interesting spread, and the first thing to say is that it's optimistic about the goal that you're trying to reach. The Ten of Cups in the final position is the card of the happy straightforward domestic life. Getting to that stage in life would very much fit with successfully turning the farmhouse into a comfortable, loved home for you and your partner.

So what does the reading say about how to achieve this? Well, the traditional interpretation of the Eight of Cups in the first position is about letting something go, perhaps walking away from it psychologically or actually. It seems as though you will have to leave behind something that up to now has been quite important to you. Perhaps it's material, or more likely this is about moving on from an attitude or a lifestyle that you have held dear. It seems like you will have to be prepared to set out on a whole new path in order to get this project underway. The interesting thing about this card is that it usually indicates a move that deep down you know to be necessary. So think for a while about what that could be. Is there anything that's beginning to feel like a rut, a habit or routine that's now holding you back? Maybe to get the renovation going you need to give up some other activities? Or you need to change your lifestyle to clear some time and energy?

The whole spread indicates that you are now setting out on a path that will achieve your dreams, so what's the advice about next moves? When I look at cards 2-6 as though they are illustrations in a story, I see quite a dramatic tale. In the first place there is a lot of struggle and conflict;

sorry but it looks like you will need to fight hard to get all this underway and initially it won't be easy. The good news is that if you identify with the figure on the horse and also with the cross guy fighting off a host of attackers, then what these cards seem to say is that you are going to have quite a battle on your hands, but that you can win it. Finally the Lion will hand you the sword of victory, or so it appears, and you will be able to look from inside your house (through the admittedly unglazed windows) and feel that you've won the fight. So, be prepared for stormy days ahead but a victorious outcome.

Once that phase is over, there is some other notable guidance in this sequence of cards. The next picture seems to me to suggest that what you'll need to do is take a long, hard look at yourself once all battles are won. Okay, by this stage you will be past the main struggle (to raise the money, to get the work done, to get help or to do the work yourself? All are possible) but you may, as a result, have become a bit battered and disillusioned in the process. In some ways you'll be showing the scars of the sheer effort you've had to put in. This is important. You should really think about the image on this card which I think is advising that you take a pause at this stage and think about who you want to be rather than focusing purely on the house. Maybe you'll come to the conclusion that it's taking too much out of you and that enough is enough. Perhaps the house doesn't need to be perfect, just liveable?

The final card in the sequence is one that often makes me smile as it's both serious and funny at the same time. The way I read this is that this is you, sitting in your newly glorious abode and hugging yourself and your possessions. In other words, there will come a time when you can sit and gloat in contentment. It will all lead on to a more relaxed period in which you can stop the struggle, settle down to being yourself again, and begin to enjoy a wonderful home life.

BIBLIOGRAPHY

Bradshaw, Dr John. The True Nature of the Cat. London: Boxtree Ltd. 1993.

Crowley, Aleister. The Book of Thoth. Samuel Weiser Inc., 1999.

Decker (Ronald), Depaulis (Thierry) and Dummett (Michael). A Wicked Pack of Cards. Duckworth 2002.

Flusser, Villem. The Shape of Things, a Philosophy of Design. London: Rekreation Books, 1999.

Howey, W Oldfield. The Cat in the Mysteries of Magic and Religion. London: Penguin Books, 1997.

Kaplan, Stuart. The Encyclopaedia of Tarot. Volume II, Stamford: US Games Systems 2002

Kaplan, Stuart. The Encyclopaedia of Tarot. Volume III, Stamford: US Games Systems 2002

Pollack, Rachel. SeventyEight Degrees of Wisdom. London: Thorsons, 1997.

Pollack, Rachel. The Forest of Souls. Minnesota: Llewellyn, 2003.

Propp, Vladimir. Morphology of the Folktale. Texas: University of Texas Press 2001 second edition

Ussher, Arland The Twenty Two Keys of the Tarot Dublin: The Dolman Press 1970 (53)

Waite, Edward Arthur. The Pictorial Key to the Tarot. York Beach, Maine: Samuel Weiser Inc 2000.

Whittier Frees, Harry. The Animal Mother Goose, With Characters Photographed from Life. Boston: Lothrop, Lee & Shepard Co., 1921.

Zipes, Jack. Fairy Tale as Myth. Myth as Fairytale. Kentucky: The University Press of Kentucky 1994.

Zipes, Jack. Spells of Enchantment. New York: Penguin Books 1991.

THE TAROT OF PRAGUE

Conjuring the magic city

Composed from thousands of original photographs of the art and architecture of Prague, each gorgeous image on the 78 cards is a stunning, original collage. For both tarot novices and experts, the accompanying book gives in-depth guidance to using this gorgeous Tarot, with:

- Interpretations and explanations of each card's symbols
- Links with traditional Tarot symbols
- How to use the deck for cartomantic readings

ISBN 0-9545007-0-9

BOHEMIAN CATS

Wild feline fantasy

Exquisitely illustrated picture book for all lovers of cats, costumes, and the bizarre.

This beautiful hard-back gift book invites readers into a magical world where lavishly dressed cats go about their business in a fantasy theatrical setting of castles, Baroque gardens, theatres and masquerade balls. Featuring:

- Eighty full-colour, detailed illustrations
- Four panoramic pull-out spreads

ISBN 0-9545007-4-1

MAGIC

REALIST

PRESS